e-flux journal reader 2009

W9-DIY-964

*Sternberg Press*

# Contents

## Editors' Note

Since Conceptualism, the field of art has become increasingly accustomed to playing host to its own critique, and recent decades have seen institutions engaged in self-critique as if by mandate. Important notions of legibility, autonomy, and critical engagement that were once necessary to carve out a space for a critic or critical art publication have transposed themselves onto artistic production proper, and are now considered to be of equal importance to artist, curator, institution, and engaged audience member alike. This has made the distance that was once the bedrock of criticism increasingly hard to come by, compounded by the fact that those same institutions have been faced with an entirely widened base of audiences and professionals, who now come to the sphere of art from diverse fields and locations, invariably entering and leaving it as they wish.

This climate of disciplinary reconfiguration and geographic dispersal has made the art world a highly complex place—the objective position that once defined the role of a critic has been effectively replaced by a need to understand just how large and varied the whole thing has become. The urgent task has now become to engage the new intellectual territories in a way that can revitalize the critical vocabulary of contemporary art. Perhaps the most productive way of doing this is through a fresh approach to the function of an art journal as something that situates the multitude of what is currently available, and makes that available back to the multitude.

The selection of essays included in this book seeks to highlight an ongoing topical thread

that ran throughout the first eight issues of
*e-flux journal*—a sequence of overlapping
concerns passed on from one contribution to the
next. While it is our hope that the essays included
here can begin to give a sense of how varied the
concerns and urgencies being engaged today are,
we also expect that certain consistencies and
overarching issues will emerge through them,
and help us shape the forthcoming editions
of the journal.

—Julieta Aranda, Anton Vidokle, Brian Kuan Wood

Initiated in fall 2008, *e-flux journal* is a monthly online art
publication. Its topics and themes are developed through
open-ended invitations to art practitioners and thinkers as
diverse as its readership.

www.e-flux.com/journal

Boris Groys
# Politics of
# Installation

The field of art is today frequently equated with the art market, and the artwork is primarily identified as a commodity. That art functions in the context of the art market, and every work of art is a commodity, is beyond doubt; yet art is also made and exhibited for those who do not want to be art collectors, and it is in fact these people who constitute the majority of the art public. The typical exhibition visitor rarely views the work on display as a commodity. At the same time, the number of large-scale exhibitions—biennials, triennials, documentas, Manifestas—is constantly growing. In spite of the vast amounts of money and energy invested in these exhibitions, they do not exist primarily for art buyers, but for the public—for an anonymous visitor who will perhaps never buy an artwork. Likewise, art fairs, while ostensibly existing to serve art buyers, are now increasingly trans-formed into public events, attracting a population with little interest in buying art, or without the financial ability to do so. The art system is thus on its way to becoming part of the very mass culture that it has for so long sought to observe and analyze from a distance. Art is becoming a part of mass culture, not as a source of individual works to be traded on the art market, but as an exhibition practice, combined with architecture, design, and fashion—just as it was envisaged by the pioneering minds of the avant-garde, by the artists of the Bauhaus, the Vkhutemas, and others as early as the 1920s. Thus, contemporary art can be understood primarily as an exhibition practice. This means, among other things, that it is becoming increasingly difficult today to differ-entiate between two main figures of the contem-porary art world: the artist and the curator.

The traditional division of labor within the art system was clear. Artworks were to be produced by artists and then selected and exhibited by curators. But, at least since Duchamp, this division of labor has collapsed. Today, there is no longer any "ontological" difference between making art and displaying art. In the context of contemporary art, to make art is to show things as art. So the question arises: Is it possible, and, if so, *how* is it possible to differentiate between the role of the artist and that of the curator when there is no difference between art's production and exhibition? Now, I would argue that this distinction is still possible. And I would like to do so by analyzing the difference between the standard exhibition and the artistic installation. A conventional exhibition is conceived as an accumulation of art objects placed next to one another in an exhibition space to be viewed in succession. In this case, the exhibition space works as an extension of neutral, public urban space—as something like a side alley into which the passerby may enter upon payment of an admission fee. The movement of a visitor through the exhibition space remains similar to that of someone walking down a street and observing the architecture of the houses left and right. It is by no means accidental that Walter Benjamin constructed his "Arcades Project" around this analogy between an urban stroller and an exhibition visitor. The body of the viewer in this setting remains outside of the art: art takes place in front of the viewer's eyes—as an art object, a performance, or a film. Accordingly, the exhibition space is understood here to be an empty, neutral, public space—a symbolic property of the public. The only function of such a space is to make the art

objects that are placed within it easily accessible to the gaze of the visitors.

The curator administers this exhibition space in the name of the public—as a representative of the public. Thus, the curator's role is to safeguard its public character, while bringing the individual artworks into this public space, making them accessible to the public, publicizing them. It is obvious that an individual artwork cannot assert its presence by itself, forcing the viewer to take a look at it. It lacks the vitality, energy, and health to do so. In its origin, it seems, the work of art is sick, helpless; in order to see it, viewers must be brought to it as visitors are brought to a bed-ridden patient by hospital staff. It is no coincidence that the word "curator" is etymologically related to "cure": to curate is to cure. Curating cures the powerlessness of the image, its inability to show itself by itself. Exhibition practice is thus the cure that heals the originally ailing image, that gives it presence, visibility; it brings it to the public view and turns it into the object of the public's judgment. However, one can say that curating functions as a supplement, like a *pharmakon* in the Derridean sense: it both cures the image and further contributes to its illness.[1] The iconoclastic potential of curation was initially applied to the sacral objects of the past, presenting them as mere art objects in the neutral, empty exhibition spaces of the modern museum or Kunsthalle. It is curators, in fact— including museum curators—who originally produced art in the modern sense of the word. The first art museums—founded in the late eighteenth and early nineteenth centuries, and later expanded in the course of the nineteenth century due to imperial conquests and the

pillaging of non-European cultures—collected all sorts of "beautiful" functional objects previously used for religious rites, interior decoration, or manifestations of personal wealth, and exhibited them as works of art, that is, as defunctionalized autonomous objects set up for the mere purpose of being viewed. All art originates as design, be it religious design or the design of power. In the modern period as well, design precedes art. Looking for modern art in today's museums, one must realize that what is to be seen there as art is, above all, defunctionalized design fragments, be it mass-cultural design, from Duchamp's urinal to Warhol's *Brillo Box*, or utopian design that—from Jugendstil to Bauhaus, from the Russian avant-garde to Donald Judd—sought to give shape to the "new life" of the future. Art is design that has become dysfunctional because the society that provided the basis for it suffered a historical collapse, like the Inca Empire or Soviet Russia.

In the course of the modern era, however, artists began to assert the autonomy of their art—understood as autonomy from public opinion and public taste. Artists have insisted upon the right to make sovereign decisions regarding the content and the form of their work beyond any explanation or justification vis-à-vis the public. And they were given this right—but only to a certain degree. The freedom to create art according to one's own sovereign will does not guarantee that an artist's work will also be exhibited in the public space. The inclusion of any artwork in a public exhibition must be—at least potentially—publicly explained and justi-fied. Though artist, curator, and art critic are free to argue for or against the inclusion of some

artworks, every such explanation and justification undermines the autonomous, sovereign character of artistic freedom that modernist art aspired to win; every discourse legitimizing an artwork, its inclusion in a public exhibition as only one among many in the same public space, can be seen as an insult to that artwork. This is why the curator is considered to be someone who keeps coming between the artwork and the viewer, disempowering the artist and the viewer alike. Hence the art market appears to be more favorable than the museum or Kunsthalle to modern, autonomous art. In the art market, works of art circulate as singularities, decontextualized, uncurated, which apparently offers them the opportunity to demonstrate their sovereign origin without mediation. The art market functions according to the rules of the potlatch as they were described by Marcel Mauss and by Georges Bataille. The sovereign decision of the artist to make an artwork beyond any justification is trumped by the sovereign decision of a private buyer to pay for this artwork an amount of money beyond any comprehension.

Now, the artistic installation does not circulate. Rather, it installs everything that usually circulates in our culture: objects, texts, films, etc. At the same time, it changes in a very radical way the role and the function of the exhibition space. The installation operates by means of a symbolic privatization of the public space of an exhibition. It may appear to be a standard, curated exhibition, but its space is designed according to the sovereign will of an individual artist who is not supposed to publicly justify the selection of the included objects, or the organization of the installation space as

a whole. The installation is frequently denied the status of a specific art form, because it is not obvious what the medium of an installation actually is. Traditional art media are all defined by a specific material support: canvas, stone, or film. The material support of the installation medium is the space itself. That does not mean, however, that the installation is somehow "immaterial." On the contrary, the installation is material par excellence, since it is spatial—and being in the space is the most general definition of being material. The installation transforms the empty, neutral, public space into an individual artwork—and it invites the visitor to experience this space as the holistic, totalizing space of an artwork. Anything included in such a space becomes a part of the artwork simply because it is placed inside this space. The distinction between art object and simple object becomes insignificant here. Instead, what becomes crucial is the distinction between a marked installation space and an unmarked public space. When Marcel Broodthaers presented his installation *Musée d'Art Moderne, Département des Aigles* at the Düsseldorf Kunsthalle in 1970, he put up a sign next to each exhibit saying: "This is not a work of art." As a whole, however, his installation has been considered to be a work of art, and not without reason. The installation demonstrates a certain selection, a certain chain of choices, a logic of inclusions and exclusions. Here, one can see an analogy to a curated exhibition. But that is precisely the point: Here, the selection and the mode of representation is the sovereign prerogative of the artist alone. It is based exclusively on personal sovereign decisions that require no further explanation or justification. The artistic

installation is a way to expand the domain of the sovereign rights of the artist from the individual art object to that of the exhibition space itself.

This means that the artistic installation is a space in which the difference between the sovereign freedom of the artist and the institutional freedom of the curator becomes immediately visible. The regime under which art operates in our contemporary Western culture is generally understood to be one that grants freedom to art. But art's freedom means different things to a curator and to an artist. As I have mentioned, the curator—including the so-called independent curator—ultimately chooses in the name of the democratic public. Actually, in order to be responsible toward the public, a curator does not need to be part of any fixed institution: he or she is already an institution by definition. Subsequently, the curator has an obligation to publicly justify his or her choices—and it can happen that the curator fails to do so. Of course, the curator is supposed to have the freedom to present his or her argument to the public, but that has nothing to do with the freedom of art, understood as the freedom to make private, individual, subjective, sovereign artistic decisions beyond any argumentation, explanation, or justification. Under the regime of artistic freedom, every artist has a sovereign right to make art exclusively according to private imagination. The sovereign decision to make art in this or that way is generally accepted by Western liberal society as a sufficient reason for assuming an artist's practice to be legitimate. Of course, an artwork can also be criticized and rejected—but it can only be rejected as a whole. It makes no sense to criticize any particular choices, inclusions, or exclusions made by an

artist. In this sense, the total space of an artistic installation can also only be rejected as a whole. To return to the example of Broodthaers: Nobody would criticize the artist for having overlooked this or that particular image of this or that particular eagle in his installation.

One can say that in Western society the notion of freedom is deeply ambiguous—not only in the field of art, but also in the political field. Freedom in the West is understood as allowing private, sovereign decisions to be made in many domains of social practice, such as private consumption, investment of one's own capital, or choice of one's own religion. But in some other domains, especially in the political field, freedom is understood primarily as the freedom of public discussion guaranteed by law—as non-sovereign, conditional, institutional freedom. Of course, the private, sovereign decisions in our societies are controlled to a certain degree by public opinion and political institutions (we all know the famous slogan "the private is political"). Yet, on the other hand, open political discussion is time and again interrupted by the private, sovereign decisions of political actors and manipulated by private interests (which then serve to privatize the political). The artist and the curator embody, in a very conspicuous manner, these two different kinds of freedom: the sovereign, unconditional, publicly irresponsible freedom of art-making, and the institutional, conditional, publicly responsible freedom of curatorship. Further, this means that the artistic installation—in which the act of art production coincides with the act of its presentation—becomes the perfect experimental terrain for revealing and exploring the ambiguity that lies at the core of the Western notion of freedom.

Accordingly, in the last decades we have seen the emergence of innovative curatorial projects that seem to empower the curator to act in an authorial, sovereign way. And we have also seen the emergence of artistic practices seeking to be collaborative, democratic, decentralized, or de-authorized.

Indeed, the artistic installation is often viewed today as a form that allows the artist to democratize his or her art, to take public responsibility, to begin to act in the name of a certain community or even of society as a whole (Liam Gillick, Rirkrit Tiravanija, Thomas Hirschhorn, Claire Bishop, etc.). In this sense, the emergence of the artistic installation seems to mark the end of the modernist claim of autonomy and sovereignty. The artist's decision to allow the multitude of visitors to enter the space of the artwork is interpreted as an opening of the closed space of an artwork to democracy. This enclosed space seems to be transformed into a platform for public discussion, democratic practice, communication, networking, education, and so forth. But this analysis of installation art practice tends to overlook the symbolic act of privatizing the public space of the exhibition, which *precedes* the act of opening the installation space to a community of visitors. As I have mentioned, the space of the traditional exhibition is a symbolic public property, and the curator who manages this space acts in the name of public opinion. The visitor of a typical exhibition remains on his or her own territory, as a symbolic owner of the space where the artworks are delivered to his or her gaze and judgment. On the contrary, the space of an artistic installation is the symbolic private property of the artist. By entering this space, the visitor leaves

the public territory of democratic legitimacy and enters the space of sovereign, authoritarian control. The visitor is here, so to speak, on foreign ground, in exile. The visitor becomes an expatriate who must submit to a foreign law—one given to him or her by the artist. Here, the artist acts as legislator, as a sovereign of the installation space—even, and maybe especially so, if the law given by the artist to a community of visitors is a democratic one.

One might then say that installation practice reveals the act of unconditional, sovereign violence that initially installs any democratic order. We know that democratic order is never brought about in a democratic fashion—democratic order always emerges as a result of a violent revolution. To decree a law is to break another. The first legislator can never act in a legitimate manner—he establishes the political order, but does not belong to it. He remains external to the order even if he decides later to submit himself to it. The author of an artistic installation is also such a legislator, who gives to the community of visitors the space to constitute itself and defines the rules to which this community must submit, but does so without belonging to this community, remaining outside of it. And this remains true even if the artist decides to join the community that he or she has created. This second step should not lead us to overlook the first one—the sovereign one. And one should also not forget: after initiating a certain order— a certain *Politeia,* a certain community of visitors —the installation artist must rely on the art institutions to maintain this order, to police the fluid *Politeia* of the installation's visitors. With regard to the role of police in a state, Jacques Derrida

suggests in one of his books *(Force de loi)* that, though the police are expected to supervise the functioning of certain laws, they are de facto also involved in creating the very laws that they should merely supervise. To maintain a law always also means to permanently reinvent that law. Derrida tries to show that the violent, revolutionary, sovereign act of installing law and order can never be fully erased afterwards—this initial act of violence can and will always be mobilized again. This is especially obvious now, in our time of violently exporting, installing, and securing democracy. One should not forget: the installation space is a movable one. The art installation is not site-specific, and it can be installed in any place and for any period of time. And we should be under no illusions that there can be anything like a completely chaotic, Dadaistic, Fluxus-like installation space free of any control. In his famous treatise "Français, encore un effort si vous voulez être républicains," the Marquis de Sade presents a vision of a perfectly free society that has abolished all existing law, installing only one: Everyone must do what he or she likes, including committing crimes of any kind.[2] What is especially interesting is how, at the same time, Sade remarks on the necessity of law enforcement to prevent the reactionary attempts of some traditionally minded citizens to return to the old repressive state in which family is secured and crimes forbidden. So we also need the police to defend the crimes against the reactionary nostalgia of the old moral order.

And yet, the violent act of constituting a democratically organized community should not be interpreted as contradicting its democratic nature. Sovereign freedom is obviously non-

democratic, so it also seems to be anti-democratic. However, even if it appears paradoxical at first glance, sovereign freedom is a necessary precondition for the emergence of any democratic order. Again, the art installation is a good example of this rule. The standard art exhibition leaves a visitor alone, allowing him or her to individually confront and contemplate the exhibited art objects. Moving from one object to another, such an individual visitor necessarily overlooks the totality of the exhibition space, including his or her own position within it. An artistic installation, on the contrary, builds a community of spectators precisely because of its holistic, unifying character. The true visitor to the art installation is not an isolated individual, but part of a collective of visitors. The art space as such can only be perceived by a mass of visitors—a multitude, if you like—with this multitude becoming part of the exhibition for each individual visitor, and vice versa.

There is a dimension of mass culture that is often overlooked, which becomes particularly manifest in the context of art. A pop concert or a film screening creates communities among its attendees. The members of these transitory communities do not know each other—their structure is accidental; it remains unclear where they have come from and where they are going; they have little to say to one another; they lack a joint identity or previous history that could provide them with common memories to share; nevertheless, they are communities. These communities resemble those of travelers on a train or airplane. To put it differently: These are radically contemporary communities—much more so than religious, political, or working

communities. All traditional communities are based on the premise that their members, from the very beginning, are linked by something from the past: a common language, common faith, common political history, common upbringing. Such communities tend to establish boundaries between themselves and strangers with whom they share no common past.

Mass culture, by contrast, creates communities beyond any common past—unconditional communities of a new kind. This is what reveals its vast potential for modernization, which is frequently overlooked. However, mass culture itself cannot fully reflect and unfold this potential, because the communities it creates are not sufficiently aware of themselves as such. The same can be said of the masses moving through the standard exhibition spaces of contemporary museums and Kunsthalles. It is often said that the museum is elitist. I have always been astounded by this opinion, which is so counter to my own personal experience of becoming part of a mass of visitors continuously flowing through the exhibition and museum rooms. Anyone who has ever looked for a parking space near a museum, or tried to leave a coat at the museum checkroom, or needed to find the museum lavatory, will have reason to doubt the elitist character of this institution—particularly in the case of museums that are considered particularly elitist, such as the Metropolitan Museum or the MoMA in New York. Today, global tourist streams make any elitist claim a museum might have seem like a ridiculous presumption. And if these streams avoid one specific exhibition, its curator will not be at all happy, will not feel elitist but disappointed for having failed to reach

the masses. But these masses do not reflect themselves as such—they do not constitute any *Politeia*. The perspective of pop-concert fans or moviegoers is too forward-directed—at stage or screen—to allow them to adequately perceive and reflect on the space in which they find themselves or the communities of which they have become part. This is the kind of reflection that advanced, present-day art provokes, whether as installation art, or as an experimental curatorial project. The relative spatial separation provided by the installation space does not mean a turn away from the world, but rather a de-localization and de-territorialization of mass-cultural transitory communities—in a way that assists them in reflecting upon their own condition, offering them an opportunity to exhibit themselves to themselves. The contemporary art space is a space in which multitudes can view themselves and celebrate themselves, as God or kings were in former times viewed and celebrated in churches and palaces (Thomas Struth's "Museum Photographs" capture this dimension of the museum very well—this emergence and dissolution of transitional communities).

More than anything else, what the installation offers to the fluid, circulating multitudes is an aura of the "here and now." The installation is, above all, a mass-cultural version of individual flânerie, as described by Benjamin, and therefore a place for the emergence of aura, for "profane illumination." In general, the installation operates as a reversal of reproduction. The installation takes a copy out of an unmarked, open space of anonymous circulation and places it—if only temporarily—within a fixed, stable, closed context of the topologically well-defined "here

and now." Our contemporary condition cannot be reduced to being a "loss of the aura" to the circulation of ritual beyond "here and now," as described in Benjamin's famous essay "The Work of Art in the Age of Mechanical Reproduction."[3] Rather, the contemporary age organizes a complex interplay of dislocations and relocations, of deterritorializations and reterritorializations, of de-auratizations and re-auratizations.

Benjamin shared high modernist art's belief in a unique, normative context for art. Under this presupposition, to lose its unique, original context means for an artwork to lose its aura forever—to become a copy of itself. To re-auratize an individual artwork would require a sacralization of the whole profane space of a copy's topologically undetermined mass circulation— a totalitarian, fascist project, to be sure. This is the main problem to be found in Benjamin's thinking: He perceives the space of a copy's mass circulation—and mass circulation in general— as a universal, neutral, and homogeneous space. He insists upon the visual recognizability, on the self-identity of a copy as it circulates in our contemporary culture. But both of these principal presuppositions in Benjamin's text are questionable. In the framework of contemporary culture, an image is permanently circulating from one medium to another medium, and from one closed context to another closed context. For example, a bit of film footage can be shown in a cinema, then converted to a digital form and appear on somebody's Web site, or be shown during a conference as an illustration, or watched privately on a television in a person's living room, or placed in the context of a museum installation. In this way, through different contexts and media, this bit of

film footage is transformed by different program languages, different software, different framings on the screen, different placement in an installation space, and so on. During all of this time, are we dealing with the same film footage? Is it the same copy of the same copy of the same original? The topology of today's networks of communication, generation, translation, and distribution of images is extremely heterogeneous. The images are constantly transformed, rewritten, reedited, and reprogrammed as they circulate through these networks—and with each step they are visually altered. Their status as copies of copies becomes an everyday cultural convention, as was previously the case with the status of the original. Benjamin suggests that the new technology is capable of producing copies with increasing fidelity to the original, when in fact the opposite is the case. Contemporary technology thinks in generations—and to transmit information from one generation of hardware and software to the next is to transform it in a significant way. The metaphoric notion of "generation" as it is now used in the context of technology is particularly revealing. Where there are generations, there are also generational Oedipal conflicts. All of us know what it means to transmit a certain cultural heritage from one generation of students to another.

We are unable to stabilize a copy as a copy, as we are unable to stabilize an original as an original. There are no eternal copies as there are no eternal originals. Reproduction is as much infected by originality as originality is infected by reproduction. In circulating through various contexts, a copy becomes a series of different originals. Every change of context, every change

of medium can be interpreted as a negation of the status of a copy as a copy—as an essential rupture, as a new start that opens a new future. In this sense, a copy is never really a copy, but rather a new original, in a new context. Every copy is by itself a *flâneur*—experiencing time and again its own "profane illuminations" that turn it into an original. It loses old auras and gains new auras. It remains perhaps the same copy, but it becomes different originals. This also evinces the postmodern project of reflecting on the repetitive, iterative, reproductive character of an image (inspired by Benjamin) to be as paradoxical as the modern project of recognizing the original and the new. This is likewise why postmodern art tends to look very new, even if—or actually because—it is directed against the very notion of the new. Our decision to recognize a certain image as either an original or a copy is dependent on the context—on the scenario in which this decision is taken. This decision is always a contemporary decision—one that belongs neither to the past nor to the future, but to the present. And this decision is also always a sovereign decision—in fact, the installation is a space for such a decision where "here and now" emerges and a "profane illumination" of the masses takes place.

So one can say that installation demonstrates the dependency of any democratic space (in which masses or multitudes demonstrate themselves to themselves) on the private, sovereign decisions of an artist as its legislator. This was something that was very well known to the ancient Greek thinkers, as it was to the initiators of the earlier democratic revolutions. But recently, this knowledge somehow became suppressed by the dominant political discourse.

Especially after Foucault, we tend to detect the source of power in impersonal agencies, structures, rules, and protocols. However, this fixation on the impersonal mechanisms of power leads us to overlook the importance of individual, sovereign decisions and actions taking place in private, heterotopic spaces (to use another term introduced by Foucault). Likewise, the modern, democratic powers have meta-social, meta-public, heterotopic origins. As previously mentioned, the artist who designs a certain installation space is an outsider to this space. He or she is heterotopic to this space. But the outsider is not necessarily somebody who has to be included in order to be empowered. There is also empowerment by exclusion, and especially by self-exclusion. The outsider can be powerful precisely because he or she is not controlled by society, and is not limited in his or her sovereign actions by any public discussion or by any need for public self-justification. And it would be wrong to think that this kind of powerful outsid-ership can be completely eliminated through modern progress and democratic revolutions. The progress is rational. But not accidentally, an artist is supposed by our culture to be mad—at least to be obsessed. Foucault thought that medicine men, witches, and prophets had no prominent place in our society any more—that they became outcasts, confined to psychiatric clinics. But our culture is primarily a celebrity culture, and you cannot become a celebrity without being mad (or at least pretending to be). Obviously, Foucault read too many scientific books and only a few society and gossip magazines, because other-wise he would have known where mad people today have their true social place. It is also well

known that the contemporary political elite is a part of global celebrity culture, which is to say that it is external to the society it rules. Global, extra-democratic, trans-state, external to any democratically organized community, paradigmatically private—I would say that these are the icons of a privacy understood also as a rejection of logic and reason, as a degree of sovereignty of judgment equivalent to madness. These icons are, in fact, structurally mad—insane.

Now, these reflections should not be misunderstood as a critique of installation as an art form by demonstrating its sovereign character. The goal of art, after all, is not to change things—things are changing by themselves all the time anyway. Art's function is rather to show, to make visible the realities that are generally overlooked. By explicitly taking aesthetic responsibility for the design of the installation space, the artist reveals the hidden sovereign dimension of the contemporary democratic order that politics, for the most part, tries to conceal. The installation space is where we are immediately confronted with the ambiguous character of the contemporary notion of freedom that functions in our democracies in parallel with sovereign and institutional freedom. The space of the installation is thus one of unconcealment (in the Heideggerian sense) of the heterotopic, sovereign power that is concealed behind the obscure transparency of the democratic order.

1    Jacques Derrida, *La dissémination* (Paris: Éditions du Seuil, 1972), 108ff.
2    Marquis de Sade, *La Philosophie dans le boudoir* (Paris: Gallimard, 1976), 191ff.
3    Walter Benjamin, "The Work of Art in the Age of Mechanical Reproduction," in *Illuminations: Essays and Reflections*, ed. Hannah Arendt, trans. H. Zohn (New York: Schocken Books, 1969), 221ff.

Hito Steyerl
# Is a Museum
# a Factory?

The film *La hora de los hornos* (The Hour of the Furnaces, 1968), a Third Cinema manifesto against neocolonialism, has a brilliant installation specification.[1] A banner was to be hung at every screening with text reading: "Every spectator is either a coward or a traitor."[2] It was intended to break down the distinctions between filmmaker and audience, author and producer, and thus create a sphere of political action. And where was this film shown? In factories, of course.

Now, political films are no longer shown in factories.[3] They are shown in the museum, or the gallery—the art space. That is, in any sort of white cube.[4]

How did this happen? First of all, the traditional Fordist factory is, for the most part, gone.[5] It's been emptied out, machines packed up and shipped off to China. Former workers have been retrained for further retraining, or become software programmers and started working from home. Secondly, the cinema has been transformed almost as dramatically as the factory. It's been multiplexed, digitized, and sequelized, as well as rapidly commercialized as neoliberalism became hegemonic in its reach and influence. Before cinema's recent demise, political films sought refuge elsewhere. Their return to cinematic space is rather recent, and the cinema was never the space for *more* formally experimental works. Now, political and experimental films alike are shown in black boxes set within white cubes—in fortresses, bunkers, docks, and former churches. The sound is almost always awful.

But terrible projections and dismal installation notwithstanding, these works catalyze

surprising desire. Crowds of people can be seen bending and crouching in order to catch glimpses of political cinema and video art. Is this audience sick of media monopolies? Are they trying to find answers to the obvious crisis of everything? And why should they be looking for these answers in art spaces?

### Afraid of the Real?

The conservative response to the exodus of political films (or video installations) to the museum is to assume that they are thus losing relevance. It deplores their internment in the bourgeois ivory tower of high culture. The works are thought to be isolated inside this elitist *cordon sanitaire*—sanitized, sequestered, cut off from "reality." Indeed, Jean-Luc Godard reportedly said that video-installation artists shouldn't be "afraid of reality," assuming of course that they in fact were.[6]

Where is reality then? Out there, beyond the white cube and its display technologies? How about inverting this claim, somewhat polemically, to assert that the white cube *is* in fact the Real with a capital R: the blank horror and emptiness of the bourgeois interior.

On the other hand—and in a much more optimistic vein—there is no need to have recourse to Lacan in order to contest Godard's accusation. This is because the displacement from factory to museum never took place. In reality, political films are very often screened in the exact same place as they always were: in former factories, which are today, more often than not, museums. A gallery, an art space, a white cube with abysmal sound isolation. Which will certainly show political films. But which also has

become a hotbed of contemporary production. Of images, jargon, lifestyles, and values. Of exhibition value, speculation value, and cult value. Of entertainment plus gravitas. Or of aura minus distance. A flagship store of cultural industries, staffed by eager interns who work for free.

A factory, so to speak, but a different one. It is still a space for production, still a space of exploitation, and even of political screenings. It is a space of physical meeting and sometimes even common discussion. At the same time, it has changed almost beyond recognition. So what sort of factory is this?

### Productive Turn

The typical setup of the museum-as-factory looks like the following. Before: an industrial workplace. Now: people spending their leisure time in front of TV monitors. Before: people working in these factories. Now: people working at home in front of computer monitors.

Andy Warhol's Factory served as a model for the new museum in its productive turn towards being a "social factory."[7] By now, descriptions of the social factory abound.[8] It exceeds its traditional boundaries and spills over into almost everything else. It pervades bedrooms and dreams alike, as well as perception, affection, and attention. It transforms everything it touches into culture, if not art. It is an a-factory, which produces affect as effect. It integrates intimacy, eccentricity, and other formally unofficial forms of creation. Private and public spheres get entangled in a blurred zone of hyper-production.

In the museum-as-factory, something continues to be produced. Installation, planning, carpentry, viewing, discussing, maintenance,

betting on rising values, and networking alternate in cycles. An art space is a factory, which is simultaneously a supermarket—a casino and a place of worship whose reproductive work is performed by cleaning ladies and cell-phone-video bloggers alike.

In this economy, even spectators are transformed into workers. As Jonathan Beller argues, cinema and its derivatives (television, Internet, and so on) are factories, in which spectators work. Now, "to look is to labor."[9] Cinema, which integrated the logic of Taylorist production and the conveyor belt, now spreads the factory wherever it travels. But this type of production is much more intensive than the industrial one. The senses are drafted into production, the media capitalize upon the aesthetic faculties and imaginary practices of viewers.[10] In that sense, any space that integrates cinema and its successors has now become a factory, and this obviously includes the museum. While in the history of political filmmaking the factory became a cinema, cinema now turns museum spaces back into factories.

### Workers Leaving the Factory
It is quite curious that the first films ever made by Louis Lumière show workers leaving the factory. At the beginning of cinema, workers leave the industrial workplace. The invention of cinema thus symbolically marks the start of the exodus of workers from industrial modes of production. But even if they leave the factory building, it doesn't mean that they have left labor behind. Rather, they take it along with them and disperse it into every sector of life.

A brilliant installation by Harun Farocki makes clear where the workers leaving the factory are headed. Farocki collected and installed different cinematic versions of *Workers Leaving the Factory*, from the original silent version(s) by Louis Lumière to contemporary surveillance footage.[11] Workers stream out of factories on several monitors simultaneously: from different eras and in different cinematic styles.[12] But where are these workers streaming to? Into the art space, where the work is installed.

Not only is Farocki's *Workers Leaving the Factory*, on the level of content, a wonderful archaeology of the (non)representation of labor; on the level of form it points to the spilling over of the factory into the art space. Workers who left the factory have ended up inside another one: the museum.

It might even be the same factory. Because the former Lumière factory, whose gates are portrayed in the original *Workers Leaving The Lumière Factory* is today just that: a museum of cinema.[13] In 1995, the ruin of the former factory was declared a historical monument and developed into a site of culture. The Lumière factory, which used to produce photographic film, is today a cinema with a reception space to be rented by companies: "A location loaded with history and emotion for your brunches, cocktails and dinners."[14] The workers who left the factory in 1895 have today been recaptured on the screen of the cinema within the same space. They only left the factory to reemerge as a spectacle inside of it.

As workers exit the factory, the space they enter is one of cinema and cultural industry, producing emotion and attention. How do *its* spectators look inside this new factory?

Cinema and Factory

At this point, a decisive difference emerges between classical cinema and the museum. While the classical space of cinema resembles the space of the industrial factory, the museum corresponds to the dispersed space of the social factory. Both cinema and Fordist factory are organized as locations of confinement, arrest, and temporal control. Imagine spectators leaving the cinema as workers leaving the factory—a similar mass, disciplined and controlled in time, assembled and released at regular intervals. As the traditional factory arrests its workers, the cinema arrests the spectator. Both are disciplinary spaces and spaces of confinement.[15]

But now imagine spectators trickling out of the museum (or even queuing to get in) as workers leaving the factory—an entirely different constellation of time and space. This second crowd is not a mass, but a multitude.[16] The museum doesn't organize a coherent crowd of people. People are dispersed in time and space—a silent crowd, immersed and atomized, struggling between passivity and overstimulation.

This spatial transformation is reflected by the format of many newer cinematic works. Whereas traditional cinematic works are single-channel, focusing the gaze and organizing time, many of the newer works explode into space. While the traditional cinema setup works from a single central perspective, multi-screen projections create a multifocal space. While cinema is a mass medium, multi-screen installations address a multitude spread out in space, connected only by distraction, separation, and difference.[17]

The difference between mass and multitude arises on the line between confinement and

dispersion, between homogeneity and multiplicity, between cinema space and museum installation. This is a very important distinction, because it will also affect the question of the museum as public space.

### Public Space
It is obvious that the space of the factory is traditionally more or less invisible in public. Its visibility is policed, and surveillance produces a one-way gaze. Paradoxically, a museum is not so different. In a lucid 1972 interview Godard pointed out that, because filming is prohibited in factories, museums, and airports, effectively eighty percent of productive activity in France is rendered invisible: "The exploiter doesn't show the exploitation to the exploited."[18] This still applies today, if for different reasons. Museums prohibit filming or charge exorbitant shooting fees.[19] Just as the work performed in the factory cannot be shown outside of it, most of the works on display in a museum cannot be shown outside its walls. A paradoxical situation arises: a museum predicated on producing and marketing visibility can itself not be shown—the labor performed there is just as publicly invisible as that of any sausage factory.

This extreme control over visibility sits rather uncomfortably alongside the perception of the museum as a public space. What does this invisibility then say about the contemporary museum as a public space? And how does the inclusion of cinematic works complicate this picture?

The current discussion of cinema and the museum as public sphere is an animated one. Thomas Elsaesser, for example, asks whether

cinema in the museum might constitute the last remaining bourgeois public sphere.[20] Jürgen Habermas outlined the conditions in this arena in which people speak in turn and others respond, all participating together in the same rational, equal, and transparent discourse surrounding public matters.[21] In actuality, the contemporary museum is more like a cacophony—installations blare simultaneously while nobody listens. To make matters worse, the time-based mode of many cinematic installations precludes a truly shared discourse around them; if works are too long, spectators will simply desert them. What would be seen as an act of betrayal in a cinema—leaving the projection while it lasts—becomes standard behavior in any installation situation. In the installation space of the museum, spectators indeed become traitors—traitors of cinematic duration itself. In circulating through the space, spectators are actively montaging, zapping, and combining fragments—effectively co-curating the show. Rationally conversing about shared impressions then becomes next to impossible. A bourgeois public sphere? Instead of its ideal manifestation, the contemporary museum rather represents its unfulfilled reality.

Sovereign Subjects
In his choice of words, Elsaesser also addresses a less democratic dimension of this space. By, as he dramatically phrases it, arresting cinema—suspending it, suspending its license, or even holding it under a suspended sentence—cinema is preserved at its own expense when it is taken into "protective custody."[22] Protective custody is no simple arrest. It refers to a state of exception or (at least) a temporal suspension

of legality that allows the suspension of the law itself. This state of exception is also addressed in Boris Groys' essay "Politics of Installation."[23] Harking back to Carl Schmitt, Groys assigns the role of sovereign to the artist who—in a state of exception—violently establishes his own law by "arresting" a space in the form of an installation. The artist then assumes a role as sovereign founder of the exhibition's public sphere.

At first glance, this repeats the old myth of artist as crazy genius, or more precisely, as petty-bourgeois dictator. But the point is: If this works well as an artistic mode of production, then it becomes standard practice in any social factory. So then, how about the idea that inside the museum, almost everybody tries to behave like a sovereign (or petty-bourgeois dictator)? After all, the multitude inside museums is composed of competing sovereigns: curators, spectators, artists, critics.

Let's have a closer look at the spectator-as-sovereign. In judging an exhibition, many attempt to assume the compromised sovereignty of the traditional bourgeois subject, who aims to (re)master the show, to tame the unruly multiplicity of its meanings, to pronounce a verdict, and to assign value. But, unfortunately, cinematic duration makes this subjective position unavailable. It reduces all parties involved to the role of workers—unable to gain an overview of the whole process of production. Many—primarily critics—are thus frustrated by archival shows and their abundance of cinematic time. Remember the vitriolic attacks on the length of films and video in documenta 11? To multiply cinematic duration means to blow apart the vantage point of sovereign judgment. It also makes it impossible

to reconfigure yourself as its subject. Cinema in the museum renders overview, review, and survey impossible. Partial impressions dominate the picture. The true labor of spectatorship can no longer be ignored by casting oneself as master of judgment. Under these circumstances, a transparent, informed, inclusive discourse becomes difficult, if not impossible.

The question of cinema makes clear that the museum is not a public sphere, but rather places its consistent *lack* on display—it makes this *lack* public, so to speak. Instead of filling this space, it conserves its absence. But it also simultaneously displays its *potential* and the *desire* for something to be realized in its place.

As a multitude, the public operates under the condition of partial invisibility, incomplete access, or fragmented realities—of commodification within clandestinity. Transparency, overview, and the sovereign gaze cloud over and become opaque. Cinema itself explodes into multiplicity—into spatially dispersed multi-screen arrangements that cannot be contained by a single point of view. The full picture, so to speak, remains unavailable. There is always something missing—people miss parts of the screening, the sound doesn't work, the screen itself and any vantage point from which it could be seen are missing.

Rupture
Without notice, the question of political cinema has been inverted. What began as a discussion of political cinema in the museum has turned into a question of cinematic politics in a factory. Traditionally, political cinema was meant to educate—it was an instrumental effort

at "representation" in order to achieve its effects in "reality." It was measured in terms of efficiency, of revolutionary revelation, of gains in conscious-ness, or as potential triggers of action.

Today, cinematic politics are post-repre-sentational. They do not educate the crowd, but produce it. They articulate the crowd in space and in time. They submerge it in partial invisibility and then orchestrate its dispersion, movement, and reconfiguration. They organize the crowd without preaching to it. They replace the gaze of the bourgeois sovereign spectator of the white cube with the incomplete, obscured, fractured, and overwhelmed vision of the spectator-as-laborer.

But there is one aspect that goes well beyond this. What else is missing from these cinematic installations?[24] Let's return to the liminal case of documenta 11, which was said to contain more cinematic material than a single person could see in the 100 days that the exhibi-tion was open to the public. No single spectator could even claim to have even seen everything, much less to have exhausted the meanings in this volume of work. It is obvious what is missing from this arrangement: Since no single specta-tor can possibly make sense of such a volume of work, it calls for a multiplicity of spectators. In fact, the exhibition could only be seen by a multiplicity of gazes and points of view, which then supplements the impressions of others. Only if the night guards and various spectators worked together in shifts could the cinematic material of documenta 11 be viewed. But in order to under-stand what (and how) they are watching, they must meet to make sense of it. This shared activ-ity is completely different from that of spectators narcissistically gazing at themselves and each

other inside exhibitions—it does not simply ignore the artwork (or treat it as mere pretext), but takes it to another level.

Cinema inside the museum thus calls for a multiple gaze, which is no longer collective, but common; which is incomplete, but in process; which is distracted and singular, but can be edited into various sequences and combinations. This gaze is no longer the gaze of the individual sovereign master, nor, more precisely, of the self-deluded sovereign (even if "just for one day," as David Bowie sang). It isn't even a product of common labor, but focuses its point of rupture on the paradigm of productivity. The museum-as-factory and its cinematic politics interpellate this missing, multiple subject. But by displaying its absence and its lack, they simultaneously activate a desire for this subject.

### Cinematic Politics
But does this now mean that all cinematic works have become political? Or, rather, is there still any difference between different forms of cinematic politics? The answer is simple. Any conventional cinematic work will try to reproduce the existing setup: a projection of a public, which is not public after all, and in which participation and exploitation become indistinguishable. But a political cinematic articulation might try to come up with something completely different.

What else is desperately missing from the museum-as-factory? An exit. If the factory is everywhere, then there is no longer a gate by which to leave it—there is no way to escape relentless productivity. Political cinema could then become the screen through which people could leave the museum-as-social-factory. But

## on which screen could this exit take place? On the one that is currently missing, of course.

1    Grupo Cine Liberación (Fernando E. Solanas, Octavio Getino), Argentina, 1968. The work is one of the most important films of Third Cinema.

2    A quote from Frantz Fanon's *The Wretched of the Earth*. The film was of course banned and had to be shown clandestinely.

3    Or videos or video/film installations. To properly make the distinctions (which exist and are important) would require another text.

4    I am aware of the problem of treating all these spaces as similar.

5    At least in Western countries.

6    The context of Godard's comment is a conversation—a monologue, apparently—with young installation artists, whom he reprimands for their use of what he calls technological *dispositifs* in exhibitions. See "Debrief de conversations avec Jean-Luc Godard," the Sans casser des briques blog, March 10, 2009, http://bbjt.wordpress.com/2009/03/10/debrief-de-conversations-avec-jean-luc-godard/.

7    See Brian Holmes, "Warhol in the Rising Sun: Art, Subcultures and Semiotic Production," 16 Beaver ARTicles, August 8, 2004, http://www.16beavergroup.org/mtarchive/archives/001177.php.

8    Sabeth Buchmann quotes Hardt and Negri: "The 'social factory' is a form of production which touches on and penetrates every sphere and aspect of public and private life, of knowledge production and communication," in "From Systems-Oriented Art to Biopolitical Art Practice," NODE.London, http://publication.nodel.org/node/74/.

9    Jonathan L. Beller, "Kino-I, Kino-World," in *The Visual Culture Reader*, ed. Nicholas Mirzoeff (London and New York: Routledge, 2002), 61.

10    Ibid., 67.

11    For a great essay about this work see Harun Farocki, "Workers Leaving the Factory," in *Nachdruck/Imprint: Texte/Writings*, trans. Laurent Faasch-Ibrahim (Berlin: Verlag Vorwerk, New York: Lukas & Sternberg, 2001), reprinted on the Senses of Cinema Web site, http://archive.sensesofcinema.com/contents/02/21/farocki_workers.html.

12    My description refers to the Generali Foundation show, "Kino wie noch nie" (2005). See http://foundation.generali.at/index.php?id=429.

13    "Aujourd'hui le décor du premier film est sauvé et abrite une salle de cinéma de 270 fauteuils. Là où sortirent les ouvriers et les ouvrières de l'usine, les spectateurs vont au cinéma, sur le lieu de son invention," Institut Lumière, http://institut-lumiere.org/ /francais/hangar/hangaraccueil.html.

14    "La partie Hangar, spacieux hall de réception chargé d'histoire et d'émotion pour tous vos déjeuners, cocktail, dîners...[Formule assise 250 personnes ou formule debout jusqu'à 300 personnes]," Institut Lumière, http://www.institut-lumiere.org/francais/location/location.html.

15    There is, however, one interesting difference between cinema and factory: In the rebuilt scenery of the Lumière museum, the opening of the former gate is now blocked by a transparent glass pane to indicate the framing of the early film. Exiting spectators have to go around this obstacle, and leave through the former location of the gate itself, which no longer exists. Thus, the current situation is like a negative of the former one: People are blocked by the former opening, which has now turned into a glass screen; they have to exit through the former walls of the factory, which have now partly vanished. See photographs at ibid.

16    For a more sober description of the generally quite idealized condition of multitude, see Paolo Virno *A Grammar of the Multitude*, trans. Isabella Bertoletti, James Cascaito, and Andrea Casson (New York and Los Angeles: Semiotext(e), 2004).

17    As do multiple single-screen arrangements.

18    "Godard on *Tout va bien* (1972),"
      http://www.youtube.com/watch?v=hnx7mxjm1k0.
19    "Photography and video filming are not normally allowed at Tate"
      (http://www.tate.org.uk/about/media/copyright/). However, filming there is
      welcomed on a commercial basis, with location fees starting at £200
      an hour (http://www.tate.org.uk/about/media/filming/). Policy at the
      Centre Pompidou is more confusing: "You may film or photograph works
      from permanent collections (which you will find on levels 4 and 5 and in
      the Atelier Brancusi) for your own personal use. You may not, however,
      photograph or film works that have a red dot, and you may not use a flash or
      stand." (http://www.centrepompidou.fr/Pompidou/Communication.nsf/0/3
      590D3A7D1BDB820C125707C004512D4?OpenDocument&L=2).
20    Thomas Elsaesser, "The Cinema in the Museum: Our Last Bourgeois
      Public Sphere?" (Paper presented at the International Film Studies Confer-
      ence, "Perspectives on the Public Sphere: Cinematic Configurations of 'I'
      and 'We,'" Berlin, Germany, April 23–25, 2009.)
21    Jürgen Habermas, *The Structural Transformation of the Public Sphere:
      An Inquiry into a Category of Bourgeois Society*, trans. Thomas Burger with
      the assistance of Frederick Lawrence (Cambridge, MA: The MIT Press,
      [1962] 1991).
22    Elsaesser, "The Cinema in the Museum."
23    Boris Groys, "Politics of Installation," *e-flux journal*, #2 (January 2009),
      http://www.e-flux.com/journal/view/31.
24    A good example would be "Democracies" by Artur Żmijewski, an un-
      synchronized multi-screen installation with trillions of possibilities of screen-
      content combinations.

Liam Gillick

# Maybe it would be better if we worked in groups of three? Part Two: The Experimental Factory

There is a doorman working at the entrance who is very good at recognizing people. He is also a judge of character based on facial appearance. However, he is blindfolded. The doorman is accompanied by a colleague who is unable to move. Tied to a chair. Incapable of physical activity. At the right time, when the music has finally stopped, people stream out past the doorman. After their activity and all their engagement with the party, the mood is subdued, people just leave normally. Not making any fuss, no rushing, just moving away. There are no lengthy periods spent milling around, talking and looking at cars. At the end of this party there's just a group of people quietly going on their way.
—Philippe Parreno, *Snow Dancing*, 1995

Maybe we're trying to catch a moment, maybe an earlier moment. Maybe it's a Volvo moment— June 17, 1974, when the view from the factory was of the trees, and the way to work together was as a team, and we knew that the future was going to work out—that everything is a trajectory as long as we can keep things this way and Ford doesn't buy the company.

For those who grew up in postwar Europe, notions of group work were embedded in educational systems. From preschool "play-groups" to the organizing structures of management, with group discussion and teamwork, we find a set of social models that carry complex implications for people who think they can create something using a related, if semi-autonomous, methodology.

The discursive is wedded to the notion of postwar social democracy. It is both a product

of its education systems and subject to its critical potentials and collapses. The European context has surrounded itself with experiment-machines in the culture. The discursive framework's success or failure is connected to various postwar phenomena connected to identity politics and postcolonial theory. At the same time, the discursive is suspicious and resistant to the idea of a key protagonist. Without key protagonists, however, it is very hard to know what to do, when to occupy, and when to function; however, the lack of leading voices does permit the discursive to evolve and be inclusive.

If we accept the postwar period as a closed one, we have to think harder about whether the discursive is merely a gesture towards recuperating ideas, places, and values. The discursive frame may merely be playing out various recuperative projects that are tacitly encouraged within a terrain of closure and globalization simultaneously.

The decentered quality of critical art practices meets an anxiety about the combination of the localized and the internationalized. This contradictory quality is exemplified by the discursive frame, with its displays of the local to the international (and vice versa) within the context of globalized cultural journeys. The discursive offers the potential for art to operate within smallish groupings out of sync with contemporary circumstances, yet deeply embedded within such circumstances' values and flows. This has a lot to do with a coalescence of smallish groupings, which then play out a suspension of aims and results within a context of indifference and projected future meetings.

The potential of the discursive framework is to engage the "out of reach" and the "too close" simultaneously—art functioning as a structural parallel to contemporary working dilemmas. A dominant, visible feature of certain developed, late-modern art practices is the idea that prior to being manufactured, a product must be sold. The discursive makes use of theories of immaterial labor in order to account for the blurred factors that surround and produce commodity value— to understand the set of factors that produce the informational and cultural content of a commodity. The discursive becomes a negotiation and demonstration of immaterial labor used for other ends.

Marx described the idea of identifying the true value of a chair in opposition to the commodity value of a chair. It is one of the philosophically weakest parts of *Capital*. Marx's notion that a chair has an essential value prior to its commodification—a natural "chairness" before being corrupted and commodified by capitalism—is at the heart of classic understandings of post-Duchampian art. This idea is exceeded and abandoned by the discursive, in sync with recent critical texts on commodity value.

I have worked on the "Volvo question" for the last few years. Most of my research on Volvo has been done through Brazilian academic papers concerning the legacy of 1970s production techniques in Scandinavia and models of flexibility, collaboration, and the idea of a better working environment in an ideally productive post-Fordist context. There has been a synchronization of desire and structure: In the last ten or fifteen years, discursive, fragmented, atomized, content-heavy art projects have somehow freed

themselves from classical ideas concerning the problem of commodity culture. They have taken on the deep structure of work and life.

In the Volvo factory you can see trees while you are making the cars. But you are still making cars, never taking a walk in the woods. Where are the models for contemporary art production in the recent past? Is it Volvo, is it the collective, or is it the infinite display of the super-subjective? Do these factors share a similar cultural DNA? The idea of collective action, and the idea of being able to determine the speed with which you produce a car, whether you produce it in a group or individually, at night, or very slowly, seems close to the question of how to make art over the last fifty years.

At Volvo, people ended up creating more and more free time, and during that free time they talked about ways to work faster. In both the cultural sphere and the traditional productive sphere, the trauma and attractiveness of infinite flexibility lead to the logic of redundancy. In the end, Ford bought the company and reintroduced the standard production line, not because it was more efficient in pure capitalist terms, but because it reinforced relations of production.

One of the reasons why I think the factory needs to be looked at again is that the factory, as a system, allows you to look at relationships in a totalizing way. In terms of productive potential, the struggle between speculation and planning has been one of the great struggles of the twentieth century. We can now say that specula- tion won, and that the rhetoric of planning has become something we do for the people we do not know what to do with. We plan for them, but everyone else should speculate.

The factory model is of use here: the factory has a planned quality in spite of the fact that it is always the playing field of the speculative. The myth is that speculation lures production, lures industry, lures investment, and in this way the factory is always caught in a psychological and philosophical dilemma: in order to effectively activate speculation, you have to plan.

In the Soviet Union, every large city had an experimental factory. In Magdeburg today, they have an experimental factory. The experimental factory is a dynamic paradox: a model for the experimental, without experiments; the factory that exists but does not produce. The idea of the experimental factory or workshop remains a dynamic legacy within the notion of productive cultural work. The postwar social project activated compromised forms of earlier idealized modernisms, and created a mesh of alleviated working circumstances that left behind the experimental factory as an attractive model of potential. You can draw a parallel between the rise of the experimental factory as a functional promise and the way critical, cultural exhibition structures developed alongside it. Without even considering the common phenomenon of occupying abandoned plants of the recent past as the site of art, these exhibition structures did so according to a program of regeneration within the mainstream contemporary art context.

Perhaps it is possible to explain the discursive cultural framework within a context of difference and collectivity—*difference* being the key word that defines our time, and *collectivity* being the thing that is so hard to achieve while frequently being so longed for. We have to negotiate and recognize difference and

collectivity simultaneously. It is an aspect of social consciousness that is exemplified in the art context. As social definitions and processes of recognition, difference and collectivity feed from the examples of modern and contemporary art. Art is nurtured and encouraged in return by way of a cultural permission that grants a space for that which cannot be tolerated, but can be accommodated under the conditions of neoliberal globalization.

The discursive thrives when we are increasingly alienated from sites of traditional production, owing to the displacing effects of globalization and the increasing tendency towards infinite subcontracting. Struggles over the site of production still exist, but they are constantly displaced and projected—the struggles are reported, but are sometimes resistant to identification across borders. They exist within a context that offers an excessive assertion of specificities, as well as tense arguments on the Left about how to accept difference and protect the local.

Difference and collectivity are semi-autonomous concepts in an art context. The logic of their pursuit leads us to the conclusion that we should destroy all traditional relations of production in order to encourage a constant recognition of disagreement and profoundly different aims within a context of desire. The focus of the discursive is more on the aims and structural efficacy of the cultural exercise than on what is produced. In turn, what is produced operates in parallel—unfettered by the requirement to be the total story.

But all of this is problematized by a nostalgia for the group. We are sometimes in thrall to structures from the recent past that were not supposed to be a model for anything. Some of the

structures that we use, as cultural producers, echo a past that was part of a contingent set of accommodations and dynamic stresses within the postwar social project. Around this, there remain old relationships of production that still exist outside complex theories of the postindustrial that are at the heart of postwar "developed" societies.

We can see how this developed and left traces in the culture. Consider the history of the French Groupe Medvedkin, which made films between 1967–1974 in the context of factories and other sites of production. They worked, filmed, and agitated at the Lipp watch factory in France and subsequently in the Peugeot factory in Sochaux. What you see very clearly in these films is a shift that is mirrored in the dominant art context. When looking today at one of their films shot in 1967, you do not see any superficial or linguistic differences between those who run the factory, those who work in the factory, and those who criticize the factory from outside— they are all from the same culture. Physically, they look the same. Though certain differences of detail can be determined, they are nuanced and require acute class consciousness. The effects of postcolonialism have not yet shifted the source of cheap labor from the various colonies to the neighborhood of the consumer. But Bruno Muel's 1974 film *Avec le sang des autres,* opens with a group of long-haired activists wearing old military jackets, standing outside the factory gates. They are attempting to play as a brass band to a group of silent, clearly embarrassed immigrant car-workers primarily from North Africa.

Through this series of films you see a clarification and separation of aesthetics in terms

of identification, language, and techniques of protest. Simultaneously, you see a conspicuous drop in easy communication. Modes of address have separated. Different groupings are talking, but only within each group, and each group has developed a sophisticated role-playing function in relation to the others. They demonstrate "positions" to each other. This shift towards the notion of a public faced by a complex display of self-conscious role-playing is familiar within an art context. It does not lack insincerity, and it does not lack genuine political engagement— it is a functional parallel.

We have created the conditions for the experimental, but no actual experiments (or vice versa). Micro-communities of redundancy have joined together to play with the difference between art time and work time. The question is how to develop a discursive project without becoming an experimental factory—without slipping into a set of conditions that lead to a certain redundancy. It is the attempt to hold the collective on this brink that energizes the discursive context.

The discursive is peopled by artists who increasingly accept a large number of perma-nently redundant citizens and who have come to terms with the notion of the permanently part-time worker in the face of the permanently educated artist. The notion of continual and permanent education is used in different cultures in order to escape what are actually clear politi-cal differences concerning class, situation, and power. It is the promise to the poor child of a way to escape bad conditions. But within the discur-sive, the notion of self-improvement is ideologi-cally specific and accompanies a philosophy

connected to postwar power structures.

My grandfather's questions were always concerned with what I would do with all the leisure time I would have in the future. The question now is: How do you know how much leisure time you have? We have to address the reduction of leisure as a promise, and as a marker within the postwar period. The discursive is linked to the question of who is managing time. Control of time was traditionally the dominant managerial tool, and it was rightly challenged. Self-management has subsequently become generalized in a postindustrial environment. It is the way even mundane jobs are advertised now.

The idea has become that it is essentially better to manage your own time within a frame-work that involves limitless amounts of work, with no concrete barrier between working and non-working. This is something that underscores the discursive frame—the potentially neurotic, anxiety-provoking situation within which we find cultural producers operating. It has superficial advantages and clear disadvantages. It is a notion of permanent soft pressure (which finds form via the computer and digital media) to manage your own time in relationship to broader networks.

The discursive demonstrates a neurotic relationship to the management of time as a negatively activated excess of discussion, discourse, and hanging around. The rise of teamwork and networks is linked to a denial of complex and disturbing old-school production relationships, which still exist as phantoms for progressive thinkers. The notion of flexibility within the workplace is a way to encourage people to rationalize their own disappearance or redundancy when necessary. Working situations

have not changed—the idea is that YOU have to change.

Maybe we have to think about revised languages of production within the context of self-management. Via small, multiple, flexible groupings, the discursive art context intends to go beyond an echo or a mirroring of simple production relations, though they remain subject to the same complexities that afflict any self-managed environment, even when they refuse to create a timetable. As a production cycle rather than a fixed performative moment in time, the discursive uses certain production analogies in relation to what "could be useful" instead of a permanent "association of free(d) time." It occupies the increasing gap between the trajectory of modernity (understood here as a flow of technologies and demographic developments) and the somewhat melancholic, imploded, self-conscious trajectory of modernism.

It is within this zone that we can explain the idea of no-surprise, sudden returns, and acceptance of gains and losses as simultaneous symptoms and catalysts. It is here that we can build contingent critical structures that critique both modernity and its critical double.

Monika Szewczyk

# Art of Conversation, Part Two

In continuing this written monologue about conversation, I am becoming aware of the sheer weirdness of thinking in this way about something that behaves so differently than writing "for the record." But if, as Maurice Blanchot demonstrates, conversation can be defined as a series of interruptions—perhaps the most powerful of which being the neutrality of silence—then writing, which is a kind of silent speech, may itself constitute an interruption to the way conversation is imagined.[1]

### Watching What We Say

When I think of conversation I increasingly think of *over*hearing. Recall Gene Hackman in Francis Ford Coppola's *The Conversation*. Hackman's character—Harry Caul—is a professional wiretapper whose obsessive records of conversations are haunted by the possibility of fatal consequences. One job may have cost a man his life; another job, the one underway during the film, may prevent another man's death. The film, which won the Palme d'Or at Cannes in May 1974, was a fortuitous echo of the Watergate Scandal that came to a boil in the summer months of the same year—a political event that churned around the *over*hearing of conversations, thereby accentuating wiretapping as an invaluable political tool—provided that one does not get caught. Richard "Tricky Dick" Nixon was the unlucky Republican president who did get caught, and he was nearly impeached for indiscriminately wiretapping the conversations of his opponents in the Democratic Party during their convention at the Watergate Hotel in Washington. Nixon and Henry Kissinger, his Secretary of State, also compulsively recorded their own conversations,

understanding that what is said seemingly "off the record" is often of the greatest political consequence. The recordings of their secret and semi-secret conversations, many of which took place between 1971 and 1973, are now available online. Just as they hold the potential to reveal the truths of policy and power, so too do they paint a general picture of a cynical political era that saw a fundamental transformation in the popular conception of conversation as not only something that shapes and reflects values— of wit, pleasure, and elegance, of time well spent —but also as information, tangible evidence, something to be placed before the law.

To be sure, spies and other lucky listeners had overheard conversations for centuries and used them for political gain, but it was only with the increasingly rampant wiretapping of the Cold War era that words could be spoken "for the record" without the speakers' knowledge or willingness. Hence *everything* you said could be used against you. And this has come to beg the question: How do we watch what we say as a result? Have we become more cautious, even paranoid, about how we break a silence, less able to test our radical ideas in the open—all because there is a greater chance of the record of such conversations coming back to haunt us, even once we have changed our minds? If so, the amount of willfully recorded and also scripted conversations—and their recent proliferation in the art world—becomes particularly curious. Artur Żmijewski's video for documenta 12, *Oni* [They], which synthesized an entire body of behavioral research about wordless conversations among Polish artists of his and earlier generations; Falke Pisano's

script for *A Sculpture Turning into a Conversation,* performed on occasion with Will Holder; Gerard Byrne's reenactments of printed interviews from past decades, such as *Homme à Femmes (Michel Debrane),* based on Catherine Chaine's 1977 interview with Sartre about women, or *1984 and Beyond,* which restages a speculative volley between futurologist writers such as Isaac Asimov, Ray Bradbury, Arthur C. Clarke, and Robert Heinlein; and Rainer Ganahl's continuous photographic documentation of talks and symposia. These examples only scratch the surface, highlighting the most formalized instances, which may not always involve something to be heard, but always offer a view onto conversation.[2] But there are also conversations that seemingly replace other ways of showing art, examples of which I will come to shortly. All this is to say that, in the realm of contemporary art, we do not seem to be watching what we say in terms of holding back. Rather, we may be increasingly interested in considering the aesthetics of people talking together.

But what to make of the sheer volume of conversation in art? It may be that, in our hyper-communicative world, any record of a person's speech is just a droplet in an ocean of such taped talk. In this kind of "infinite conversation" it might in fact be the volume that counts.[3] Is the idea to talk more so as to turn the droplet into a weightier drop, maybe even a "new wave"? If so, it remains to be seen whether a shared horizon of social change grounds many of the artistic and curatorial projects that have taken up conversation as a subject and form of late.

The most convincing arguments regarding the rise of discursive activity point to its

foundational relation with a kind of informal education that allows for various, often oral and communal means of transmitting knowledge and shaping thoughts and values. All of this is happening as education in the humanities and the arts experiences ever-greater pressures to standardize its approaches, especially in Europe under the Bologna Process. In response, there arises a growing need for a heterodox educational exchange that allows new information, and (especially) the type of knowledge that cannot even be quantified as information, to flow more easily. It has been noted that this expansion blurs the boundaries between educational time and free time, or that it secretly hopes to erase the category of work time as an isolated activity. The expansion and cultivation of minds must not be restricted to a few years at school, after which the professional life follows; rather, these activities constitute the (necessarily constant) "care of the self"—a concept from Ancient Greek philosophy resuscitated by Foucault. The more I think about it, the more important it becomes to reactivate the category of the *aesthetic* in this context as a frame of mind that combines education and pleasure, that does not reduce knowledge to information, and, perhaps most problematically, that grounds the faculty of judgment in categories that are difficult to set in stone—often requiring conversations and debates to bring these to life.

Elaborating on the care of the self in a lecture on "parrhesia," or fearless speech, Foucault underscores the need to step back, not so much to judge oneself, but to practice an "aesthetics of the self." The distinctions he draws between aesthetics and judgment are lucid, and

help to clarify the spirit in which I am proposing that an "art of conversation" may be aesthetically conceived and practiced:

> The truth of the self involves, on the one hand, a set of rational principles which are grounded in general statements about the world, human life, necessity, happiness, freedom, and so on, and, on the other hand, practical rules for behavior. And the question which is raised in these different exercises is oriented towards the following problem: Are we familiar enough with these rational principles? Are they sufficiently well-established in our minds to become practical rules for our everyday behavior? And the problem of memory is at the heart of these techniques, but in the form of an attempt to remind ourselves of what we have done, thought, or felt so that we may reactivate our rational principles, thus making them as permanent and as effective as possible in our life. These exercises are part of what we could call an "aesthetics of the self." For one does not have to take up a position or role towards oneself as that of a judge pronouncing a verdict. One can comport oneself towards oneself in the role of a technician, of a craftsman, of an artist, who from time to time stops working, examines what he is doing, reminds himself of the rules of his art, and compares these rules with what he has achieved thus far.[4]

Foucault's notion of aesthetics might be applied to conversation as much as to the self. But in the former case, it needs to be understood dialectically—within a notion of conversation

that is as much the *means* of constructing an aesthetics as it is the *object* of this stepping back. Such a double role complicates critical distance. And what is at stake is not some conclusive verdict on what it means to have a conversation, but a continual grasping at what has been accomplished (what can be seen and said) and what else needs to be crafted through an infinitely interrupted speech. When we step back for a moment from a conversation, there arises a golden opportunity to catch something of the strange knowledge it produces.

If the catch here is to sense things anew and (as Foucault would have us consider) to perceive the truth of a situation, such perception is (ironically) often reserved for the uneducated. Recall the small child in Hans Christian Andersen's "The Emperor's New Clothes," who is the only one able to cry out the truth about the emperor. Parading a purely discursive wardrobe through town, the sovereign is too afraid to admit that he cannot see the "nothing" under discussion as his finest clothes. In a perfect premonition of the dematerialized art object, Andersen describes how the elaborate descriptions offered by two tricksters, conjuring clothes so fine they are invisible to the riff-raff, gains the support of the king's ministers who dare not contradict their king or, worse still, betray their arbitrary authority by admitting to seeing nothing. They keep up the appearance by elaborating the descriptions in conversation. This conversation upholds the regime. The fact that it takes a child to cry out the simple truth that the emperor has no clothes aligns with a moral habit of sorts: it used to be the aim of art education to get adults to challenge the status quo by thinking like children, *again*.

(Consider Paul Klee before the Second World War and COBRA afterwards, or Rafie Lavie at the Israeli Pavilion in this year's Venice Biennale). Now the game is different. In an information economy, the power of discourse to shape the world gives conversation ever more complex and concrete potential. And the question becomes how to employ conversation as a medium.

And if conversation can be a medium, it is also increasingly subject to mediation. This childlike, unmediated view gives way to another fantasy: a neutral or *other* perspective. The plurality of conversation—made up of so many interruptions—may forge a complex neutral space. And, currently, the roaming eye of a film or video camera still seems to embody this neutrality with lenses that have carried the mantle of truth since their inception; to a lesser extent, the still photograph or the electronic sound recording could be trusted. Hence the proliferating documents of conversational activity in art may be understood as carving out that neutral space of conversation—an aesthetic means of stepping back. Put differently, there seems to be a hope that the increasing number of intersections of conversation and recording technologies may produce a point of reflection that teaches us what we cannot perceive when we are *in the middle of* such a discursive event.

Thus, immersion is, paradoxically, part and parcel of the stepping back. I do not think, moreover, that the obsession with documentation becomes strongest amongst those driving some radical and absolute social change. Rather, it seems most logical for those who see themselves as the guardians of a living history, which may not be popular or part of the most widely taught

curriculum—the most visible reality—but nevertheless exists. This history may be forged in parallel with official records; i.e. it is interested in continuing and perhaps refining *aspects of* the status quo. If there is any hope of social change at stake, another notion of revolution haunts it—one that assures the *continuation* of a minor history. The flourishing of a documentary impulse for keeping records then becomes competitive. This is less about turning things upside down than it is about keeping the proverbial wheels turning, ensuring that "we" survive.

### Quiet as It's Kept

"I can't believe we're not filming this!" whispered a friend of mine recently, during the final (and the most polyphonic and animated[5]) of three symposia entitled "Rotterdam Dialogues: Critics, Curators, Artists" held recently at the Witte de With, where I work as the head of publications. The entirety of the three events was recorded for sound only—a self-conscious wiretapping that nevertheless excluded numerous exchanges in the corridors, or at the bar, or in the back of the gallery spaces that were converted into stages for panels and dialogues. These offstage sites may have been where the "real" conversations took place. Certainly for me, this friend's whispered comment was crucial and will likely filter into the official talk about how Witte de With will shape a book from these comings together that cannot be fully re-presented. Granted, it would have taken a Cold War mentality to record all of the pertinent exchanges in full. For now, it is up to the people who attended the symposia to allow their most valuable conversations to continue to

do their work after the event.

In light of this work of witnessing, I wonder what would have happened had we insisted on cutting *all* electronic recording devices and committed ourselves more consciously to the role of living archives? I have also wondered for some time about what is being kept silent by the presence of cameras at numerous discursive events that I have attended or helped organize recently. Would something different be shared were there no cameras rolling, were the sound recorders turned off? In thinking this, I am inspired by the example of an artist like Ian Wilson who, over the course of the past forty-one years, has organized specific, meticulously framed discussions, which always take place *in camera*, but without cameras or other recording devices that could transmit the proceedings to those who did not attend.[6] The only thing that remains, if the work is collected, is a certificate stating that a discussion has taken place (and when and where). This certificate is only produced if the work is bought, not if it is presented without purchase, as has been the case on occasion. The gesture of generating a certificate thus intersects specifically and somewhat paradoxically with the money economy: On the one hand, there is the implication that money cannot buy the real heart of the work, the experience of the discussion that could be made available, albeit at a remove, were an index created; on the other hand, the commod-ification of a discussion does ensure that a paper record of its having taken place exists for poster-ity. A discussion is only visible if it involves the exchange of currency. People who come across such a record forty years after the event will wonder—I certainly did—what precisely was

said when this discussion took place in New York in 1968? The administrative blankness of the small typed notes holds a great, almost conspiratorial promise. Adding to this is the artist's conduct: Wilson never divulges the details of the discussions he organizes; he prefers to talk about the structure and the larger frames of the project. He honors a shared secret that only those present can fully enjoy and remember.

Having only ever been *outside* an Ian Wilson discussion, and as someone who encountered first a certificate and then sought out the artist himself, I wonder about entering this structure. Would my attention—especially my sight and hearing—be more acute at such an event due to its elaborate frames and the lack of a camera? Or—without the distractions of snapping pictures, the worry that some recording device is out of batteries, or the carelessness that comes from knowing that you can come back to what is said via a recording—would I forget about remembering and be fully present at the event once and for all?

Recently, I tried to test these questions in the course of a public conversation that I was invited to at the Western Front in Vancouver. Jonah Lundh and Candice Hopkins had asked me to elaborate upon my interest in thinking through what it might mean to consider conversation as an art today; hence the occasion had something of a *mise en abyme* about it.[7] The audience was made up largely of friends, so it seemed especially necessary to make things a little ceremonial, a little strange. I borrowed a *Talking Stick* made by Brian Jungen from a friend who had been given this work—one of several baseball bats that Jungen had had router-carved with

archly ironic slogans alluding to the simultaneous embrace and disempowerment of First Nations cultures in Canada.[8] Jungen often "misuses" sports equipment in his art, and I have always fantasized about misusing this particular work of his in turn; that is to say, I wanted to take the art object, which is usually presented with a "Do Not Touch" sign, and simply use it. In this case, misusing it meant to use it *literally*. In the course of our public discussion, we ended up passing the carved baseball bat around, going through the motions of an idea of oral culture that we could hardly access, the systematic persecution of such practices in Canada having broken much of the continuity that ensures the life and survival of storytelling. Nonetheless, this very physical thing in the midst of the dematerialized space of conversation did somehow render material the movement of ideas around the room, even as it all remained rather theatrical, especially since everything was wired for sound, and a camera looked me right in the eye as I sat at the head of the room.

This tension between the logic of oral culture and the logic of recording gatherings and conversations seemed to be working against the spirit of what I had intended, and at some point I insisted on switching off the camera and the sound recorder that had been rigged up in the room. In my mind, and some who were there may disagree, the moment the recording devices were unplugged, another kind of electricity also faded away. The performative flair of many people's utterances dissipated and there was a lot of straight talk, mostly about the naïveté of my gesture. Judy Radul—an artist and onetime poet who performed live at the Western Front,

and who has shifted her focus to experiments with the roles cameras play, especially in defining space as mechanisms of law and sovereignty— was most adamant in reminding me that, were it not for the people who bothered to turn *on* the cameras and other recording devices in the very room where we sat, much of what has been called the "whispered" history of art in Vancouver would have been lost. This is a history of media experimentation, persona formation, poetry, music, and other variants of the living arts that have received much less historical attention than what is known internationally as the "Vancouver School of Photography."[9] She also pointed out that cameras have the uncanny ability to capture the non-verbal aspects of conversation, especially the incredible power of—and here she stopped speaking for what seemed like eternity, though it was probably less then a minute—silence. The next day, Hopkins and I discussed how Radul's long silence had brought the electricity back into the room and how we regretted not capturing it on camera. This is partly why I am writing about it, but only a camera could have fully represented this strange interruption. Subsequently, my ears have since been more attuned to such silences.

And recently (midway through writing this text, in fact), I had an encounter with a self-declared silence in the form of a conversation —a kind of non-work (or maybe a meta-work?)— in the midst of an exhibition by Oskar Dawicki at Raster in Warsaw.[10] This took the form of a typed-out text, simply pinned on the doors dividing the two exhibition spaces of the prewar Warsaw apartment-turned-gallery. It is entitled "I have never made a work about the Holocaust," and in it Łukasz Gorczyca—who founded Raster

—questions Dawicki about this pronouncement and another conversation the artist had with Zbigniew Libera. We read about Libera's concerns regarding the reductive approaches to the subject.[11] Artist and curator further discuss feeling called upon to address the Holocaust, particularly in Poland, and the simultaneous impossibility of creating something that preserves an artwork's integrity—that is, its autonomy—in relation to this subject.[12] Here, conversation performs a limit by paradoxically speaking a type of silence. Adorno and Wittgenstein haunt the text, especially Adorno's assertion that there can be no poetry after Auschwitz. But I'm interested in how this impossibility bears on the other, more properly autonomous works in the exhibition, which grant the conversation the status of something on the edge of art making—something that is done when making work is impossible.

This brings me to another conversation I would like to discuss—and I realize I am employing a rather loose definition of the term "conversation," allowing it to hold together various forms of discourse; as may be clear by now, in each case my defining criteria involve interruptions by means of silence and a shaky claim to the status of art. The conversation in question is in fact twice removed from (what I'll dare to call) "a natural state": not only is it a staged trial (and therefore another kind of meta-conversation), but it is also a record of this staged event—a very purposeful document that used several cameras, and was strongly manipulated in its editing into a film.[13] We might say that art has been made of a conversation, which was a kind of performance art in the first place. Yet this artfulness is

particular in that the film never really asserted itself as gallery art, but was rather distributed on the festival circuit and left open to various classifications.

I am thinking here of Hila Peleg's *A Crime Against Art*, a film that is based on an eponymous mock trial staged at the 2007 ARCO Art Fair in Madrid. The charge: collusion with the bourgeoisie. Here again, silence speaks volumes about a very current taboo, but one that has been with us for centuries. There is a lot to say about how this film captures a particular network within the art world, and how it articulates positions, constructs contradictions, and crafts a subtle comedy. But I will concentrate on one decisive detail of the cross-examination. Asked directly whether he considers himself to be a member of the bourgeoisie, the defendant blankly stares just shy of the camera's dead center and remains silent for a moment worthy of a Harold Pinter play.[14] At this point, it is difficult to tell what he is thinking, but this interruption in the communicative exchange lets viewers consider the question in some detail. And (perhaps depending on whether you've read your Blanchot or not) you might say that this is precisely where the real conversation begins. By the time the answer "Yes" is uttered—an effective admission of "guilt"—the binary code of yes/no has been filled with the neutrality of saying nothing. The cinematically amplified silence refreshes the question of class at a time when the charge that artists are affecting bourgeois norms— gentrifying neighborhoods, making more money than is good for them, and so on—is becoming something of a staple (a self-congratulatory one, as well) in art-related discourse. Here we

get to the neutral ground of non-judgment that keeps a question alive.

## Nothing Gold Can Stay

The moral of the story is thus temporary and tentative: Maybe we need to think more about what class is, as well as which one we (want to) belong to. Considering that we are only "we" because we share values, and therefore can continue to create things that will prove valuable for us to exchange, it would be interesting to ask to what extent this creation and exchange of value is understood as a situation in which the sole or most important currency is money. In thinking this, readers might keep in the back of their minds a couple of conversations painted (so as to be watched, but not heard?) by Antoine Watteau during a time of growing confusion surrounding the ruling classes: *Le Pèlerinage à l'île de Cithère* [The Pilgrimage to the Island of Cythera] from 1717 and *L'Enseigne de Gersaint* [Gersaint's Sign] from 1720–1721, both of which hang today in the Schloss Charlottenburg in Berlin. In thinking further through the *currency* of conversation, it seems crucial to ask what values are both created and traded in the course of contemporary conversations. What interruptions are admitted and which ones are yet to be registered?

A caveat (rich in irony): I'm writing this on a train from Warsaw to Berlin, and I've just been interrupted by a very polite Polish man who distributes language books abroad and is passionate about collecting coins, and about the treatment of "our" people in Germany—Austria and Switzerland are better, he assures me, even though everyone speaks German there too. "As

long as a German is your boss, he or she will be nice to you. If it's the opposite, well . . ." This is irritating—I don't want to think about collectible coins but about a wholly different kind of currency. And I'm weary of his notion of the "we." I thought of telling him that he is paranoid and that we all need to think less about nations and more about cities, better still about *civitas*. But I've decided to interrupt our conversation with my silence. I'm fully focused on my screen now, though I continue to think: whose interruption would I value at this moment? Here comes the German conductor—I hope she's nice so my neighbor has no base on which to build his biases!

The cinematic silence of one accused of collusion with the bourgeoisie may be the base for thinking about how conversation has everything to do with the construction of social class—especially one that is still difficult to name. I say "class" rather than "community" because the word resonates with key allusions, and it is also in danger of losing some of its *punctum*.[15] The question of whether a class is being constructed by virtue of the co-presence of certain people at certain conversations and not others is perhaps only interesting if that notion of class escapes easy classification. Rather than advocating a return to Marxist dogma, I am thinking of something that hovers somewhere between two more particular senses of the term. One is employed by Diedrich Diederichsen at the end of his book *On (Surplus) Value in Art*:

Previously, the bourgeoisie was a stable, cultural class that had its place at the center of cultural production, which it regulated by

means of a mixture of free-market attitudes and subsidies, staging its own expression as both a ruling class and a life force that stood in need of legitimation. The bourgeoisie is now fragmenting into various anonymous economic profiteers who no longer constitute a single, cultural entity. For most economic processes, state and national cultural formations are no longer as crucial for the realization of economic interests as they were previously. As a result, the bourgeoisie, as a class that once fused political, economic, and cultural power, is becoming less visible. Instead, the most basic economic factors are becoming autonomous. Once these factors become autonomous, the obliga-tion towards cultural values that even the worst forms of the culture industry kept as standards, disappears.[16]

The notion of class cannot be understood primar-ily in economic terms, Diederichsen reminds us, especially when we think of the "ruling class" and even if we think that money rules the world these days. Once money becomes the only currency that people trade in, the ruling class disappears. Conversely, it might be said that members of a specific class develop mechanisms for appear-ing to each other, and at a certain moment this can be called a shared aesthetics or a shared worldview. But we might ask: Does watching what we say mark this process in its formation? And this brings up the other, more literal sense of class: namely, people who learn things together. If emphasis is placed on coming together to converse and to trade valuable information, what can then be seen in the process of many such

activities is the construction of a style of living and a set of values that can only be exchanged by those who not only have read the same books, but who are also able to embody their knowledge and its most interesting limits.

The idea of knowledge as something that only a good conversation can transmit is inherited in part from the aristocracy, a class that did not distinguish between art and life, or not as much as we do. Interestingly, aristocrats only began to obsess about the subtleties of conversation as they grew closer to losing their claims to a divine right to rule. In *Watteau's Painted Conversations,* Mary Vidal writes about aristocratic notions of conversation in seventeenth- and eighteenth-century France as a "disguised, diluted, non-bourgeois type of education."[17] Sound familiar? Accused of an instrumental approach to all knowledge, the bourgeoisie was feared for promoting a trade in information that could be institutionally/democratically taught, which for the aristocrats amounted to an unnatural knowledge. Vidal argues that what Watteau depicts in his paintings is never the content of the conversations as something distinct from their form—never the pointed, instructional gestures of a Gainsborough painting that exaggerate things so as to render them readable, even to the (morally) unschooled. Rather, their secret knowledge is always embedded—a set of values (elegance, harmony with nature) is expressed in paintings that espouse those very values and posit conversation as an art of living. Vidal makes a strong case for considering the "naturalness" of the corseted aristocrats that Watteau painted in terms of being "God-given" and full of grace— something that might escape a contemporary

(secular) eye which looks for naturalness in wildness or the absence of technology. The paintings are strange to us, perhaps because they do not reflect our values, but they are also somewhat *unheimlich* insofar as they point to the contemporary representation of conversation as the potential for creating a set of values, a common currency, a kind of network.

There is great interest nowadays in representing networks. The recent disclosure by the makers of Facebook that they will not fully delete records of their users—even those who choose to deactivate their accounts—underscores a somewhat paranoid logic that potentially preys on friendship as a mapping of consumers that lead to more consumers. It is with this in the back of my mind that I look at both of Watteau's aforementioned paintings. The shop sign in the form of a painting was made for the art dealer Edme-François Gersaint and shows people evaluating and appreciating other paintings. The mass and mobility of these pictures—which are no longer attached to castle or church walls (as was customary for major commissions until about the fifteenth century), but can be packed in a crate (as shown on the left) and shipped to hang in anyone's home—are a source of titillation. This early picture of the art market makes a point of exhibiting conversation as a basis of the market transaction. In some ways, conversation is the real value being exchanged; or it might be said that conversations arise in the places where value must be negotiated.

Sure, I am reading into the picture—speculating, projecting, appreciating it in a way that might not be appreciated by scholars—but I do see a speculative sense of value in *L'Enseigne*

*de Gersaint* that may account for the greater sense of tension in this image—greater even than is perceptible in Watteau's earlier depiction of a pilgrimage to the Island of Cythera, the ludicrously lovely dwelling place of Aphrodite.[18] If the earlier painting is gratuitously graceful—to my eyes at least—the heavenly element (embodied by the putti in the background of *Le Pèlerinage à l'île de Cithère*) is gone from the shop sign (and perhaps this is the reason for the midsummer melancholia of the embarkation). I'll even play a little faster and looser with art history still, and posit that perhaps this grace has been replaced by another "other" in the very front of the picture—a dog that is quite obviously not taking part in the conversations at Gersaint's shop. Since "dog" only spells "god" backwards in English, it is unlikely that Watteau was thinking in the same vein—seeing divinity in an animal and thus a true "other" to converse with—but even in French they say "*Le bon Dieu est dans le détail*," and this one needs some attention.

I've always been told that dogs in paintings are code for some abstract notion of "loyalty," but this one's not very convincing. If anything, he denaturalizes the entire scene. And if the dog refuses to play his allegorical part, his presence on the edge of the frame may be pointing to the fact that the pictures are *framed*, movable, and thus of continually reframed value. Looking at that oddly placed dog in Watteau's painted conversation, I wonder how *we* fit into this picture. On a couple of occasions, I have heard Martha Rosler confront her interlocutors in a public forum with the problem of forgetting about bohemia. For her, the staginess of today's conversations has evacuated some of the fun

and much of the real political force from what she experienced when people gathered together in the 1960s and 1970s.[19] But the real problem seems to be a kind of waning of a particular class-consciousness—a sense of common values involving a self-imposed poverty for the sake of other riches. Maybe Watteau's dog is a budding bohemian, or better still Diogenes, the "dog philosopher" who, when asked by Alexander the Great if the admiring Omnipotent could grant him any wish, any riches, simply requested that the emperor get out of his sun. The question of class might become more interesting if we begin to ask ourselves whether it is not just bohemia, but the middle class, that is being eclipsed—and with what. The other (increasingly urgent) question of what we are currently projecting onto animals will have to wait for another time, another conversation.

1    Part I of this ongoing essay, published in *e-flux journal* #3, worked through Maurice Blanchot's notion of conversation developed in his polyphonous book *The Infinite Conversation*, ed. and trans. Susan Hanson (Minneapolis and London: University of Minnesota Press, 1993). It focuses particularly on Blanchot's idea of conversation as interrupted thought and speech; and on genuine interruption as coming from *autrui*, or "the other." Blanchot's notion of *autrui*, which is somewhat enigmatic and radically open, posits silence as a key form of interruption and a space of neutrality. Thus, conversational interlocutors that greet us with silence—such as God, animals, and finally a rock (as these are found in certain films, artworks, and poetry)—are featured prominently in the text. Further following Blanchot's notion that "true conversation" is shaped by the profound silence of the other, which is always understood beyond binary opposition, Part I posed the question of whether what currently passes for conversation is really that. The question may never be resolved, but is likely to spur the continuation of this multi-part essay infinitely, without end or a clear horizon.

2    Thanks to Michał Woliński for noting Żmijewski's legacy recently.

3    Though this is not to say that this is what Blanchot meant with the title of his eponymous book!

4    See Michel Foucault, *Fearless Speech* (Los Angeles: Semiotext(e), 2001), 165–166.

5    As audience participation matched the engagement of the invited speakers.

6    I have never attended one of Wilson's discussions so cannot elaborate on their content. But what I know from meeting the artist is that the crafting of a discussion is of great importance, and that the absence of all recording devices makes for an atmosphere that puts a much greater emphasis on participation and the role of each participant as a witness to an event. The

task of memory could here be taken as primary. Or, given the inability to remember perfectly, one could completely give oneself over to participation and let oneself then be the evidence of what took place by virtue of any transformation of the person.

7   Jonah Lundh is a freelance curator developing a program of conversations for this artist-run center, and Candice Hopkins is the curator of exhibitions there.

8   As can be seen in the photograph, Jungen's *Talking Sticks* are usually displayed to emphasize their relation to the sports equipment they are made from—baseball bats. But in the context of his work, which often takes up questions of First Nations identity and its commercialization in North American sports culture, they are often seen to echo totem poles (at the size they might be made for the tourist industry). Having worked with Jungen at the time he developed these carvings, I do recall discussions of their formal relation to the kind of carved staffs, which are often decorated with First Nations motifs and paraded at official functions by the Lieutenant Governor of the province of British Columbia (the Queen's representative) or the presidents of the universities in Vancouver. Each time, such objects slyly enact a kind of transfer of sovereignty from the First Nations, which never took place legally and continues to be a point of debate.

9   See *Whispered Art History: Twenty Years at the Western Front*, ed. Keith Wallace (Vancouver: Arsenal Pulp Press, 2002).

10   What you are reading now was added towards the end of writing this text, but it seemed right to interrupt myself in this context.

11   Recall Libera's highly controversial *LEGO Concentration Camp* (1996), which was recently purchased by the Jewish Museum in New York.

12   This is not the first instance in which Dawicki has used conversation as a form of meta-art to stress impossibility or refusal. In his earlier work with the members of the artists' "supergroup" Azorro (supergroup in the sense that each artist also has an independent practice), entitled *Everything has been done* (2003), a conversation expresses the impossibility of making certain works of conceptual art quite simply because they have already been conceived. But in the case of the current work about the difficulty of addressing the Holocaust in art, the tone is very different. The conversation is situated amidst works that deal much more symbolically with the search for knowledge, failure, death, and palliatives, using a variety of neo-conceptual pictorial media (and one soft-sculpture consisting of the artist's clothes, tied together to form an escape line out the window of the gallery). Ironically, this conversation about strategic silence was totally missed by a reviewer in *Gazeta Wyborcza*, who took time to mention every other work in the exhibition. See Dorota Jarecka, "Przegrywamy do Końca" *Gazeta Wyborcza*, May 28, 2009, 14.

13   The structural undercurrents of conversation in court proceedings and the construction of judgments in particular are explored in a recent single-channel video work by Judy Radul: a seemingly natural conversation that turns out to be completely constructed on the basis of the three elements announced in its title: *Question, Answer, Judgment* (2008).

14   Those who have seen the film may know that the defendant happens to be one of the editors of this journal, Anton Vidokle. And I am as aware that my text may be read as an act of collusion (with those already accused of collusion!), as I am interested in forging a way to speak from within such conditions of complicity. In eschewing the fiction of critical distance, it might be possible to think through more complex notions of thinking critically, not only about dead or distant figures, but also about the people we tend to have conversations with and the very conditions we are immersed in.

15   Interestingly, in a recent review of Vidokle's activities by Taraneh Fazeli in the Summer 2009 issue of *Artforum*, titled "Class Consciousness," the focus is not awareness of social class—rather the title alludes to the educational activities of e-flux, which are discussed in terms of social consciousness, but not in terms of class.

16  Diedrich Diederichsen, *On (Surplus) Value in Art*, ed. Nicolaus Schafhausen, Caroline Schneider, and Monika Szewczyk (Rotterdam and Berlin: Witte de With Publishers and Sternberg Press, 2008), 48.

17  Mary Vidal, *Watteau's Painted Conversations: Art, Literature and Talk in Seventeenth and Eighteenth-Century France* (New Haven and London: Yale University Press, 1992), 95. Thanks to Søren Andreasen for recommending this fascinating book.

18  Not that the latter is void of tension. In fact there is some debate about whether the aristocrats are already on the island and finding it difficult to leave, or whether they are about to embark. Regardless of whether the good trip is deferred or coming to an end, the conversationalists are in limbo.

19  One was "The New York Conversations," in June 2008 in the new e-flux space; another was at the above-mentioned "Rotterdam Dialogues: The Artists" at Witte de With, where Rosler was a keynote speaker.

Luis Camnitzer
# Art and Literacy

**You teach a child to read, and he or her will be able to pass a literacy test.**
—George W. Bush, in a speech given in Townsend, Tennessee, February 21, 2001

Interestingly, at least in the languages I know, when one talks about alphabetization there is always the mention of reading and writing, in that order. Ideologically speaking, this prioritized order not only reflects the division between production and consumption, but also subliminally emphasizes the latter: ignorance is shown more by the inability to read than by the inability to write. Further, this order suggests that alphabetization is more important for the reception of orders than for their emission.

Of course, this theory—that if one wants to be able to write something, one should know how it is written—has some logic to it. It forces one first to read, then to copy what one reads—to understand somebody else's presentation in order to then re-present it. In art terms, however, this is similar to saying that one has to first look at the model in order to then copy it. Now the logical construction becomes much less persuasive. This is not necessarily wrong, insofar as one really wants to copy the model, or the need to copy the model is well grounded. In essence, if there is no proven need, the logical construction ceases to be one—it becomes a dogma disguised as logic.

This theory establishes first that the model deserves to be copied, second that there is a merit in making a reasonably faithful copy, and third that this process is useful to prepare the artist to produce art. This idea is a leftover from the nineteenth century, and its relevance today

is highly questionable. An artist then has to ask whether the problems posed today by alpha-betization might not be in need of new and more contemporary approaches. Is there an analysis of these problems informed by the attitudes that removed art from the nineteenth century and brought it into the twentieth? In other words, is alphabetization a tool to help presentation or re-presentation? Where is power located? Is it granted to the literate-to-be or to be found in the system that wants him or her to be literate?

One tends to speak of art as a language. In some cases it is even described as a universal language, a kind of Esperanto capable of transcending all national borders. As a universal language, stress-ing *universal,* art serves the interests of coloni-zation and the expansion of an art market. The notion of art as a plain language, however, under-lines a notion of it as a form of communication. In this case, power is not granted to the market, but to those who are communicating.

Educational institutions expect everybody to be able to learn how to read and write. It would follow that, if everybody has the potential to use reading and writing for expression, everybody should also have the potential to be an artist. Yet in art the assumption is different. Everybody may be able to appreciate art, but only a few are expected to produce it—not all readers are writers. Such inconsistent expectations overlook the fact that, just as alphabetization should not aim for Nobel Prizes in literature, art education should not aim for museum retrospectives. Nobel Prizes and retrospectives are more indicative of a kind of triumphal competitiveness than of good education. Put simply, good education exists to develop the ability to express and communicate.

This is the importance of the concept of "language" here, the implication being that both art and alphabetization can be linked to nurture each other.

### Reading, Writing, and the Rest

At this moment, we are in the precise middle of the decade that the United Nations has designated as the Decade for Alphabetization (alphabetization here used in the sense of education for literacy). UNESCO estimates that there are thirty-nine million illiterates in Latin America and the Caribbean, roughly eleven percent of whom are adults.[1] Sixteen million of them are in Brazil. These statistics only include people who do not know how to read or write. If we add those who are functionally illiterate—people who have the techniques, but are not able to use them to understand or to develop ideas—these figures grow astronomically. In developing countries, one out of every five people older than fifteen is considered illiterate. Among developed countries, nearly five percent of the population of Germany, for example, is functionally illiterate. And among literate students in the US, it is estimated that seventy-five percent of those finishing high school do not have the reading skills required for college.

The teaching of reading and writing has been a major part of the schooling mission for over two centuries. It has also been on the minds of countless specialists who ponder gaps in formal education in both expected and unexpected sectors of the public. That everybody should know how to read and write is taken for granted. However, beyond vague truisms regarding its function, there is little discussion

about how those abilities are used. And yet the problem of illiteracy persists even in countries claiming to have eradicated it.

Art has dealt with illiteracy on amazingly rare occasions, and when it did, it did so mostly of its own accord, keeping within its disciplinary identity and confusions, among them an idea that appreciating art is for everyone while making art is for the few. This means that art's main strengths—speculation, imagination, and its questions of "what if?"—have not really been explored on those occasions. Supposedly art is art and the rest is the rest. Art, however, happens to be the rest, too.

## My Imperialism

Forty years ago, I was invited to organize the art department in an American university. I refused on the grounds that art is not really "art," but a method to acquire and expand knowledge. Consequently, art should shape all academic activities within a university and not be confined to a discipline. I recognize that my position reflected a form of art-imperialism, and this is something I still adhere to. As in all imperialisms, my position was not necessarily based on solid information, and I used aggression as a tool for persuasion. Predictably, I was defeated, and shortly after was condemned to solitary confinement in the art department I had so proudly rejected. Yet I am unrepentant: I continue to operate with poorly informed opinions, I continue to be aggressive, and, to be sure, I will continue to be defeated.

My imperialism is based on a generalist view of art in which everything (including the "rest") can be seen as art. I also believe that the

social structures that divide us into producers and consumers—those that ensure that our lives conform to the laws of the market instead of seeking a collective well-being—should be demolished. These were the views we developed as students during the late 1950s while I was in art school in Uruguay. These views took for granted that such a broad definition of art, in which everybody could be a creator, would become a tool for improving society. We were defeated then, and today these beliefs are considered anachronistic and out of place.

Regardless of their feasibility, these perspectives had some importance because they introduced an awareness of the role and distribution of power in matters of art and education that should not be ignored. They clarified claims surrounding the ownership of knowledge, how that ownership is distributed, and who benefits from it. Even if these issues are normally considered to be outside the scope of art, it is on their account that the use of language and the means of engaging illiteracy become interesting to art.

Indoctrinating Subversion

Both art education and alphabetization have in common the dual and often contradictory mission of facilitating individual and collective cultural affirmation and expression on the one hand, and of being necessary tools to cement and expand forms of consumption on the other. Consequently, education is not only an ideologically fractured field, but one in which each of its ideologies assumes its own particular pedagogical approach to apply to all fields of knowledge, overcoming all irresolvable contradictions. When reasonably progressive, such pedagogies assume

that one can ensure the stability and smoothness of the existing society while at the same time forming critically questioning, non-submissive, creative individuals. This approach takes for granted that education will create good, accepting citizens who play by the rules, but who will also be subversive individuals attempting to change that society. In a conservative pedagogical approach, the latter part of the mission will simply be ignored.

As it is, the educational system emphasizes good citizenship during the early stages of formation and postpones any potential subversion until the postgraduate level. Speculation and imagination are allowed only after becoming a good citizen. In order for actual subversion to take place, it would first have to address the earlier parts of the educational process. This explains why alphabetization takes place at the beginning of the educational voyage while true art-making is placed at its end, or is indeed postponed until after formal education is over.

The tension that emerges from this built-in stability/instability contradiction creates two main divisions in how education is approached: between "integralism" and "fragmentalism," on the one hand, and between tutorial education and massive education, on the other. Although the two divisions are not necessarily aligned with each other, in traditional education, fragmentation tends to be coupled with massive education. Here, information is reified, classified into disciplines, and simultaneously transmitted to large groups of people with the aim of achieving an efficient conformist stability. Knowledge travels from the outside to the inside. The elements are distinct, and their classification and order are

presumed to be good and unchangeable.
Power lies in the hands of somebody other than
the student.

     The second alignment is different. In more
progressive education practices, integralism
tends to be associated with a tutorial style of
instruction in which there is more room for inter-
disciplinary research, encouragement of discov-
ery, and an emphasis on individual processing.
While not necessarily seeking either a flexible
society or a critical analysis of one's connections
to it, there is at the very least this emphasis on
individuation. And inasmuch as it includes the
possibility of a permanent critique, there is an
empowerment of the individual in the form of an
encouraged, self-aware perception of the world.
     It is this notion of empowerment that
creates ideological differences between the
two alignments. As soon as empowerment is
introduced, the politics around the distribu-
tion of power becomes an indissoluble part of
the educational process. This can explain why
the most paradigmatic pedagogical figures in
Latin America sought to develop not only the
basic process of alphabetization within the field
of education, but also self- and social aware-
ness. Both the Venezuelan Simón Rodríguez
(1769–1854) and the Brazilian Paulo Freire
(1921–1997) saw education as a form of building
a progressive and just social community. In the
1820s, Rodríguez declared that education had
to deal "first with things, and second with
those who own them."[2] In the 1960s, Freire wrote
that "before learning how to read words, one
should learn how to read the world."[3] Both
educators underlined the importance of decod-
ing the social situation prior to decoding the

disciplines of reading and writing.

It is not surprising that this form of social decoding is easier to achieve through individual exchanges rather than collective ones. Individual tutoring seems to be ideal. When the teacher can focus all his or her energy and attention on one person, it allows for immediate calibration and response to the most minimal signs of incomprehension. Done well, it takes the Socratic method to the level of extreme psychological therapy, making for a tailor-made education for each individual. If the teacher is a good one, this makes for perfection. Seen in terms of efficiency, however, individual tutoring is the least economical strategy. It is no coincidence that having a personal tutor is a symbol of wealth reserved for the upper classes, so it becomes paradoxical to expect this highly elitist mechanism to also be the most appropriate means of achieving a just and classless society.

On the other hand, massive education remains seductive for its apparent economic efficiency as well as its populist appeal. A teacher can form tens or hundreds of individuals with the same investment of time and energy that a tutor makes for one. As far as the empowerment of the individual is concerned, however, massive education has the tendency to disseminate information and indoctrinate rather than to promote investigation and self-consciousness. In other words, striving for efficiency favors cheap output at the expense of qualitative evaluation. Quality becomes assessed within an economic frame of reference. Alarmingly, this distortion is accepted as the norm. Of course, there are tutors who inform and indoctrinate their students, just as there are teachers educating the masses who are

able to raise awareness and empower them. In the first case, however, the tutor is betraying the teaching mission; in the second, the ideals are only reached by overcoming built-in obstacles.

## Coding and Decoding How and What

Sixty-five years ago, when I was learning how to write, I was forced to fill pages with the same letter, repeating it over and over again. I had to copy single letters before I was allowed to write words. I was given words before I could express other people's ideas, before I could express my own ideas, before I could even explore what my own ideas might be. It only occurred to me as an adult that, if I know how to write with a pencil, I also know how to draw with that pencil.[4]

For my mother, educated in First World War Germany, matters were even worse. She had to use a pen designed specially—not for writing— but for learning how to write. The pen looked as if it had been designed for torture. Oval pieces of sharp tin forced the placement of the fingers into one particular position. If the fingers were not in the required position, they would be hurt. One could speculate that these pens were instrumental in preparing for Nazi Germany's ethos of obedience.

Art education has always been faced with a confusion between art and craft: in teaching *how* to do things, one often neglects the more important question of *what* to do with them. The conventional way of teaching how to write concentrates on readability and spelling, which only addresses the *how* of writing without regard to the *what*. Exemplified by the practice of teaching someone how to write by concentrating on a frozen aesthetic feature such as calligraphy,

this approach fails to first identify the need for a message, which would then open an approach to writing that concerns the structure and clarity of what is being written.

In an exaggerated form, the pen synthesizes everything I hated about my education: the fragmentation of knowledge into airtight compartments, the confusion between how-to-do and what-to-do, the development of communication without first establishing the need for it. It was like learning how to cook without first being hungry—without even identifying what hunger is. After all, education is less about being hungry than about awakening appetite to create the need for consumption. In fact, I believe that this is how cooking is taught.

Why can't one first identify and explore the need to communicate in order to then find a proper way of communicating? Languages themselves are generated in this manner, and this is how they evolve. Words are created to designate things that had hitherto been either unknown or unnamable. Today's spelling errors determine tomorrow's writing. Many of those errors are the simple product of an oral decoding that overlays written coding. Of course, errors should be acknowledged—but they should also be subject to critical evaluation. As a derogatory term, "error" reflects a particular code-centrism typical of our culture. Illiteracy is, after all, only a problem within a literacy-based culture. In general, codes are created by a need to translate a message into signs, and then decoded by a need to decipher the message. Through this coding and decoding, there is a process of feedback in which "improper" or misplaced codings produce evocations that change or enrich the message.

## Finding Discovery

When the reason to read and write is primarily to receive and give orders, it is understandable that the need for learning should not be identified by the person to be alphabetized, but by the same power structure that produces those needs. Knowledge becomes predetermined and closed when both definition and identification are performed within this restricted functional field, while a more open field would stimulate questioning and creation. In essence, one cannot educate properly without revealing the power structure within which education takes place. Without an awareness of this structure and the way it distributes power, indoctrination necessarily usurps the place of education.

While this is true for education in general, it becomes more insidious when applied to the teaching of reading and writing. In this case, indoctrination is not necessarily visible in the content, but instead seeps heavily into the process of transmission: if one is taught to repeat like a parrot, it doesn't really matter what is actually being repeated; only the desired automatic, internalized act of repetition will remain. If we only teach to recognize things by their forms without addressing concepts, it won't matter what generates these forms. Only the recognition of the packaging will remain, and worse, the acquisition of knowledge will stop there.

A real education for an artist consists of preparation for a pure research of the unknown. In a strong art education, this starts at the very beginning. But as institutional education in other areas is organized to convey only known information and to perpetuate conventional habits, these

are two pedagogies in fundamental conflict. Where, then, should the fight against illiteracy be placed? Should alphabetization be handled as a subject for training, or as a tool for discovery?

The question may be too schematic. In art, pure discovery leads to amateurism, while pure training leads to empty professionalism—good preparation ultimately seeks a balance between them. The question does not concern which activity should be eliminated, but rather which one should inform the other. Those in favor of training often defend it with the need to supply good scaffolding for the student. Yet, if one ultimately hopes that discovery will be the main purpose of a student's life, whether for self-realization or for collective enrichment, it is clear that the student should not just learn to build scaffolds.

We now find ourselves in an age when the amount of available knowledge far exceeds our capabilities for codification. The imbalance is such that we must speculate on whether the concept of restricted alphabetization based on the re-presentation of known things may be an unforgivable anachronism. We may have arrived at a point where we need an education that goes far beyond all this: one that first makes the subject aware of the personal need for literacy and then identifies the coding systems already in use, so that they may be used as a reference; one that proceeds to activate translation processes as a primary tool for entering new codes; one that, from the very beginning, fosters the ability to reorder knowledge, to make unexpected connections that present rather than re-present. In other words, we need a pedagogy that includes speculation, analysis, and subversion of conventions, one that addresses literacy in the same

way any good art education addresses art. This means putting literacy into the context of art. By forcing art to focus on these things, in turn, the art empire itself will also be enriched.

1   According to a National Adult Literacy Survey cited in 1996 by The National Right to Read Foundation, forty-two million adult Americans cannot read. According to a 2003 report by the National Institute for Literacy, "The mean prose literacy scores of U.S. adults with primary or no education, ranked 14th out of 18 high-income countries."

2   Simón Rodríguez, *Obras Completas* (Caracas: Ediciones del Congreso de la República, 1988), 1:356.

3   Later, Freire would rephrase this by saying: "To read a word and to learn to write it to then read it are consequences of learning the writing of reality, of having had the experience of feeling reality and modifying it." Paulo Freire and Donaldo Macedo, *Alfabetizaci—n: Lectura de la palabra y lectura de la realidad* (Barcelona: Paid—s, 1989), 67.

4   In fact, John Gadsby Chapman had already proclaimed that "Anybody who can learn to write can learn to draw" in the first lines of his *The American Drawing-Book* (New York: J.S. Redfield, 1847), as quoted by Arthur D. Efland in his *History of Art Education* (New York: Teachers College Press, 1990).

Raqs Media Collective
# Stammer, Mumble, Sweat, Scrawl, and Tic

To be legible is to be readable. To be legible is to be an entry in a ledger—one with a name, place, origin, time, entry, exit, purpose, and perhaps a number. To be legible is to be coded and contained. Often, when asked an uncomfortable question, or faced with an unsettling reality, the rattled respondent ducks and dives with a stammer, a mumble, a sweat, a scrawl, or a nervous tic. The respondent may not be lying, but neither may he be interested in offering a captive legible truth either to the interrogator or to his circumstances.

An insistence on legibility produces its own shadow, the illegible. Between the bare-faced lie and the naked truth lies the zone of illegibility— the only domain where the act of interpretation retains a certain ontological and epistemic significance.

We read each other for signs, not because we are opaque, or necessarily wish for opacity, but because our desires, fears, and experiences still require the life-giving breath of translation. The transparency that brooks no translation also requires no engagement.

The tree of life, and therefore of art, would be barren were it not for the fruit of occasional misunderstandings.

1    <u>Stammer</u>

Two performers, Mahmood Farooqui and Danish Husain, tell stories in Delhi as part of an attempt to revive a traditional narrative form called *Dastangoi* (story-speech).[1]

Among the stories they tell are accounts of people, incidents, places, and facts frozen as notes and jottings in the archives related to the Indian subcontinent's partition in 1947. In telling

these stories, they attempt to work through what it means to be poised on the hyphen between the terms "Indian" and "Muslim," in whichever order the two are read, when they are read together. Sometimes this exercise takes the form of a meditation on the conflict between life and the ledger.

The partition of India was meant to give rise to a new "homeland"—Pakistan—for "Muslim-Indians," who, of course, would cease to be so the moment they moved to Pakistan. The new Indian state, however, maintained that India was the only proper homeland for "Indian-Muslims," who were Indians as much as they were Muslim. In this tug of war over how the "Indian-Muslim" or the "Muslim-Indian" could be made legible as present or future subjects of two states, some strange things were bound to happen.

A person who had been a "Muslim-Indian" before partition ceased to be an "Indian-Muslim" the moment he became a Pakistani. And if he became a Pakistani, then he could no longer easily revert to being an Indian. To the Indian state, Pakistan was an enemy, and all Pakistanis, who had once been Indians, were actual or potential antagonists.

On the other hand, after a certain date, the state of Pakistan, the homeland of those who hitherto had been "Muslim-Indians," was no longer willing to accept any more "Indian-Muslim" emigrants from India. They were beginning to be seen as a burden, as outsiders, and, at worst, as potential fifth columnists from India in the new Pakistan.

This meant that those "Indian-Muslims" who had crossed over to Pakistan, but subsequently wanted to return to India could not do so,

while those "Muslim-Indians" who had stayed on in India, but subsequently wanted to cross over to Pakistan could not do so either. India would not let the first kind return, and Pakistan would not let the second kind enter. Both of these desires became obstacles to those who governed the two new states. The "Indian-Muslim" and the "Muslim-Indian" came unstuck between the powers who claimed the terms at either ends of the hyphens that joined them. Their lives, and the claims that their lives made on history, were no longer seen as valid. The legibility of the law that classified people as either "Indian" or "Pakistani" now produced its own illegible shadow—of the movements of people who did not quite fit into either category, and who, by their actions and by the articulation of their desires, refused to "fit" into either India or Pakistan, but stayed on as the stubbornly illegible marginalia of the unfolding of two grand narratives of new nationhood.

Farooqui and Husain's performance, which takes off from the investigations of historians like Vazira Fazila-Yacoobali Zamindar, comes to a head with the story of someone we like to think of as the "uncontainable man." Here is his story.[2] There was once an uncontainable man. Let us call him Ghulam Ali. That is how he is named in the files and the correspondence that surround his strange but unremarkable story.

In the aftermath of the Partition of India, in 1947, this man, like thousands of others, could not offer a clear, concise reading of his self. He had not yet learned to be legible to himself as a citizen of either nation. Neither India nor Pakistan could hold him in place.

This uncontainable man wanted to stay on in India, but went to look for a missing relative in

Pakistan. His decisions were sound; his timing was awry. Straying to search for someone, and then staying to search for someone—falling sick, tarrying, confusion—all this meant that in a few months' time he became a Pakistani. People were still figuring out how to spell Pakistan, and how to tell it apart from India. Ghulam Ali read himself with a stammer. The book that became his passport had already told a new story.

Caught between petitions, jottings, and files, Ghulam Ali tried to read himself—sometimes as an Indian, at other times as a Pakistani. But all he could say with confidence was that he had learnt to play the kettle drum in the British Indian Army band. Kettle drumming is not a legible nationality. You can't just rat-a-tat-tat your way through two new warring nations as if it were a parade; not if you are an ordinary decommissioned soldier with nothing to your name but a quest for a missing relative. Your petitions may travel, but you stay where you are written into history. Over time, even the inscription in the file, overwritten many times over, becomes as illegible as the acts of travel that it sought to contain. Legibility, when it eats its own tail, digests itself into illegibility.

2      Mumble

In Ritwik Ghatak's *Jukti, Takko aar Gappo* (Arguments, Reasons, Stories), a Bengali film set against the backdrop of the first wave of Maoist rebellion in late 1960s/early 1970s India, an old man, Nachiketa, played by Ghatak himself, falls in with a group of "underground" Maoist insurgents in the course of his eccentric, picaresque adventures.

His conversations with one of his indulgent hosts, which cover a large historical remit, inevitably end in his admission, "I am confused, young man. I do not understand anymore." He travels with the band of rebels, and yet, it is they who are all conformists in comparison to his awkwardly exhibitionist display of ambiguity. Caught in the "crossfire" between the certainties of the state and the insurgents, Nachiketa (with a name that packs in a throwback to Nachiketa, the death-defying practitioner of the "via negativa"—neti, neti, neti/not this, not that, not the other—of the *Katha Upanishad*), is a celebrant of the mumbled doubt.

Nachiketa's insistence on inhabiting his confusion has other ramifications as well. In addition to its awkward evasion of definitive articulation, it also outlines a position based on a refusal to be an informant. The owning-up to not being able to "understand" is as much an assertion of deliberate reticence as it is a tacit admission of ignorance. Often, in the course of cultural transactions, a demand is placed on the artist, curator, and critic to be a model "interpreter." This demand is usually underwritten by the assumption that the place, biography, history, predicament, relationship, or situation that the "interpreter" is being asked to translate is available to him as a transparent template. Nachiketa, by holding on to his confusion, questions the imperative of transparency.

Nachiketa's prevarication offers neither redemption nor rejection. Rather, it suggests hesitant incomprehensibility as a reason to keep going. Nachiketa "keeps going" until he is finally undone by the assurance of gunfire in one of Indian cinema's first depictions of the now

commonplace "encounter," a form of contact between the state and its more recalcitrant subjects, which takes place through the medium of a well-placed bullet lodged in an insurgent's head. A doubting body is an uncomfortable sprawl of questions. A dead body is a legible statistic in a police ledger. The transformation of the doubting body into the dead body is another kind of translation. It happens far too often, and though forensics is one way of looking at the dead body, especially in search of well-writ answers, it has not as yet yielded its own hermeneutic science, or the kind of interpretation that stays on the ball with the questions that continue to haunt the record, much like the confused ghost of a confused man.

3    Sweat

A judge in the western Indian city of Pune recently convicted a woman for murder based on the results of a Brain Electrical Oscillations Signature (BEOS) test.[3] This technique, developed by a Bangalore-based neuroscientist, claims to act as an efficient instrument for determining culpability in crime through brain mapping.[4] The accused, who is said to have poisoned her fiancé with arsenic at a local McDonald's, was subjected to an electroencephalogram. Thirty-two electrodes were placed on her skull while she sat in silence and listened to a series of statements read out mainly in the first person, some of which were neutral, such as "The sky is blue," while others made assertions which could be connected to the crime, such as "I bought arsenic" or "I went to McDonald's."

Unlike other neural investigation and prognostic techniques used in forensic

psychology, BEOS does not rely on an evaluation of skin texture (as in a lie detector) or brain images (as in Narco Analysis) associated with the making of "true" or "false" statements by the suspect in response to a set of questions, often fielded while the accused is made suggestible through strong pharmacological intervention. BEOS does not rely on the accused having recourse to speech, but on what is supposed to be revealed by the colors of her silence. It "maps" what happens in the accused person's brain while she "listens" rather than when she speaks. This silent cartography of the brain divides the cerebral cortex into areas corresponding to "concepts" and "experiences." In this theory, should the area of the brain devoted to the storage of "experiential" data light up in response to stimuli pertaining to the scene or particulars of a crime, the suspect is taken to be someone who has actually participated in the unfolding of the events in question. The brain is taken to preserve within it a legible impression of the crime, much as a roll of film contains an emulsion on which a scene may be imprinted through the action of light.

The question is: Is a dream, an act of the imagination, a response to a murder in a film, an "experience" or a "concept"? If the life of the imagination is rendered indistinct from the life of actions then all of us are criminals, or have been, at least some of the time. We have all experienced the fear and rush of violence, in dreams, in recollections, or through recounting.

What if we did not commit a murder, but obsessed about it instead? What if we went over, again and again, the real or imagined details of a conspiracy in our minds? Would we then be

conspirators or witnesses, or both—in turns, and all together?

Would it then make sense to say that if you are not an eligible victim, you must be a legible perpetrator? Which would it make more sense to be?

4    Scrawl

In looking at traditional land deeds and documents that encode customary titles, one is struck by the scrawls that thicken the task of reading. The research of Solomon Benjamin, a scholar of urbanism based in Bangalore, involves looking at the changing ways of registering legal and customary claims to land.[5]

Benjamin's work takes the form of a series of digressions into the meanings of signatures and countersignatures. To him, the story of a land deed or other such documents, is told by the marks and annotations that overlay each other on paper to form a palimpsest of claims—here reinforcing, there overruling exclusive rights— erecting, dismantling, and shifting the boundaries between enclosures. Claims touch claims, infect claims, mate, proliferate. Relationships to land become both more and less than being simply about "property." The rights of ownership are read against the claims of custody. Usage, usufruct, usury, uxoriality, estates, and estovers all shade off into discussions about different kinds of entitlement. Habits and habitation yield to each other, and the thin fabric of legal legibility often buckles under the overlay of ink on ink on ink on paper.

Jane Caplan, historian of information processes and identification techniques, takes a close interest in the evolution of the signature. To

her, the signature is an "equivocal artifact deeply mired within the terrain of legibility/illegibility."[6] Citing historians who claimed that an illegible hand was seen as a mark of gentility in the 16th century, Caplan points out that "legibility" and the penmanship that produced it was closely tied to what was once seen as the "vulgar" commercial activity of accountancy. This view reversed itself in nineteenth-century Britain and its empire, when good handwriting came to be associated with gentility.

The signature, however, remains an exception to the cult of legibility. Even now, legal opinion customarily holds that a "normal" signature is an "illegible" signature, i.e., that illegibility is a defining feature of the signature, "which is not a piece of writing intended to convey a meaning, but a graphic, symbol, or device."[7]

Illegibility, in other words, is the hallmark of individuality. Children learning to write their name legibly soon realize that growing up involves the transformation of a readable name into an illegible scrawl. The consistency of this illegible scrawl through time then becomes the identifier of a well-formed adult's ability to represent him or herself on paper.

How can the knots and scrawls of human relationships, especially as they get entangled over generations, be read in anything other than their illegibility? What does an "illegible" reading amount to? Would hearing such a reading amount to listening to the rustling glossolalia of aging paper? In such situations of universally diminished legibility, disputes over land would often end in long, drawn-out negotiations that, in their durability, acted as tacit instruments of compromise. So someone owned, someone

ploughed, someone grazed, someone camped, and someone lived, and all of them quarreled and felt that they were as much in the right as they were in the wrong.

Today, however, property claims are hard-coded with digital signatures. Barcodes don't scrawl into each other the way that inked inscriptions could. A patch of land is no longer a field of interpretation, guarded by a picket fence with many gaps and holes. As land becomes transacted on a global scale, and as traditional claims and claimants are erased in neat satellite-imaged cadastral records, information—not habitation—becomes the key to property. A right to land is no longer a dispute to be settled by reading a layer of ink under another layer of ink. It is instead a piece of information protected by a firewall, amenable to entrance only on the pronouncement of a password, and only legible to its owner.

5    Tic

The jagged peaks of stock market fluctuations are legible, apparently, to sharp punters on good days. The nervous tics on the faces in the crowds that gaze with rapt attention at the scrolling news of the day's highs and lows on the electronic murals, which wrap themselves around the glass facades of the citadels of finance, are eloquent testimonies to the affective intensity of capital.

It is possible, some say, to read despair, skepticism, hope, and euphoria in the glyphs formed by these crests and troughs. If so, then news of investment is as sentimental as the chapters of a pulp romance. The promise of romance and the hope of eventual recompense on risky bids are the eventual trophies for which

both speculators and sweethearts vie. Yet each lover, and each stockbroker, is a prisoner of a private language. Every man (and woman) who has laid a wager on the possibility of a return in love or money has done so knowing that the object of his attention may not even hear, let alone care for, the intensity of his longing. How many have squandered their dreams on Freddie Mac and Fannie Mae, and to what little avail? Sentimental poets declaim that "to love is to lose." Addicted market players see the losses of some as the opportunities for a win on the "rebound." And so, victory and defeat, pursuit and being pursued, blur into each other such that it begins to be difficult to tell losses from gains. If the legibility of loss lies in recognizing the state as bereft, then it becomes equally necessary to know that bereavement can render us speechless. Within silence lies another, keener illegibility. And who would dare edit the lexicon of a wordless language with a million entries for only two sets of meanings: intangible hope and opaque despair?

1    Dastangoi Blog, http://dastangoi.blogspot.com.
2    See Vazira Fazila-Yacoobali Zamindar, *The Long Partition and the Making of Modern South Asia: Refugees, Boundaries, Histories* (New York: Columbia University Press, 2007).
3    Anand Giridharadas, "India's use of brain scans in courts dismays critics," *International Herald Tribune*, September 15, 2008. http://www.iht.com/articles/2008/09/15/asia/15brainscan.php .
4    Lawrence Liang, "... And Nothing but the Truth, So Help Me Science," in *Sarai Reader 07: Frontiers* (2007): 100-110. http://www.sarai.net/publications/readers/07-frontiers.
5    Solomon Benjamin, "Occupancy Urbanism: Ten Theses," in *Sarai Reader 07: Frontiers* (2007), http://www.sarai.net/publications/readers/07-frontiers.
6    Sensor-Census-Censor, Investigating Circuits of Information, Registering Changes of State, 2007, http://www.sarai.net/publications/occasional/sensor-census-censor.
7    ibid.

Sean Snyder

# Disobedience in Byelorussia: Self-Interrogation on "Research-Based Art"

Good evening, I'm in charge of security for
El Al, do you speak Hebrew?

In the art world, people don't entirely know
what they are talking about. They ask a lot of
questions. It's not that people don't know what
they already know, but rather that they want to
know something more in order to do the next
thing—and somehow get it right. That's enough
of a reminder that you might have something to
say, and that at some point it might make sense. It
is in fact those who ask questions who make the
entire mechanism function.

The single most interesting discussion
I have had about art was not with an artist,
curator, critic, or the like, but with an El Al security
officer a few years ago when I was detained
and subsequently escorted onto a flight to Tel
Aviv. I really messed up when I mentioned that I
never intended to be an artist. As it turned out,
the interrogator was himself an artist, or, more
precisely, a cartoonist.

During the flight, I was separated from my
laptop. When asked, I didn't think to mention that
it contained a folder of al-Qaeda videos clearly
marked as such. Only later did I consider the
possible consequences of my curiosities, which
would have been more than difficult to justify as
"artistic research."

Are these your only bags? Do you have any
weapons or sharp items in your luggage? Is
this laptop yours? If I were to look at your
laptop, what would I find on it?

I know what I said because I immediately
transcribed what I remembered from the series

of interrogations as soon as I arrived at my hotel. I have since tried to figure out why I said what I said, which I will try to clarify here in the present tense by returning to the original questions in the form of self-interrogation. Although I was familiar with El Al's procedures—another red flag for the interrogator—I suppose that what struck me most was that I became annoyed at having the same ritualistic conversations you end up having when participating in art exhibitions.

Where do you live? What sort of art do you make? What are you trying to say?

I have often placed myself in precarious situations in order to access information and images for my work. I have been thrown out of places, been arrested, had cameras confiscated, have faked journalist credentials, paid bribes, and so on. A compulsion? A "research-based art practice"? Well, more the former, supported by the notion of the latter.

Art is facilitated by responsible practitioners who frame art. And artists are often bound to their own caricature. The stereotypes are well known: savant, creative, hysteric, convoluted, contradictory, and so on. However, the *institution* also has its connotations: mental facility, the state, government, social order, and so forth.

As I write, I will not assume the role of the artist, but more that of a cartoonist. I will enter a state of psychosis for a few days in an attempt to explicate, in the form of satire and caricature, the notion of "context" and its relation to art, occasionally fluctuating between scientific and clinical terminology (applied arbitrarily).

What do you mean you've been invited to participate in a conference? I thought you said you're an artist.

As an artist, I generally don't like to involve myself in discussions about art. More often than not, they exemplify what not to do rather than what to do. They often reveal the way art is instrumentalized. However, in this case I will make an exception and write something.

As I understand it, the format of *e-flux journal* is intended to generate a new form of discourse. I am always optimistic when I read these sorts of formulations. e-flux itself is a reflection of the art world in which the entire spectrum of production is laid bare. Its organizational structure is based on the simple necessity of disseminating information, and is interestingly not bound to contextual framing—conflicts of interest, party affiliations, art magazines, etc.— and, unlike most of the art-related junk mail that somehow ends up in my inbox, I don't automatically delete it. I read some of it.

As *e-flux journal* has begun to establish some general parameters, broadly concerned with issues surrounding the institution, I would like to mention the immediately relevant questions posed by Tom Holert in regard to the production of knowledge in art, which correspond to the growing discussion about "research-based" art practice and its institutionalization.[1] I also agree with Irit Rogoff's comments on the occasional circular patterns in regard to "context."[2]

I have recently produced two works that reflexively, if obliquely, address issues related to how I see current art practice, works that

unexpectedly border on some oblique form of institutional critique. It was certainly not a category or designation I would want to end with, but something that simply happened, and I would like to attempt to identify the short circuit.

Concrete thinking has led me to believe that the recently applied designation of the "research-based" artist is possibly appropriate—the next in a series of terms applied to my practice. Of course, such terms are necessary to rationalize art. Typically, however, when such terms are applied I try and circumvent them and do something else.

I recently conducted a form of research on "research-based practice"—my own—and would like to explain the hypothesis, and outline some subsequent results so they can be held up as a specimen for analysis. I will try and explain in plain language, not the language that gets confused in the real world, the sort of words automatically corrected by Microsoft Word. The word I got tangled up in was "context." I will explain how it happened.

What I will attempt to underline should serve as something of a potential warning to designations such as "research-based practice."

I am curious myself: Does it give ammunition to the notion that research-based practice should be institutionalized? That I should be institutionalized? Or re-institutionalized? After all, isn't the artist as incoherent psychotic generally the most acceptable practice? More seriously, the practice of art is not confined to finality. It is centered on questioning rather than illustrating, self-reflexive without guarantee, and, as any material practice, open to possible consequences.

Why do you do it?
What are you trying to say?

I was late sending the signed documents to the institution. The art institution. But I did have an excuse this time: the FedEx plane crashed at Narita this morning.[3] That is an unfortunate fact. It was very windy last night. I was not expecting anything. But other people were expecting something from me. And it will be delayed. Because plane accidents are more important than discussions about art. Than anything I do. And I can talk about plane accidents. I can talk about the different models and types of planes, which airlines, the dates. But it's up to journalists to check facts.

Then there are art journalists. And they understand what they understand. And that's good. But sometimes they try and explain things they don't really understand because sometimes they speak about politics. And they confuse other journalists.

While I am writing this text, I am listening to conservative American talk radio online. Not because I like it, but because it is annoying. People talk. And talk and talk. And it presents itself for what it is. But sometimes the host has something funny to say. For example, "Even a blind squirrel can occasionally find a nut."

As art develops an increasing interest in other disciplines, it seems to attract people who have little more to say than to insist on their imaginary roles in the institution. They just talk, telling us who said this about what, and so on. And they have increasingly more to say. Based on what others have to say. And will keep talking. Until you remember. Demanding more discipline

or the Bologna Process. Because anyone can get away with anything in art, if one is insistent enough. And it's precisely this sort of "discourse" that often leads me to question the discourse itself.

Here, in admission of my own gullibility, I'll diffuse some of my comments.

As a kid I spent hours a day listening to short-wave radio. Particularly the English-language broadcasts from socialist countries. One host named Vladimir Posner, who spoke with a perfect American accent, was particularly convincing. I also had a subscription to a magazine called *Soviet Life*. I found everything very impressive, so much so that when I was thirteen I went to the Soviet Union on a student exchange. I remember being in Leningrad, sitting in two groups, drinking bottled lemonade and discussing politics with well-versed Soviet students who were intent on convincing us that their system was better than ours. After explaining the capitalist system to us, they invited themselves to visit us in the United States. It was a bit unexpected. When we left the building where the conference was held they threw a dead pigeon out the window at us.

Much the same confusion predominates in the art world, whose idealism wouldn't exist without a basis.

> I thought you said your work includes photography. Why don't you have camera equipment with you? There are many interesting things to photograph in Israel.

**"All works of art are objects and should be treated as such, but these objects are not ends**

**in themselves: They are tools with which to influence spectators."** —Asger Jorn

Topicality creates the expectation that theory and politics can be enforced through art. But art is not propaganda.

Let me give an example of the arbitrary nature of what might be misconstrued as politics. Imagine that you are watching television. And you are following the capture of Saddam Hussein. Not actually following Saddam Hussein, but watching it on television and reading about it on the Internet. You are curious. Incidentally, you notice near the television a book with the title *The Dictatorship of the Viewer*. And you, the "irrational" artist, invert it. Viewer of the Dictatorship. Knowing you exhibit in the art world. And it will be inverted again. Viewer of the Artist viewing the Dictatorship. And you the artist are aware of the implications.

A few years later it finally happens. You cause the media to speak to itself. Nonsense. Feedback. And it tells you what not to do next.

I recognized the journalist. He was from CNN. He had a lot of makeup on. More than I realized one had to wear on television. He was in my exhibition in the institution. He wants to talk about my exhibition. I tell him I want to talk about the show. I mean his show. I tell him I watch his show. But he is talking about my exhibition. I tell him I can talk about the subject of what's in the exhibition but it will take a while. But I would rather talk about the subject of his show. But he wants to talk about journalism. Then I tell him, "So let's talk about your show." But he still wants to talk about my exhibition.

> While preparing for the camera he asked:
> What is the purpose of your work, again?

I had to come clean and explain my intent. The
exhibition is an attempt to collapse all meaning of
the subject. It is about the futility of representa-
tion. To make you think about the subject you see.
About what you already know. To look again in the
real world. Nothing more.

The consequences were productive. I'm
not exactly talking about ethics, but I realized
everything had come full circle. For a moment
I was able to use art to cause distortion in the
media. To occupy space. But I also knew there
was something wrong.

> So where can I see your work? In interna-
> tional media, do you mean like magazines?
> Do you have examples of your work with
> you?

Dictated by new formats, there is amnesia of
how art exists in a particular time and space.
The often archaic processes of the art world
are unable to articulate the practice. Unable to
keep up with cutting and pasting itself into the
present, the Internet is a quick reference tool for
art professionals, giving the illusion that art can
be comprehended without seeing it.

I can talk about "dematerialized" art
because I have seen it in books. But I never
experienced it. Conceptual art was commu-
nicated by means of postcards, faxes, and
magazines before I was born, and I read about it
years after it was made.

The mechanisms and conventions on which
the art system relies are in fact real. There are

institutions, galleries, critics, publications, and so on. A lot of wasted paper and thought goes into the mechanization of cultural production, providing evidence that ideas were exchanged, and often the illusion that they were communicated.

What do you mean? What is the myth of Bauhaus in Tel Aviv about? Why is it a myth?

How can art negotiate its own means of mediation? How does the physical art space relate to the quick dissemination of information? How much of that discourse is nonsense? You can hope that at least the facts of the subject of research are checked.

Not an accusation, but an admittance of operating on the wrong frequency. Which can go nearly undetected. The slight incisions into the cultural fabric are more evidence of what not to do. My temporary conclusion has not been to update information about production. Ignore it and let it reside in a system that generates itself. Let meaning disintegrate until it collapses and can be made into a subject of its own.

To let information operate parallel to art in order to know something about the subject. Something I don't already know.

Where did you study? What did you study?

The art world sometimes seems more like school than school itself. So it's logical that the discussion about education arises. I have basically gone from one institution to another. That is, from art school to institutionalized professional art practice. I have long taken exhibition thematics as serious propositions with potential. And when

the subject is based on a secondary or non-existent notion, I make it into the subject itself. In some cases I have produced work simply to see what happens. Then I determine its function and go from there. When I can't detect what the intent of the exhibition is, it's an opportunity to try something, to experiment.

Have you ever visited a synagogue?

The rituals of participation can be pretty grotesque. They can be worse than school ever was. You don't want to go to the art bar. You want to go to a real bar. You have to go to the same fucking Italian restaurant the second night in a row because one artist is vegetarian, and a bad artist. A slobbering artist can't concentrate anymore on your conversation because an important curator walks in the door of the exhibition. You get introduced to someone you've known for ten years because the person wants them to know that they know you.

More artists stealing the banners, slogans, and balloons from protesters until there is no longer protest. And disciplinarians speak about protest, because art allows them to. And artists do it, because they were told to do it. Another whining artist waiting for a crate with his art to arrive. He opens it and it's another neon. It looks like the neon in the last exhibition but it says something slightly different. Another slogan about non-conformity. He's talking about how he got the idea from Deleuze while eating a cone of pistachio ice cream. Another moron does some "social design" that everyone is forced to sit in. Otherwise you have to stand all night and look at it.

An artist from a country where you went to do a project asks you to give an interview for his magazine. You say sure, but you tell him to first read a text. Where you got the idea to start the project. The text was written by an architect. A theorist. The artist doesn't write back. He publishes the article with the photograph you took to illustrate the text. Uncredited. The same artist goes to the same place you did the project. And does the same thing, in a different way. His version. There's a monument to the country he immigrated to in his own country. So he makes a video of the monument to the country he immigrated to in his own country. It's a better project.

A curator shoving a card in another curator's face interrupts your discussion. Talking about her plans to do an exhibition of Hungarian artists in Turkey. You ask if the title of the show will be Hungary Turkey. You are serious. She thinks you're a lunatic. Why not? Her card is from an American-supported foundation. Because you read it and know who taught her to shove cards in people's faces. And you somehow feel respon- sible, but not really.

You should exploit your background. Scandalize and provoke. Politely.

Recently an art historian proposed that van Gogh did not cut off his own ear, that it was likely the result of a fight with Gauguin, who threw a glass at him. This came from a researcher looking carefully through existing criminal documents. They have been there for more than 100 years, while the fictions have been made.[4]

Where did you meet? How long have you known each other?

But experience goes along with it. There are interesting people in between, so it's worthwhile. Like school. And then you get institutionalized, in art institutions. So you have different responsibilities. You have to talk. A lot. About yourself. And they send you a press package with what they have to say. And you read it because your work is about media and you're curious about what the media writes about your work. "Is interested in this . . ." "Examines that . . ." You read it and you think, what the hell? That's not what you were thinking—at least not what you thought you were thinking. And the facts are all wrong.

Do you have any Jewish relations or has anyone in your family immigrated to Israel?

I'd rather speak Japanese to someone who might understand the second or third time I repeat what I'm saying, than with someone who simply will never understand what the hell I'm talking about with art. But if they are not involved in the art world, I try to explain.

Last year I went through the process of Japanese immigration. Japanese immigration is very strict. There are twenty-seven classifications for visas. I gave them too many documents and they were confused. They were unsure whether I was applying for cultural purposes, humanities, or whatever. It was kind of a surprise when the immigration officer said, "But your last visa was from an institution. It says you are an artist. Can you prove that?" Technically I qualify for permanent residency.[5] I suddenly was reminded I'm an artist.

Say you decide to start a center in Ukraine together with some academics in the university.

There was a Soros center, but now they complain about funding for art, and that's understandable. But when they get it they don't always use it for art. And that's understandable too. You don't want to start another art scene. You just want to do something with what you know because there is no contemporary art, at least as you understand it. There is a new private museum, with animals behind glass. I mean the art. It's part of a shopping mall. It's decadent and amusing. At least people get more interested in art.

Then you talk with someone you know in the art world who is also interested. He is the editor of a magazine. A real magazine you read in art school. He had a similar idea and you realize you might be able to do something together. A lot of people get interested in the idea. Suppose the university has a film archive with more than 5,000 16mm films, and they belong to the center you started. They would have been thrown out if you hadn't organized them and put them on shelves so they can be screened and edited. You know you can't watch them all. You don't want to do an art project with the films. You just want to watch them. And invite other artists to make art projects.

You know that all the formatting problems of the art world you've encountered for years can be solved with one cheap media player that is made in China, which you can get on the market for seventy dollars. It plays everything. You're in Ukraine and there is no formatting, as you know it. You can get new pirated software as soon as it's on the market. The black market, where there's no formatting.

You end up speaking with people about "context" and they don't know what you're talking

about. So you have to explain and explain, and in the process it starts to make sense, maybe not to you, but to them. It sounds convincing, and then maybe you can make some meaning out of that for yourself. So you try and do something with what you have learned—what you always understood as "context." It might fail, but so what?

> How long have you had it? Has it been in your possession all the time?

Back to the art world. I have had interesting discussions with other artists who have also worked with the same subject, and I have spoken with art journalists who don't know the difference between North and South Korea. But the journalists like the idea of North Korea.

I could use North Korea as a sort of metaphor for the art world. Not the politics and horrific conditions that exist in the country. They are real. Not to bring "awareness" to the art world. These things I can't change. I am not delusional. Let me be clear here, not to sound irresponsible. I am referring to the circulation of information. I am thinking of the insularity of the country. This is a metaphor. Or concrete thinking.

For example, you can take someone's statement, de-contextualize and reframe it so that it might sound as if it applies to the Bologna Process:

**It has trained a large number of revolutionary talents in the crucible of the arduous revolutionary struggle, thus successfully playing a pivotal role in carrying out the policy of training native cadres and the policy of intellectualizing all members of the society, and actively conducted**

scientific research, making a great contribution to the development of the nation's science and technology.

But it's not. It's from the other day. Kim Jong-il visiting a new swimming pool at a university.[6] A short anecdote, related to Liam Gillick's research on the experimental factory.[7] I am reminded of an incident that speaks to the fate of all good intentions: in the 1970s, Sweden's Social Democratic government sent a few thousand Volvos to North Korea on the trust of the Swedes. The North Koreans just ripped them off and never paid for the cars. They are still on the streets in Pyongyang.[8] An important consideration here is where the production ends up. Who accumulates the knowledge? Who is producing what for whom? Will you get back what you give?

Once again, my interest is nothing new. When I was a teenager I listened to Radio Pyongyang. It was again the interestingly contorted language. Propaganda. Korean Central Television edits the outside world into a surrealistic and alien spectacle with consistent themes: war, accidents, natural disasters, intimidating technology, worldwide protest, extreme physical activity and endurance, and so on. Appearing once a week towards the end of the news report, following the perfunctory fifteen to twenty minutes of praise for Kim Jong-il and reports on his daily activities, the program is called "News of the World."

Without realizing that you have nearly become a thematically programmed production zombie, you start to listen to yourself repeating yourself. Cynically. You realize this when you are talking to students about how to do the same.

You sound convincing because it's what students expect. Because you have experience. And then you have to catch yourself and tell them what you are thinking. Because that's more useful.

In another city for yet another reason, I ran into Stephan Dillemuth by coincidence, in yet another academy with yet more students. But these students were different. The same fantasy I had in school of the art world. I felt like I was finally back in the real art world. The art world of the *Akademie* that I read about in art school. The illusionary, bohemian, delusional, real art world of art. Where everyone reads faked scripts, wears costumes, and talks incoherently. I have recently found myself wandering around the art supply store looking at paint materials.

At the end of the night I had to leave and go back to the institution. The art institution.

Anyway, here is where I would start to identify the short circuit. I often found that the notion of "context" doesn't necessarily translate. The further off and more "peripheral" the places I exhibited, the less knowledge there was about "context." But I could still discuss the subject of the research. And then I might attempt to explain "context" and its considerations.

Or maybe it's simply a disorder. I am, in fact, a savant. I have Asperger's syndrome. And I can remember a lot of information. I can archive. And it can be a fucking intricate mess. And I can present it as art.

Not that the subject of archiving is not interesting. I just can't read another concept based on another concept for yet another exhibition about archiving. It gives me a headache. And the idea of more curators archiving concepts of other curators archiving artists to archive the

notion of the archive is annoying. So is the idea of more and more artists digging through more and more archives as another pretext for another exhibition.

To try and understand what the hell I am doing I look at Walter Benjamin. Not in his archive, but in a book. By someone who researched his archive, and edited it. His list of seemingly meaningless pictures and notes is justification. The mistakes, what is crossed out, misspellings, diagrams, notes in the margin. Constant revisions. Editing. Something more idiotic than the last thing I have archived for whatever reason.

**"The knowledge of truth does not exist. For truth is the death of invention."** —Walter Benjamin

Architecture is not politics. A photograph of a building is not politics, but it can generate readings. I have never attempted to make political art. I have made art informed by politics in terms of the narratives and visual surfaces, that ideology produces. I have never inferred the notion of truth. In fact, I have worked with distortion, played with presentation implying truth. I passed through a matrix of contradictory forms that imitate authority, and alluded to the problems and failures of representation.

Artistic experimentation, whether presented as research or not, precludes an outcome—a conclusion or a statement. It is entirely reliant on the dismantling and framing of a given subject matter.

This situation of self-correction reminded me of the regime I was once seduced by. I caught myself going all the way back to when I was about sixteen. On the premise of producing an

art project, I bought the issues of *Soviet Life* that I had received with my subscription at that time. When the magazines arrived, I realized I actually just wanted to re-read them to see what I could remember. One article in particular has an interesting series of images. They contradict the current situation in Byelorussia. It is even optimistic in a twisted way. And I remember the photo from when I was sixteen years old.

Concrete thinking makes me consider the art world though metaphors in order to make it seem rational so I don't have to spend all my time in the institution. I mean the art institution. So I can exist in the real world. I learned in school that you can always walk out of class when you don't like it.

So is it your main profession? Who sells your artwork? Who buys your artwork?

There is not one instance in which I have been turned away from approaching another discipline for source material. Occasionally I have been altogether stopped, and probably for good reason. Yes, much of the language of "context" remains largely untranslatable for a broader society (depending on where you are), but people do know what art is. First there is skepticism, as most people have preconceptions. Followed by explanation. At the end, when they see what you have done with what they entrusted you with, it often comes as a surprise. The result informs their discipline. In these cases it is successful. But that's the point where it's often useless in the art context.

What is repeatedly forgotten in discussions about research-based art practice is that

it cannot simply be reduced to research. To do so is to forget what art can do and what research can't. Art makes the form the site of knowledge. Without rejecting the content. It is art itself that delineates its own borders.

Here again, I see possibilities for the notion of hijacking art. If you can convince someone that art is intangible, it can act as a stand-in for something else. And then maybe you can get something done with it, inside or outside any discipline if that is in fact what you want.

I first learned this a few years ago from two El Al interrogators and a curator. Who works in an institution. An art institution. One of the interrogators was skeptical about whether I was an artist when he called the curator on the telephone. The curator later told me that the interrogator was also a cartoonist.

1   "I am particularly interested in how issues concerning the actual situations and meanings of art, artistic practice, and art production relate to questions touching on the particular kind of *knowledge* that can be produced within the artistic realm (or the artistic *field*, as Pierre Bourdieu prefers it) by the practitioners or actors who operate in its various places and spaces. The multifarious combinations of artists, teachers, students, critics, curators, editors, educators, funders, policymakers, technicians, historians, dealers, auctioneers, caterers, gallery assistants, and so on, embody specific skills and competences, highly unique ways and styles of knowing and operating in the flexibilized, networked sphere of production and consumption. This variety and diversity has to be taken into account in order for these epistemes to be *recognized* as such and to obtain at least a slim notion of what is at stake when one speaks of *knowledge* in relation to art—an idea that is, in the best of cases, more nuanced and differentiated than the usual accounts of this relation." Tom Holert, "Art in the Knowledge-based Polis," *e-flux journal*, #3 (February 2009), http://www.e-flux.com/journal/view/40.

2   "And so the art world became the site of extensive talking—talking emerged as a practice, as a mode of gathering, as a way of getting access to some knowledge and to some questions, as networking and organizing and articulating some necessary questions. But did we put any value on what was actually being said? Or, did we privilege the coming-together of people in space and trust that formats and substances would emerge from these?" Irit Rogoff, "Turning," *e-flux journal*, #0 (November 2008), http://www.e-flux.com/journal/view/18.

3   See "Deadly plane crash at Tokyo airport," CNN.com, March 23, 2009, http://www.cnn.com/2009/WORLD/asiapcf/03/22/japan.planecrash.

4   See Bärbel Küster, "Wir müssen einen Schnitt machen," *Süddeutsche Zeitung*, February 24, 2009, http://www.sueddeutsche.de/

kultur/833/459475/text/.

5 See "Guidelines for Contribution to Japan," Immigration Bureau of Japan, http://www.immi-moj.go.jp/english/tetuduki/zairyuu/contribution.pdf.

6 See "Kim Jong Il Provides On-the-Spot Guidance to Newly Built Swimming Complex at Kim Il Sung University," Korea News Services, March 19, 2009, http://www.kcna.co.jp/item/2009/200903/news19/20090319-12ee.html.

7 Liam Gillick, "Maybe it would be better if we worked in groups of three? Part Two: The Experimental Factory," *e-flux journal*, #3 (February 2009), http://e-flux.com/journal/view/41.

8 See Volvo Car Corporation, "75 Years of Volvo Taxis," press release, March 11, 2005, http://www.volvocars.com/intl/corporation/NewsEvents/News/Pages/default.aspx?item=58.

Sean Snyder **Disobedience in Byelorussia:**
**Self-Interrogation on "Research-Based Art"**

Tom Holert

# Art in the Knowledge-Based Polis

Lately, the concept of "knowledge production" has drawn new attention and prompted strong criticism within art discourse. One reason for the current conflictual status of this concept is the way it can be linked to the ideologies and practices of neoliberal educational policies. In an open letter entitled "To the Knowledge Producers," a student from the Academy of Fine Arts Vienna eloquently criticizes the way education and knowledge are being "commodified, industrialized, economized, and being made subject to free trade."[1]

In a similar fashion, critic Simon Sheikh addresses the issue by stating that "the notion of knowledge production implies a certain placement of thinking, of ideas, within the present knowledge economy, i.e. the dematerialized production of current post-Fordist capitalism"; the repercussions of such a placement within art and art education can be described as an increase in "standardization," "measurability," and "the molding of artistic work into the formats of learning and research."[2] Objections of this kind become even more pertinent when one considers the suggestive rhetoric of the major European art educational network ELIA (European League of Institutes of the Arts), which, in a strategy paper published in May 2008, linked "artistic research" to the EU policy of the generation of "'New Knowledge' in a Creative Europe."[3]

I am particularly interested in how issues concerning the actual situations and meanings of art, artistic practice, and art production relate to questions touching on the particular kind of knowledge that can be produced within the artistic realm (or the artistic "field," as Pierre Bourdieu prefers it) by the practitioners or actors

who operate in its various places and spaces. The multifarious combinations of artists, teachers, students, critics, curators, editors, educators, funders, policymakers, technicians, historians, dealers, auctioneers, caterers, gallery assistants, and so on, embody specific skills and competences, highly unique ways and styles of knowing and operating in the flexibilized, networked sphere of production and consumption. This variety and diversity has to be taken into account in order for these epistemes to be recognized as such and to obtain at least a slim notion of what is at stake when one speaks of knowledge in relation to art—an idea that is, in the best of cases, more nuanced and differentiated than the usual accounts of this relation.

"Far from preventing knowledge, power produces it," Foucault famously wrote.[4] Being based on knowledge, truth claims, and belief systems, power likewise deploys knowledge—it exerts power through knowledge, reproducing it and shaping it in accordance with its anonymous and distributed intentions. This is what articulates the conditions of its scope and depth. Foucault understood power and knowledge to be interdependent, naming this mutual inherence "power-knowledge." Power not only supports, but also applies or exploits knowledge. There is no power relation without the constitution of a field of knowledge, and no knowledge that does not presuppose power relations. These relations therefore cannot be analyzed from the standpoint of a knowing subject. Subjects and objects of knowledge, as well as the modes of acquiring and distributing knowledge, are effects of the fundamental, deeply imbricated power/knowledge complex and its historical transformations.

1      The Hornsey Revolution

On May 28, 1968, students occupied
Hornsey College of Art in the inner-suburban
area of North London. The occupation originated
in a dispute over control of the Student Union
funds. However, "a planned programme of films
and speakers expanded into a critique of all
aspects of art education, the social role of art
and the politics of design. It led to six weeks of
intense debate, the production of more than
seventy documents, a short-lived Movement for
Rethinking Art and Design Education (MORADE),
a three-day conference at the Roundhouse in
Camden Town, an exhibition at the Institute of
Contemporary Arts, prolonged confrontation with
the local authority, and extensive representa-
tions to the Parliamentary Select Committee on
Student Relations."[5]

Art historian Lisa Tickner, who studied at
Hornsey College of Art until 1967, has published
a detailed account of these events and discus-
sions forty years after the fact. As early as 1969,
however (only a few months after the occupation
of Hornsey College of Art had been brought to an
end by pressure from the above-mentioned local
authority in July 1968), Penguin released a book
on what had already gained fame as "The Hornsey
Affair," edited by students and staff of the college.
This paperback is a most interesting collection of
writings and visuals produced during the weeks
of occupation and sit-ins, discussions, lectures,
and screenings. The book documents the traces
and signs of a rare kind of enthusiasm within
an art-educational environment that was not
considered at the time to be the most prestigious
in England. Located just below Highgate, it was
described by one of the participants as being

"squeezed into crumbling old schools and tottering sheds miles apart, making due with a society's cast-offs like a colony of refugees."[6] One lecturer even called it "a collection of public lavatories spread over North London."[7]

But this modernist nightmare of a school became the physical context of one of the most radical confrontations and revolutions of the existing system of art education to take place in the wake of the events of May '68. Not only did dissenting students and staff gather to discuss new terms and models of a networked, self-empowering, and politically relevant education within the arts, the events and their media coverage also drew to Hornsey prominent members of the increasingly global alternative-utopian scene, such as Buckminster Fuller.

However, not only large-scale events were remembered. One student wrote of the smaller meetings and self-organized seminars:

> It was in the small seminars of not more than twenty people that ideas could be thrashed out. Each person felt personally involved in the dialogue and felt the responsibility to respond vociferously to anything that was said. These discussions often went on to the small hours of the morning. If only such a situation were possible under "normal" conditions. Never had people en masse participated so fully before. Never before had such energy been created within the college. People's faces were alight with excitement, as they talked more than they had ever talked before. At least we had found something which was real to all of us. We were not, after all, the complacent receivers of

an inadequate educational system. We were actively concerned about our education and we wanted to participate.[8]

From today's standpoint, the discovery of talking as a medium of agency, exchange, and self-empowerment within an art school or the art world no longer seems to be a big deal, though it is still far from being conventional practice. I believe that the simple-sounding discovery of talking as a medium within the context of a larger, historical event such as the "Hornsey Affair" constitutes one of those underrated moments of knowledge production in the arts—one that I would like to shift towards the center of a manner of attention that may be (but should not necessarily be) labeled as "research." With a twist of this otherwise over-determined term, I am seeking to tentatively address a mode of understanding and rendering the institutional, social, epistemological, and political contexts and conditions of knowledge being generated and disseminated within the arts and beyond.

The participants in the Hornsey revolution of forty years ago had very strong ideas about what it meant to be an artist or an art student, about what was actually at stake in being called a designer or a painter. They were convinced that knowledge and knowledge communication within art education contained enormous flaws that had to be swept away:

Only such sweeping reforms can solve the problems ... In Hornsey language, this was described as the replacement of the old "linear" (specialized) structure by a new "network" (open, non-specialized) structure

... It would give the kind of flexible train-
ing in generalized, basic creative design
that is needed to adapt to rapidly changing
circumstances—be a *real* training for work,
in fact ... the qualities needed for such a real
training are no different from the ideal ones
required to produce maximal individual devel-
opment. In art and design, the choice between
good workmen and geniuses is spurious. Any
system worthy of being called "education,"
any system worthy of the emerging new world,
must be both at once. It must produce people
whose work or 'vocation' is the creative,
general transformation of the environment.[9]

To achieve this "worthy" system, it was consid-
ered necessary to do away with the "disastrous
consequence" of the "split between practice and
theory, between intellect and the non-intellectual
sources of creativity."[10] Process held sway over
output, and open-endedness and free organiza-
tion of education permeated every aspect of the
Hornsey debates.[11] It was also clear that one of
the most important trends of the mid-1960s was
the increasing interaction and interpenetration of
creative disciplines. "Art and Design," the Hornsey
documents argued, "have become more unified,
and moved towards the idea of total architecture
of sensory experience"; England underwent "a
total revolution of sensibility."[12]

    The consequences of the intersecting
developments within the rebelling body of
students and staff at Hornsey (and elsewhere),
as well as the general changes within society
and culture, had to become manifest in the very
conceptual framework not only of art educa-
tion, but of art discourse as such. Hence, there

was a widespread recognition that in the future all higher education in art and design should incorporate a permanent debate within itself. "Research," in this sense, became an indispensable element in education:

> We regard it as absolutely basic that research should be an organic part of art and design education. No system devoted to the fostering of creativity can function properly unless original work and thought are constantly going on within it, unless it remains on an opening frontier of development. As well as being a general problem in art and design (techniques, aesthetics, history, etc.), such research activity must also deal with the *educational process itself* . . . It must be the critical self-consciousness of the system, continuing permanently the work started here in the last weeks [June, July 1968]. Nothing condemns the old regime more radically than the minor, precarious part research played in it. It is intolerable that research should be seen as a luxury, or a rare privilege.[13]

Though this emphatic plea for "research" was written in a historical situation apparently much different than our own, it nonetheless helps us to apprehend our present situation. Many of the terms and categories have become increasingly prominent in the current debates on artistic research, albeit with widely differing intentions and agendas. It seems to be of the utmost importance to understand the genealogy of conflicts and commitments that have led to contemporary debates on art, knowledge, and science.

## 2  An Art Department as a Site of Research in a University System

Becoming institutionalized as an academic discipline at the interface of artistic and scientific practices in an increasing number of art universities throughout Europe, artistic research (sometimes synonymous with notions such as "practice-led research," "practice-based research," or "practice-as-research") has various histories, some being rather short, others spanning centuries. The reasons for establishing programs and departments fostering the practice-research nexus are certainly manifold, and differ from one institutional setting to the next. When art schools are explicitly displaced into the university system to become sites of research, the demands and expectations of the scientific community and institutional sponsorship, vis-à-vis the research outcomes of art schools, change accordingly.

Entitled "Development and Research of the Arts," a new program of the Austrian funding body FWF aims at generating the conceptual and material environment for interdisciplinary art-related research within, between, and beyond art universities. Thus far, however, the conceptual parameters of the FWF appear to be the subject of debate and potential revision and extension. One should be particularly careful of any hasty grafting of a conventional image of a "scientific" model or mode of research (whatever it may be) onto the institutional context of an art academy. This is not only a matter of epistemological concern, but of education policies and of political debate as well.

One only has to look at the history of the implementation of practice-led research in Art

and Design in Great Britain. In 1992 the Research Assessment Exercise (RAE) of the Higher Education Founding Council for England (HEFCE) began to formulate criteria for so-called practice-based/practice-led research, particularly in the field of performance, design, and media. By 1996 the RAE had reached a point where it defined research as:

> original investigation undertaken in order to gain knowledge and understanding. It includes work of direct relevance to the needs of commerce and industry, as well as to the public and voluntary sectors; scholarship; the invention and generation of ideas, images, performances and artifacts including design, where these lead to new or substantially improved insights; and the use of existing knowledge in experimental development to produce new or substantially improved materials, devices, products and processes, including design and construction.[14]

The visual or fine arts of that time had yet to be included in this structure of validation, though in the following years various PhD programs in the UK and elsewhere did try to shift them to an output-oriented system of assessment close to those already established for design, media, and performance arts. "New or substantially improved insights" as well as "substantially improved materials, devices, products and processes" are the desired outcomes of research, and the Research Assessment Exercise could not be more explicit about the compulsory "direct relevance to the needs of commerce and industry."

PARIP (Practice as Research in Performance)

Tom Holert **Art in the Knowledge-based Polis**

is a research group that supervises, assesses, and discusses the ongoing research in the new art and design environment initiated by the RAE and other organizations concerned with higher arts education in the UK. A 2002 report by Angela Piccini repeatedly focuses on the relation between research and (artistic) practice, and on the subjects and subjectivities, competencies, and knowledges produced and required by this development. After having interviewed various groups of researchers and students from the field of performance arts and studies, it became clear that both concepts assume specific meanings and functions demanded by the configuration of their new settings. One of the groups Piccini interviewed pondered the consequences of the institutional speech act that transforms an *artistic practice* into an *artistic practice-as-research*:

> Making the decision that something is practice as research imposes on the practitioner-researcher a set of protocols that fall into: 1) the point that the practitioner-researcher must necessarily have a set of separable, demonstrable, research findings that are abstractable, not simply locked into the experience of performing it; and 2) it has to be such an abstract, which is supplied with the piece of practice, which would set out the originality of the piece, set it in an appropriate context, and make it useful to the wider research community.[15]

It was further argued that "such protocols are not fixed," that "they are institutionalized (therefore subject to critique and revision) and the practitioner-researcher communities must recognize

that." The report also expressed concern about "excluded practices, those that are not framed as research and are not addressing current academic trends and fashion," and it asked, "what about practices that are dealing with cultures not represented within the academy?"[16]

When articulated in terms of such a regime of academic supervision, evaluation, and control (as it increasingly operates in the Euroscapes of art education), the reciprocal inflection of the terms "practice" and "research" appears rather obvious, though they are seldom explicated. The urge among institutions of art and design education to rush the process of laying down validating and legitimating criteria to purportedly render intelligible the quality of art and design's "new knowledge" results in sometimes bizarre and ahistorical variations on the semantics of practice and research, knowledge and knowledge production.

For applications and project proposals to be steered through university research committees, they have to be upgraded and shaped in such a way that their claims to the originality of knowledge (and thus their academic legitimacy) become transparent, accountable, and justified. However, to "establish a workable consensus about the value and limits of practice as research both within and beyond the community of those directly involved" seems to be an almost irresolvable task.[17] At the least, it *ought to* be a task that continues to be open-ended and inevitably unresolved.

The problem is, once you enter the academic power-knowledge system of accountability checks and evaluative supervision, you have either explicitly or implicitly accepted the

parameters of this system. Though acceptance does not necessarily imply submission or surrender to these parameters, a fundamental acknowledgment of the ideological principles inscribed in them remains a prerequisite for any form of access, even if one copes with them, contests them, negotiates them, and revises them. Admittedly, it is somewhat contradictory to claim a critical stance with regard to the transformation of art education through an artistic research paradigm while simultaneously operating at the heart of that same system. I do not have a solution for this. Nonetheless, I venture that addressing the power relations that inform and produce the kind of institutional legitimacy/consecration sought by such research endeavors could go beyond mere lip service and be effective in changing the situation.

3    Art in the Knowledge-Based Polis
I would like to propose, with the support and drive of a group of colleagues working inside and outside the Academy of Fine Arts Vienna, a research project bearing the title "Art in the Knowledge-based Polis." The conceptual launch pad for this project is a far-reaching question about how art might be comprehended and described as a specific mode of generating and disseminating knowledge. How might it be possible to understand the very genealogy of significant changes that have taken place in the status, function, and articulation of the visual arts within contemporary globalizing societies?

With reference to the work of French sociologist Luc Boltanski, the term "polis" has been chosen deliberately to render the deep imbrications of both the material (urbanist-

spatial, architectural, infrastructural, etc.) and immaterial (cognitive, psychic, social, aesthetic, cultural, legal, ethical, etc.) dimensions of urbanity.[18] Moreover, the knowledge-based polis is a conflictual space of political contestation concerning the allocation, availability, and exploitation of "knowledge" and "human capital."

As a consequence, it is also a matter of investigating how the "knowledge spaces" within the visual arts and between the protagonists of the artistic field are organized and designed.[19] What are the modes of exchange and encounter, and what kind of communicative and thinking "styles" guide the flow of what kind of knowledge? How are artistic archives of the present and the recent past configured (technologically, cognitively, socially)? In what ways has artistic production (in terms of the deployment and feeding of distributed knowledge networks in the age of "relational aesthetics") changed, and what are the critical effects of such changes on the principle of individualized authorship?[20]

The implications of this proposal are manifold, and they are certainly open to contestation. What, for instance, is the qualifier enabling it to neatly distinguish between artistic and non-artistic modes of knowledge production? Most likely, there isn't one. From (neo-)avant-garde claims of bridging the gap between art and life (or those modernist claims that insist on the very maintenance of this gap) to issues of academic discipline in the age of the Bologna process and outcome-based education, it seems that the problem of the art/non-art dichotomy has been displaced. Today, this dichotomy seems largely to have devolved into a question of how to establish a discursive field capable of rendering an

epistemological and ontological realm of artistic/ studio practice as a scientifically valid research endeavor.

As art historian James Elkins puts it, concepts concerning the programmatic generation of "new knowledge" or "research" may indeed be "too diffuse and too distant from art practice to be much use."[21] Elkins may have a point here. His skepticism regarding the practice-based research paradigm in the fine arts derives from how institutions (i.e. university and funding bodies) measure research and PhD programs' discursive value according to standards of scientific, disciplinary research. For Elkins, "words like research and knowledge should be confined to administrative documents, and kept out of serious literature."[22] In a manner most likely informed by science and technology studies and Bruno Latour, he argues instead that the focus should turn toward the "specificity of charcoal, digital video, the cluttered look of studio classrooms (so different from science labs, and yet so similar), the intricacies of Photoshop ... the chaos of the foundry, the heat of under-ventilated computer labs."[23] I think this point is well taken.

However useless the deployment of terms such as "research" and "knowledge" may seem, such uselessness is bound to a reading and deployment of the terms in a way that remains detached from the particular modes of discourse formation in art discourse itself. The moment one enters the archives of writing, criticism, interviews, syllabi, and other discursive articulations produced and distributed within the artistic field, the use of terms such as "research" and discussion about the politics and production of "knowledge" are revealed as fundamental to

twentieth-century art—particularly since the inception of Conceptual art in the late 1960s. After all, modernists and neo- or post-avant-gardists aimed repeatedly at forms and protocols relating to academic and intellectual work—of research and publication, the iconography of the laboratory, scientific research, or think tanks. Administrative, information, or service aesthetics, introduced at various moments of modernist and postmodernist art, emulated, mimicked, caricaturized, and endorsed the aesthetics and rhetoric of scientific communities. They created representations and methodologies for intellectual labor on and off display, and founded migrating and flexible archives that aimed to transform the knowledge spaces of galleries and museums according to what were often feminist agendas.

Within the art world today, the discursive formats of the extended library-cum-seminar-cum-workshop-cum-symposium-cum-exhibition have become preeminent modes of address and forms of knowledge production. In a recent article in this journal on "the educational turn in curating," theorist Irit Rogoff addresses the various "slippages that currently exist between notions of 'knowledge production,' 'research,' 'education,' 'open-ended production,' and 'self-organized pedagogies,'" particularly as "each of these approaches seems to have converged into a set of parameters for some renewed facet of production." Rogoff continues, "Although quite different in their genesis, methodology, and protocols, it appears that some perceived proximity to 'knowledge economies' has rendered all of these terms part and parcel of a certain liberalizing shift within the world of contemporary art practices." However, Rogoff is afraid that "these initiatives

are in danger of being cut off from their original impetus and threaten to harden into a recognizable 'style.'" As the art world "became the site of extensive talking," which entailed certain new modes of gathering and increased access to knowledge, Rogoff rightly wonders whether "we put any value on what was actually being said."[24]

Thus, if James Elkins is questioning the possibility of shaping studio-based research and knowledge production into something that might receive "interest on the part of the wider university" and be acknowledged as a "position— and, finally, a discipline—that speaks to existing concerns,"[25] Rogoff seems to be far more interested in how alternative practices of communality and knowledge generation/distribution might provide an empowering capacity.

## 4 Artistic Knowledge and Knowledge-Based Economies

Since the neo-avant-gardes of the 1960s (at the latest), knowledge generation within the visual arts has expanded through the constitutive dissolution (or suspension) of its subjects and media. Meanwhile, however, its specific aesthetic dimension has continued to be marked by elusiveness and unavailability—by doing things, "of which we don't know what they are" (Adorno).[26] A guiding hypothesis of the "Art in the Knowledge-Based Polis" conceit is that this peculiar relationship between the availability and unavailability of artistic knowledge production assigns a central task to contemporary cultural theory, as such. This not only concerns issues of aesthetics and epistemology, but also their relation to other (allegedly non-artistic) spaces of knowledge production.

To advance this line of reasoning, the various reconfigurations of knowledge, its social function, and its distribution (reflected within late modernist and postmodernist episte-mological discourses) have to be considered. From the invocation of the post-industrial information society[27] to the critique of modernist "metanarratives"[28] and the theorization of new epistemological paradigms such as reflexivity, transdisciplinarity, and heterogeneity,[29] the struc-ture, status, and shape of knowledge has changed significantly. Amongst other consequences, this has given rise to a number of specific innovative policies concerning knowledge (and its produc-tion) on national and transnational levels.[30]

A point of tension that can become produc-tive here is the traditional claim that artists almost constitutively work on the hind side of rationalist, explicated knowledge—in the realms of non-knowledge (or emergent knowledge). As a response to the prohibition and marginalization of certain other knowledges by the powers that be, the apparent incompatibility of non-knowl-edge with values and maxims of knowledge-based economies (efficiency, innovation, and transferability) may provide strategies for escap-ing such dominant regimes.

Michel Foucault's epistemology offers a hardly noticed reasoning on artistic knowledge that appears to contradict this emphasis on non-knowledge, while simultaneously providing a methodological answer to the conundrum. In his 1969 *L'Archéologie du savoir* (The Archaeology of Knowledge), Foucault argues that the techni-cal, material, formal, and conceptual decisions in painting are traversed by a "positivity of knowledge," which could be "named, uttered, and

conceptualized" in a "discursive practice."[31] This very "positivity of knowledge" (of the individual artwork, a specific artistic practice, or a mode of publication, communication, and display) should not be confused with a rationalist transparency of knowledge. This "discursive practice" might even refuse any such discursivity. Nonetheless, the works and practices do show a "positivity of knowledge"—the signature of a specific (and probably secret) knowledge.

At the heart of "Art in the Knowledge-Based Polis" would be a recognition, description, and analysis of such "positivity"—as much as an exploration of the epistemological conditions in which such positivity appears. Just as the forms and discourses through which artists inform, equip, frame, and communicate their production have become manifold and dispersed, so has a new and continuously expanding field of research opened up as a result.

In many ways, the recent history of methodologies and modes of articulation in the visual arts is seen to be co-evolutionary with developments in the complex transition from an industrial to a postindustrial (or in terms of regulation theory: from a Fordist to a post-Fordist) regime. However, the relationship between art and society cannot be grasped in terms of a one-sided, sociological-type causality. Rather, the relationship must be seen as highly reciprocal and interdependent. Hence it is possible to claim that in those societies for which "knowledge" has been aligned with "property" and "labor" as a "steering mechanism," the visual arts dwell in an isolated position.[32] The pertinent notion of "immaterial labor" that originated in the vocabulary of *post-operaismo* (where it is supposed to

embrace the entire field of "knowledge, informa-
tion, communications, relations or even affects")
has become one of the most important sources of
social and economic value production.[33] Hence,
it is crucial for the visual arts and their various
(producing, communicating, educating, etc.)
actors to fit themselves into this reality, or oppose
the very logic and constraints of its "cognitive
capitalism."[34]

Amongst such approaches is an informal,
ephemeral, and implicit "practical wisdom"
that informs individual and collective habits,
attitudes, and dialects. Moreover, the influence
of feminist, queer, subaltern, and postcolonial
epistemologies and "situated knowledges" is of
great importance in relation to the visual arts.[35]
Thus, for the purposes of inquiring into "Art in
the Knowledge-Based Polis," the array of artistic
articulations (both discursive and those deemed
non-discursive) will be conceived as reaching
far beyond common art/science and theory/
practice dichotomies, while a careful analysis
of the marks left on artistic epistemologies will
be pursued throughout.

The relocation and re-contextualization of
the knowledge issue create room-for-play that
is absent in traditional research designs. The
socio-spatial dimension of knowledge production
within the visual arts should constitute another
essential interest. Urban spaces are under-
stood today as infrastructures of networked,
digital architectures of knowledge as much as
material, built environments. The contemporary
knowledge-based city is structured and managed
by information technology and databases, and
the new technologies of power and modes of
governance they engender (from surveillance

strategies to intellectual property regulations to the legal control of network access) demand an adapted set of methodologies and critical approaches. Much of the work to be done might deploy updated versions of regime analysis and Foucauldian governmentality studies (which would by no means exclude other approaches). This urban "network society" displays features of a complex "politics of knowledge" that cannot be limited to stately and corporate management of biotechnological knowledge, because it is also actively involved in sponsoring the so-called creative industries, universities, museums, etc.[36] By this token, it also becomes important to investigate and explore the social, political, and economic shares held by the visual arts in the knowledge-based polis.

What is needed is a multifocal, multidisciplinary perspective with a fresh look at the interactions and constitutive relations between knowledge and the visual arts. The specific, historically informed relations between artistic and scientific methodologies (their epistemologies, knowledge claims, and legitimating discourses) should play a major role. However, as deliberately distinguished from comparable research programs, research will be guided onto an expanded epistemic terrain on which "scientific" knowledge is no longer a privileged reference. Internal exchanges and communications between the social/cultural worlds of the visual arts and their transdisciplinary relationalities will be structured and shaped by those very forms of knowledge whose legitimacy and visibility are the subject of highly contested epistemological struggles.

An adequate research methodology has to be developed in order to allow the researchers' positions to operate on multiple social-material time-spaces of actual making and doing—positions that permit and actually encourage active involvement in the artistic processes in the stages of production *before* publication, exhibition, and critical reception. I would suggest that notions of "research" motivated by a sense of political urgency and upheaval are of great importance here. As can be seen in what took place at Hornsey in 1968, positions that are criticized (and desired) as an economic and systemic privilege should be contested as well as (re)claimed. Otherwise, I am afraid that the implementation of practice-based research programs and PhDs in art universities will turn out to be just another bureaucratic maneuver to stabilize hegemonic power/knowledge constellations, disavowing the very potentialities and histories at the heart of notions of "practice" and "research."

*This essay is a revised and abridged version of a talk given at the conference "Art/Knowledge. Between Epistemology and Production Aesthetics" at the Academy of Fine Arts Vienna, November 11, 2008.*

1    R0370126@student.akbild.ac.at, "To the Knowledge Producers," in *Intersections. At the Crossroads of the Production of Knowledge, Precarity, Subjugation and the Reconstruction of History, Display and De-Linking*, ed. Lina Dokuzović, Eduard Freudmann, Peter Haselmayer, and Lisbeth Kovačič (Vienna: Löcker, 2008), 27.

2    Simon Sheikh, "Talk Value: Cultural Industry and Knowledge Economy," in *On Knowledge Production: A Critical Reader in Contemporary Art*, ed. Maria Hlavajova, Jill Winder, and Binna Choi (Utrecht: BAK, basis voor actuele kunst; Frankfurt am Main: Revolver, Archiv für aktuelle Kunst, 2008), 196-7.

3    Chris Wainwright, "The Importance of Artistic Research and its Contribution to 'New Knowledge' in a Creative Europe," European League of Institutes of the Arts Strategy Paper (May 2008), http://www.elia-artschools.org/publications/position/research.xml.

4    Michel Foucault, *Discipline and Punish: The Birth of the Prison*, trans. Alan Sheridan (New York: Vintage, [1975] 1995).

5    Lisa Tickner, *Hornsey 1968: The Art School Revolution* (London: Frances Lincoln, 2008), 13-14.

6    T.N., "Notes Towards the Definition of Anti-Culture," in *The Hornsey Affair*, ed. students and staff of Hornsey College of Art (Harmondsworth, London: Penguin, 1969), 15.

7     Ibid., 29.
8     Ibid., 38-7.
9     Ibid., 116-7.
10    Ibid. [Document 46], 118.
11    See ibid., [Document 46], 122.
12    Ibid., [Document 46], 124.
13    Ibid., [Document 46], 128-129.
14    Angela Piccini, "An Historiographic Perspective on Practice as Research,"
      PARIP (Practice as Research in Performance), http://www.bristol.ac.uk/
      parip/t_ap.htm.
15    Ibid.
16    Ibid.
17    See Anna Pakes, "Original Embodied Knowledge: The Epistemology of the
      New in Dance Practice as Research," *Research in Dance Education* 4, no. 2
      (December 2003): 144.
18    See Luc Boltanski and Laurent Thévenot, *De la justification. Les économies
      de la grandeur* (Paris: Gallimard, 1991); Luc Boltanski and Ève Chiapello, *Le
      nouvel esprit du capitalisme* (Paris: Gallimard, 1999).
19    See *Räume des Wissens: Repräsentation, Codierung, Spur,* ed. Hans-Jörg
      Rheinberger, Michael Hagner, and Bettina Wahrig-Schmidt (Berlin:
      Akademie Verlag, 1997).
20    See Caroline A. Jones, "The Server/User Mode: the Art of Olafur Eliasson,"
      *Artforum International* 46, no. 2 (October 2007): 316-324, 396, 402.
21    James Elkins, "Afterword: On Beyond Research and New Knowledge," in
      *Thinking Through Art: Reflections on Art as Research,* ed. Katy Macleod and
      Lin Holdridge (London/New York: Routledge, 2006), 243.
22    Ibid., 247.
23    Ibid., 246.
24    Irit Rogoff, "Turning," *e-flux journal*, no. 0 (November 2008),
      http://www.e-flux.com/journal/view/18.
25    Elkins, "Afterword," 244.
26    Theodor W. Adorno, "Vers une musique informelle," in *Gesammelte
      Schriften*, vol. 16, (Frankfurt/Main: Suhrkamp, 1978), 493-540.
27    See Daniel Bell, *The Coming of Post-Industrial Society* (New York: Harper &
      Row, 1973).
28    See Jean-François Lyotard, *La condition postmoderne: rapport sur le savoir*
      (Paris: Minuit, 1979).
29    See Michael Gibbons et al., *The New Production of Knowledge: The
      Dynamics of Science and Research in Contemporary Societies* (London:
      Sage, 1994).
30    See Organisation for Economic Co-Operation and Development, *The
      Knowledge-Based Economy* (Paris: Organisation for Economic Co-Operation
      and Development, 1996); "Putting Knowledge Into Practice: a Broad-Based
      Innovation Strategy for the EU," communication from the Commission to
      the Council, the European Parliament, the European Economic and Social
      Committee, and the Committee of the Regions (September 9, 2006), http://
      ec.europa.eu/enterprise/innovation/index_en.htm.
31    Michel Foucault, *L'Archéologie du savoir* (Paris: Gallimard, 1969).
32    Nico Stehr, *Wissenspolitik: Die Überwachung des Wissens* (Frankfurt/Main:
      Suhrkamp, 2003), 30.
33    Antonio Negri and Michael Hardt, *Multitude: War and Democracy in the Age
      of Empire* (New York: Penguin, 2004), 126.
34    Yann Moulier-Boutang, *Le capitalisme cognitif: La Nouvelle Grande
      Transformation* (Paris: Éditions Amsterdam, 2007).
35    See Donna Haraway, "Situated Knowledges: The Science Question in
      Feminism and the Privilege of Partial Perspective," *Feminist Studies* 14,
      no. 3 (Autumn 1988): 575-599.
36    See Stehr, *Wissenspolitik.*

Irit Rogoff
# Turning

We have recently heard much about the "educational turn in curating" among several other "educational turns" affecting cultural practices around us.[1] Having participated in several of the projects emerging from this perceived "turn," it seems pertinent to ask whether this umbrella is actually descriptive of the drives that have propelled this desired transition.[2]

My questions here firstly concern what constitutes a "turn" to begin with? Are we talking about a "reading strategy" or an interpretative model, as was the understanding of the "linguistic turn" in the 1970s, with its intimations of an underlying structure that could be read across numerous cultural practices and utterances? Are we talking about reading one system—a pedagogical one—across another system—one of display, exhibition, and manifestation—so that they nudge one another in ways that might open them up to other ways of being? Or, are we talking instead about an active movement—a generative moment in which a new horizon emerges in the process—leaving behind the practice that was its originating point?

Secondly, it seems pertinent to ask to what extent the hardening of a "turn" into a series of generic or stylistic tropes can be seen as capable of resolving the urgencies that underwrote it in the first place? In other words, does an "educational turn in curating" address education or curating at precisely the points at which it urgently needs to be shaken up and made uncomfortable?

Delving into these questions is made more difficult by the degree of slippage that currently takes place between notions of "knowledge

production," "research," "education," "open-ended production," and "self-organized pedago-gies," when all these approaches seem to have converged into a set of parameters for some renewed facet of production.[3] Although quite different in their genesis, methodology, and protocols, it appears that some perceived proximity to "knowledge economies" has rendered all of these terms part and parcel of a certain liberalizing shift within the world of contemporary art practices.

Concerned that these initiatives are in danger of being cut off from their original impetus and threaten to harden into a recognizable "style," I would like to invoke, towards the end of this discussion, Foucault's notion of "parrhesia"—free, blatant public speech—as perhaps a better model through which to understand some kind of "educational turn" in art.

### Education

It might be easiest to enter the fray of education via what were for me the two projects that best reflected my own engagement with "education" within the arenas of display and of gathering.

The first of these was "A.C.A.D.E.M.Y." (2006) at the Van Abbemuseum in Eindhoven.[4] Consisting of a series of exhibitions, projects, and events that took place between a number of institutions, this installment in the Netherlands was a collaboration between twenty-two partici-pants and the staff of the museum. The project as a whole posed the question, "What can we learn from the museum?" and referred to a form of learning that could take place beyond that which the museum sets out to show or teach.

Our initial question addressed whether an idea of an "academy" (as a moment of learning within the safe space of an academic institution) was a metaphor for a moment of speculation, expansion, and reflexivity without the constant demand for proven results. If this was a space of experimentation and exploration, then how might we extract these vital principles and apply them to the rest of our lives? How might we also perhaps apply them to our institutions? Born of a belief that the institutions we inhabit can potentially be so much more than they are, these questions ask how the museum, the university, the art school, can surpass their current functions.

Of course, we touched on this problematic at the very moment a heated debate regarding the Bologna process—the European so-called reform of education—was erupting all around us. Instead of hanging our heads and lamenting the awfulness of these reforms, with their emphasis on quantifiable and comparable outcomes, we thought it might be productive to see if this unexpected politicization of the discussion around education might be an opportunity to see how the principles we cherish in the education process might be applied across a broader range of institutional activities. This could be a way of saying to the politicians: "You want to politicize education? Let's really politicize education. Let's make it a principle of actualization that really does touch the institutions of culture—not by producing perfectly trained, efficient, and informed workers for the cultural sector, but by thinking of the cultural sector as a market economy, and bringing the principles of education there to operate as forms of actualization."

When we say that these institutions of ours could be so much more than they are, we don't imply that they should be larger, or more efficient, or more progressive, or more fun (though they certainly should be more fun). Instead, we wish to say that their reach could be wider, that they might provide sites for doing so much more than they ever thought they could.

In asking what we can learn from the museum beyond what it sets out to teach us, we were not focused on the museum's expertise, what it owns and how it displays it, conserves it, and historicizes it. Our interests were in the possibilities for the museum to open a place for people to engage ideas differently—ideas from outside its own walls. So the museum in our thinking was the site of possibility, the site of potentiality.

"A.C.A.D.E.M.Y." wanted to stimulate reflections on this potentiality within society. It situated itself in the speculative tension between what one needs to know and what one aspires to know. Academies often focus on what it is that people need to know in order to start thinking and acting, but we chose to approach the academy as a space that generates vital principles and activities—principles and activities you can take with you and apply beyond the academy's walls to become a mode of life-long learning. As such, "A.C.A.D.E.M.Y." aimed to develop a counterpoint to the professionalization, technocratization, and privatization of academies that resulted from the Bologna process, and to the monitoring and outcome-based culture that characterize higher education in Europe today.

In considering what we might have at our disposal to counter such official assessments

of how learning can be evaluated and appreciated, we focused on two terms: "potentiality" and "actualization."

By "potentiality" we meant a possibility to act that is not limited to an ability. Since acting can never be understood as being enabled simply by a set of skills or opportunities, it must be dependent on a will and a drive. More importantly, it must always include within it an element of fallibility—the possibility that acting will end in failure. The other term we wanted to mobilize in conjunction with "academy" was that of "actualization," which implies that certain meanings and possibilities embedded within objects, situations, actors, and spaces carry a potential to be "liberated," as it were. This points to a condition in which we all function in a complex system of embeddedness—one in which social processes, bodies of learning, and individual subjectivities cannot be separated and distinguished from one another.

Both these terms seem important for mobilizing any re-evaluation of education, as they allow us to expand the spaces and activities that house such processes. Similarly, they allow us to think of "learning" as taking place in situations or sites that don't necessarily engage in or prescribe to such activity.

At Van Abbe, we envisaged an exhibition project that brought together five teams of different cultural practitioners and allowed them access to every aspect of the museum's collection, staff, and activities. Each of these teams pursued a line of inquiry into what we could learn from the museum beyond the objects on display and its educational practices.

The access was not aimed at producing institutional critique or exposing the true realities of the institution. Instead, it aimed at eliciting the unseen and unmarked possibilities that already exist within these spaces—the people who are already working there and who bring together unexpected life experiences and connections; the visitors whose interactions with the place are not gauged; the collection that could be read in a variety of ways far beyond splendid examples of key art-historical moments, the paths outward that extend beyond the museum, the spaces and navigational vectors which are unexpectedly plotted within it.

There were many questions circulating in the spaces of the exhibition, with each room and each group producing its own questions in relation to the central one: "What can we learn from the museum?"

There were questions regarding who produces questioning: What are legitimate questions, and under what conditions are they produced? The seminar class, the think tank, the government department, and the statistician's bureau are sites for the production of questions, but we were suggesting others born of fleeting, arbitrary conversations between strangers, of convivial loitering and of unexpected lines of flight in and out of the museum as in *The Ambulator* (Susan Kelly, Janna Graham, Valeria Graziano).

There were questions regarding the relations between expertise and hope and expertise and governance, between knowledge that is used to bolster hopeful fantasies and knowledge that is used to impose dominant concerns, such as in *Think Tank* (John Palmesino and Anselm Franke).

There were questions regarding what kind of modes of attention are paid in a context such as a museum or a library. For what could these modes of attention be liberated? Could they be useful in some other way? Could they become an instrument of liberation, as in *Inverted Research Tool* (Edgar Schmitz and Liam Gillick)?

There were questions regarding the very nature of ownership of an image or an idea. How does a simple object come to stand in for an entire complex network of knowing, legitimating, conserving, and "anointing with cultural status" (all of which operate under the aegis of ownership)? *Imaginary Property* (Florian Schneider and Multitude e.V.) asked, "What does it mean to own an image?"

There were questions regarding cultural difference, which asked whether a museum really is an institution of representation meant to represent those outside its systems and privileged audience. If it is not, then maybe those "outsiders" are not outside at all, but can be recognized as already here and part of us, but only if we listen—really listen to ourselves, as in *Sounding Difference* (Irit Rogoff, Deepa Naik).

And there were other questions about the museum's knowledge versus our own knowledge, and about open forums for learning at the edges of that which is acknowledged, as in *I Like That* (Rob Stone and Jean-Paul Martinon).

### Summit

That initial project within the spaces and parameters set by the museum led several of us to think about taking those questions into a less regulated and prescribed space, one in which institutional practices could encounter

self-organized, activist initiatives. This led to "SUMMIT non-aligned initiatives in education culture" (www.summit.kein.org), a forum which took place in Berlin in May 2007.[5]

In a sense, we came together in the name of "weak education," a discourse on education that is non-reactive, and does not seek to engage in everything that we know fully well to be wrong with education—its constant commodification, its over-bureaucratization, its ever-increasing emphasis on predictable outcomes, etc. If education is forever reacting to the woes of the world, we hoped to posit that education is in and of the world—not a response to crisis, but part of its ongoing complexity; not reacting to realities, but producing them. Often these practices end up being low-key, uncategorizable, non-heroic, and certainly not uplifting, but nevertheless immensely creative.

Why education and why at that particular moment?

This focus on education provided a way to counter the eternal lament of how bad things are—how bureaucratized, how homogenized, how understaffed and underfunded, how awful the demands are of the Bologna process with its homogenizing drives, how sad the loss of local traditions is, etc. Though not without its justifications, this voice of endless complaint serves to box education into the confines of a small community of students and education professionals. How, then, to paraphrase Roger Buergel, can education become more? How can it be more than the site of shrinkage and disappointment?

And why at this particular moment? Because, with Bologna and all its discontents, this moment is also seeing an unprecedented

number of self-organized forums emerging outside institutions, as well as self-empowered departures inside institutions. Propelled from within rather than boxed in from outside, education here becomes the site of a coming-together of the odd and unexpected—shared curiosities, shared subjectivities, shared sufferings, and shared passions congregate around the promise of a subject, an insight, a creative possibility. Education is by definition processual—involving a low-key transformative process, it embodies duration and the development of a contested common ground.

Here was perhaps one of the most important leap from "A.C.A.D.E.M.Y." to "SUMMIT"—an understanding of "education" as a platform that could signal a politics, a platform that could bring together unexpected and momentary conjunctions of academics, art world citizens, union organizers, activists, and many others in such a way that they could see themselves and their activities reflected within the broadly defined field of "education."

At its best, education forms collectivities—many fleeting collectivities that ebb and flow, converge and fall apart. These are small ontological communities propelled by desire and curiosity, cemented together by the kind of empowerment that comes from intellectual challenge. The whole point in coming together out of curiosity is to not have to come together out of identity: *We* the readers of J. L. Nancy encounter *we* the migrant, or *we* the culturally displaced, or *we* the sexually dissenting—all of these being one and the same *we*. So at this moment in which we are so preoccupied with how to participate and how to take part in the limited space that remains

open, education signals rich possibilities for coming together and participating in an arena not yet signaled.

Having liberated myself from the arena of strong, redemptive, missionary education, I would like to furnish the field with the following terms: Notions of "potentiality" and "actualization" offer a capacity to replace the reorganization of education with ideas concerning distribution and dissemination. This speaks to an idea that there might be endless possibilities within us that we might never be able to bring to successful fruition. "A.C.A.D.E.M.Y." becomes the site of this duality, of an understanding of "I can" as always, already yoked to an eternal "I can't." If this duality is not paralyzing, which I do not think it is, then it has possibilities for an understanding of what it is in an academy that can actually become a model for "being in the world." Perhaps there is an excitement in shifting our perception of a place from education or training to one that is not pure preparation, pure resolution. The academy might instead encompass fallibility, which can be understood as a form of knowledge production rather than one of disappointment.

Equally, I would suggest education to be the site of a shift away from a culture of "emergency" to one of "urgency." Emergency is always reactive to a set of state imperatives that produce an endless chain of crises, mostly of our own making. So many of us have taken part in miserable panels about "the crisis in education." A notion of urgency presents the possibility of producing an understanding of what the crucial issues are, so that they may become driving forces. The morning after George W. Bush was re-elected president, my classroom moved swiftly from amazement to

a discussion about why electoral forums were not the arena of political participation, and what they might actually represent instead—a move from an emergency to an urgency.

Perhaps most importantly, I want to think about education *not* through the endless demands that are foisted on both culture and education to be "accessible," to provide a simple entry point to complex ideas. The Tate Modern comes to mind as an example of how a museum can function as an entertainment machine that celebrates "critique lite." Instead, I want to think of education in terms of the places to which we have "access." I understand this access as the ability to formulate one's own questions, as opposed to simply answering those that are posed to you in the name of an open and participatory democratic process. After all, it is very clear that those who formulate the questions produce the playing field.

Finally, I would like to think of education as the arena in which "challenge" is written into our daily activity, where we learn and perform critically informed challenges that don't aim at undermining or overtaking. When political parties, courts of law, or any other authority challenges a position, it is done with the aim of delegitimizing it with a better one, of establishing absolute rights and wrongs. In education, when we challenge an idea, we suggest that there is room for imagining another way of thinking. By doing so in a way that does not overcome the original idea, we don't expend energy by forming opposition, but reserve it for imagining alternatives. At a conference I attended, Jaad Isaac, a Palestinian geographer, produced transportation maps of the Israeli occupation of the West Bank

that had an almost mind-blowing clarity to them. It made me think of what gargantuan energies had to be put into turning the evil chaos of that occupation into the crystalline clarity of those maps—energies that were needed in order to invent Palestine. In their pristine clarity, the maps performed a challenge to the expenditure of energies as a response to an awful situation. If education can release our energies from what needs to be opposed to what can be imagined, or at least perform some kind of negotiation of that, then perhaps we have an education that is more.

Turn

Quite a long time ago, when I had just finished my PhD and was embarking on a postdoctorate and a radical change of path towards critical theory, I ran across my very first art history professor on the street. This was unexpected—my being in a different country and city with the promise of another life on the horizon was not conducive at that moment to knowing how to deal elegantly with what I had left behind. Having asked me what I was up to, he listened patiently as I prattled away, full of all the new ideas and possibilities that had just opened up to me. My professor was a kind, humane, and generous scholar of the old school. He may have been somewhat patrician, but he had an intuitive grasp of the changes shaping the world around him. At the end of my excited recitative he looked at me and said, "I do not agree with what you are doing and I certainly don't agree with how you are going about it, but I am very proud of you for doing this." It is hard now to imagine my confusion at hearing this, yet I realize with hindsight that he was recognizing a "turn" in the making, rather

than expressing concern or hostility for what it was rejecting or espousing. Clearly this man, who had been a genuinely great teacher of things I could no longer be excited by, saw learning as a series of turns.

In a "turn," we shift *away* from something or *towards* or *around* something, and it is *we* who are in movement, rather than *it*. Something is activated in us, perhaps even actualized, as we move. And so I am tempted to turn away from the various emulations of an aesthetics of pedagogy that have taken place in so many forums and platforms around us in recent years, and towards the very drive to *turn.*

So my question here is twofold, concerning on the one hand the capacity for artistic and curatorial practices to capture the dynamics of a turn, and on the other, the kind of drive being released in the process.

In the first instance, this might require that we break somewhat with an equating logic that claims that process-based work and open-ended experimentation create the speculation, unpredictability, self-organization, and criticality that characterize the understanding of education within the art world. Many of us have worked with this understanding quite consistently, and while some of its premises have been quite productive for much of our work, it nevertheless lends itself far too easily to emulating the institutions of art education, with its archives, libraries, and research-based practices as primary representational strategies. On the one hand, moving these principles into sites of contemporary art display signaled a shift away from the structures of objects, markets, and dominant aesthetics, towards an insistence on the unchartable,

processual nature of any creative enterprise. Yet on the other hand, it has led all too easily into the emergence of a mode of "pedagogical aesthetics" in which a table in the middle of the room, a set of empty bookshelves, a growing archive of assembled bits and pieces, a classroom or lecture scenario, or the promise of a conversation have taken away the burden to rethink and dislodge daily those dominant burdens ourselves.[6] Having myself generated several of these modes, I am not sure that I want to completely dispense with them, because the drive that they made manifest—to force these spaces to be more active, more questioning, less insular, and more challenging—is one to which I would like to stay faithful. In particular, I would not wish to give up the notion of "conversation," which to my mind has been the most significant shift within the art world over the past decade.

In the wake of documenta X and documenta 11, it became clear that one of the most significant contributions that the art world had made to the culture at large has been the emergence of a conversational mode hosted by it.[7] In part, this has had to do with the fact that there already exists a certain amount of infrastructure within the art world, where there are available spaces, small budgets, existing publicity machines, recognizable formats such as exhibitions, gatherings, lecture series, interviews, as well as a constant interested audience made up of art students, cultural activists, etc.[8] As a result, a new set of conversations between artists, scientists, philosophers, critics, economists, architects, planners, and so on, came into being and engaged the issues of the day through a set of highly attenuated prisms. By not being

subject to the twin authorities of governing institutions or authoritative academic knowledge, these conversations could in effect be opened up to a speculative mode, and to the invention of subjects as they emerged and were recognized.

And so the art world became the site of extensive talking—talking emerged as a practice, as a mode of gathering, as a way of getting access to some knowledge and to some questions, as networking and organizing and articulating some necessary questions. But did we put any value on what was actually being said? Or, did we privilege the coming-together of people in space, and trust that formats and substances would emerge from these?

Increasingly, it seems to me that the "turn" we are talking about must result not only in new formats, but also in another way of recognizing when and why something important is being said.

Foucault, in a lecture he once gave at Berkeley, embarked upon a discussion of the word "parrhesia," a common term in Greco-Roman culture.[9] He stated that it is generally perceived as free speech, and that those who practice it are perceived to be those who speak the truth. The active components of parrhesia, according to Foucault, are frankness ("to say everything"), truth ("to tell the truth because he knows it is true"), danger ("only if there is a risk of danger in his telling the truth"), criticism ("not to demonstrate the truth to someone else, but as the function of criticism"), and duty ("telling the truth is regarded as a duty"). In parrhesia, Foucault tells us, we have "a verbal activity in which the speaker expresses his personal relation to truth, and risks his life because he recognizes truth-telling as a duty to improve

or help other people (as well as himself). In parrhesia, the speaker uses his freedom and chooses frankness instead of persuasion, truth instead of falsehood or silence, the risk of death instead of life and security, criticism instead of flattery and moral duty instead of self-interest and moral apathy."[10]

It is hard to imagine a more romantic or idealistic agenda for invoking "turns" in the educational field. And yet, I am drawn to these with less embarrassment than you might think one would have as a self-conscious critical theorist working within the field of contemporary art. Perhaps because nowhere in this analysis are we told *which truth,* or *to what ends* it is being deployed. Truth, it would seem, is not a position, but a drive.

To add an even more active dimension to Foucault's discussion of parrhesia, we can also establish that in Aramaic the term is invoked in relation to such speech when it is stated "openly, blatantly, in public." So this truth, which is in no one's particular interest or to any particular end, must be spoken in public, must have an audience, and must take the form of an address.

Foucault called this "fearless speech," and at the end of his lecture series he says, "I would say that the problematization of truth has two sides, two major aspects... One side is concerned with establishing that the process of reasoning is correct in ensuring if a statement is true. And the other side is concerned with the question: What is the importance for the individual and for the society of telling the truth, of knowing the truth, of having people who tell the truth, as well as knowing how to recognize them?"[11]

Increasingly, I think "education" and the "educational turn" might be just that: the moment when we attend to the production and articulation of truths—not truth as correct, as provable, as fact, but truth as that which collects around it subjectivities that are neither gathered nor reflected by other utterances. Stating truths in relation to the great arguments, issues, and institutions of the day is relatively easy, for these dictate the terms by which such truths are both arrived at and articulated. Telling truths in the marginal and barely-formed spaces in which the curious gather, is another project altogether: one's personal relation to truth.

1   "Salon Discussion: 'You Talkin' to me? Why art is turning to education,'"
    The Institute of Contemporary Arts, London.
2   Among others; "A.C.A.D.E.M.Y" Hamburg, Antwerp, Eindhoven, 2006–7;
    "SUMMIT non-aligned initiatives in education culture," 2007, "Faculties of
    Architecture," Dutch Pavillion, Venice Architecture Biennale, 2008; the PhD
    program "Curatorial/Knowledge" at Goldsmiths College, London University,
    co-directed with Jean-Paul Martinon.
3   Mårten Spångberg, "Researching Research, Some reflections on the current
    status of research in performing arts," International Festival.
4   Initiated by Angelika Nollert, then at the Siemens Art Fund, "A.C.A.D.E.M.Y"
    was a collective project between Hamburger Kunstverein, MuKHA Antwerp,
    Van Abbemuseum Eindhoven, and the Department of Visual Cultures,
    Goldsmiths College, London University. It took place in three cities through-
    out 2006 and was accompanied by a book, published by Revolver—Archiv
    für aktuelle Kunst and edited by A. Nollert and I. Rogoff et al.
5   The project was organized by a collective—Irit Rogoff (London), Florian
    Schneider (Munich), Nora Sternfeld (Vienna), Susanne Lang (Berlin), Nicolas
    Siepen (Berlin), Kodwo Eshun (London)—and in collaboration with the HAU
    theatres, Unitednationsplaza, BootLab, and the Bundeskulturstiftung, all
    in Berlin.
6   I say all this with a certain awkwardness, in light of my own involvement
    with so many of these initiatives. Exhibitions, self-organized forums
    within the art world, and numerous conversation platforms all shared the
    belief that turning to "education" as an operating model would allow us to
    re-invigorate the spaces of display as sites of genuine transformation.
7   I refer to the discussion forum "100 days – 100 guests" at documenta X
    (1997, curated by Catherine David), which hosted 100 talks during the
    exhibition, and to the four documenta discussion platforms across the
    globe prior to the opening of documenta 11 (2002, curated by Okwui
    Enwezor et al.). See documenta 11, exhibition catalogue (Ostfildern-Ruit,
    Germany: Hatje Cantz, 2002).
8   Another key example is unitednationsplaza, a project in Berlin in 2006-2007
    (the exhibition as art school), now continued in New York as nightschool,
    and in this reincarnation connected to Mårten Spångberg's project of
    "Evening Classes" at the YourSpace.com section of "A.C.A.D.E.M.Y."

9   Michel Foucault, *Fearless Speech*, ed. Joseph Pearson (New York: Semiotext(e), 2001).
10  Ibid., 19-20.
11  Ibid., 170.

Dieter Roelstraete

# The Way of
the Shovel:
On the
Archeological
Imaginary
in Art

**He who seeks to approach his own buried past must conduct himself like a man digging.**
—Walter Benjamin[1]

[*Preliminary admonition: There is no disgrace in seeking to define either the essence or the attributes of art. For…*]

...art is, or at least *can* be, many things at many different points in time and space. Throughout its history—which is either long or short, depending on the definition agreed upon—it has assumed many different roles and been called upon to defend an equal number of different causes. Or, alternately—and this has turned out to be a much more appealing and rewarding tactic for most of the past century—it has been called upon to attack, question, and criticize any number of states of affairs. In the messianic sense of a "calling" or κλησις—a call to either change or preserve, for those are the only real options open to the messianic—we might locate both the roots of art's historical contribution to the hallowed tradition of critique and the practice of critical thought, as well as its share in the business of shaping the future—preferably (and presumably) a different future from the one that we knowingly envision from the vantage point of "today."

In the present moment, however, it appears that a number of artists seek to define art first and foremost in the thickness of its relationship to history. More and more frequently, art finds itself looking back, both at its own past (a very popular approach right now, as well as big business), and at "the" past in general. A steadily growing number of contemporary art practices engage not only in storytelling, but

more specifically in history-telling. The retro-spective, historiographic mode—a method-ological complex that includes the historical account, the archive, the document, the act of excavating and unearthing, the memorial, the art of reconstruction and reenactment, the testimony—has become both the mandate ("content") and the tone ("form") favored by a growing number of artists (as well as critics and curators) of varying ages and backgrounds.[2] They either make artworks that want to remember, or at least to turn back the tide of forgetfulness, or they make art *about* remembering and forgetting. We can call this the "meta-historical mode," an important aspect of much artwork that assumes a curatorial character. With the quasi-romantic idea of history's presumed remoteness (or its darkness) being invariably quite crucial to the investigative undertaking at hand, these artists delve into archives and historical collections of all stripes (this is where the magical formula of "artistic research" makes its appearance) and plunge into the abysmal darkness of history's most remote corners. They reenact—yet another mode of historicizing and storytelling much favored by artists growing up in a culture of accelerated oblivion—reconstruct, and recover. Happy to honor their calling, these artists seek out the facts and fictions of the past that have mostly been glossed over in the more official channels of historiography, such as the "History Channel" itself.[3] They invariably side with both the downtrodden and the forgotten, reveal traces long-feared gone, revive technologies long-thought (or actually rendered) obsolete, bring the unjustly killed back to (some form of) life, and generally seek to restore justice to

anyone or anything that has fallen prey to the blinding forward march of History with a capital, monolithic "H"—that most evil of variations on the Hegelian master narrative.

The reasons for this oftentimes melancholy (and potentially reactionary) retreat into the retrospective mode of historiography are manifold, and are of course closely related to the current crisis of history both as an intellectual discipline and as an academic field of enquiry. After all, art's obsession with the past, however recently lived, effectively closes it off from other, possibly more pressing obligations, namely that of imagining the future, of imagining the world otherwise ("differently"). Our culture's quasi-pathological systemic infatuation with both the New and the Now ("youth") has effectively made forgetting and forgetfulness into one of the central features of our contemporary condition, and the teaching of history in schools around the globalized world has suffered accordingly.

[*This diagnosis of a "crisis of history" may strike the informed reader as unnecessarily alarmist and overblown: Indeed, even the most cursory glance at the groaning bookshelves in the "History" section of one's local culture mall—or its counterpart on Amazon.com—seems to suggest the opposite to be true. There is, in fact, plenty of historiography out there, but it is of a very problematic, myopic kind that seems to add to the cultural pathology of forgetting rather than fight against it. It is a type of writing that prefers to hone in on objects (the smaller, the more mundane, and the less significant, the better) rather than people, the grand societal structures that harness them, or the events that befall them and/or help bring those structures*

into being. Virtually every little "thing" has become the subject of its own (strictly "cultural") history of late, from the pencil to the zipper, the cod, the porcelain toilet bowl, the stiletto, the potato, or the bowler hat. It does not require too great an imaginative effort to discern the miserable political implications of this obsession with detail, novelty, and the quaint exoticism of the everyday (best summed up by the dubious dictum "small is beautiful"). Indeed, it seems sufficiently clear that the relative success story of this myopic micro-historiography, with its programmatic suspicion of all forms of grand historicization, is related both to today's general state of post-ideological fatigue as well as to the political evacuation (or de-politicization) of academia, of which the "crisis of history" is precisely such an alarming, potent symptom.]

In this sense, art has doubtlessly come to the rescue, if not of history itself, then surely of its telling: It is there to "remember" when all else urges us to "forget" and simply look forward— primarily to new products and consumerist fantasies—or, worse still, inward. Indeed, this new mode of discursive art production boasts an imposing critical pedigree, a long history of resistance and refusal: the eminent hallmarks, as we know, of true vanguardism.

One geopolitical region whose recent (and rewardingly traumatic) history has become especially prominent with art's turn towards history-telling and historicizing (its turn away from both the present and the future), is post-communist Central and Eastern Europe—the preferred archeological digging site (if only metaphorically) of many well-read artists whose work has come of age in the broader context of

the globalized art market of the last decade and a half. Ironically enough, the region's triumph was wholly determined by the demise of the system of state socialism that so many of us now seek to memorialize.

[*It is perhaps unnecessary to add here that the majority of these amateur archeologists hail from the "West," where there may still exist certain pockets of nostalgia for the ideological clarity, among other things, of the Cold War era, when Central and Eastern Europe could be imagined as something radically "different," belonging to "another" political world entirely—hence also its quasi-inexhaustible appeal to critical art: art that is committed to "making a difference." Obviously, a similar type of nostalgia is also felt by a younger generation of artists from the former Eastern Bloc—but differently so, and the generational shift is of crucial importance here.*[4]]

In their cultivation of the retrospective and/or historiographic mode, many contemporary art practices inevitably also seek to secure the blessing (in disguise) of History proper: in an art world that seems wholly dominated by the inflationary valuations of the market and its corollary, the fashion industry ("here today, gone tomorrow," or, "that's so 2008"), time, literally rendered as the subject of the art in question, easily proves to be a much more trustworthy arbiter of quality than mere taste or success. Hence the pervasive interest of so many younger artists and curators in the very notion of anachronism or obsolescence and related "technologies of time": think of Super 8 mm and 16 mm film, think of the Kodak slide carousel, think of antiquated, museum-of-natural-history-style vitrines meant to convey a sense of the naturalization of history,

or of time proper. Perhaps many artists use these tried-and-tested methods of history as a science, or as a mere material force (the archival mode ranks foremost among these methods), in hopes that some of its aristocratic sheen will rub off on their own products or projects, or otherwise inscribe them and their work in the great book of post-History . . .

One of the ways in which this historiographic "turn" has manifested itself lately is through a literalized amateur archeology of the recent past: digging. Archeology's way of the shovel has long been a powerful metaphor for the various endeavors that both spring from the human mind and seek to map the depths of, among other things, itself. Perhaps the most famous example of this would be psychoanalysis (or "depth psychology"), in which the object of its archaeological scrutiny *is* the human mind. Throughout a history that stretches far beyond the work of, say, Robert Smithson, Haim Steinbach, or Mark Dion, psychoanalysis has long been a source of fascination and inspiration for the arts. Certainly, one could conceive of an exhibition consisting solely of artistic images of excavation sites, of "art about archeology." The truth claims of art often quote rather literally and liberally from the lingua franca of archeology: Artists often refer to their work as a labor of meticulous "excavation," unearthing buried treasures and revealing the ravages of time in the process; works of art are construed as shards, fragments (the Benjaminian ciphers of a revelatory truth), traces preserved in sediments of fossilized meaning. Depth delivers artistic truth: That which we dig up (the past) in some way or other must be more "real" and therefore also more "true" than

all that has come to accumulate afterwards to form the present. This also says something about why we think the present is so hard to explain.

Likewise, the scrupulous archeological ethic of unending patience and monastic devotion to detail—seamlessly mirrored in its preferred optic, that of the clinical close-up—is, in spirit, close to the obsessive labor or "science" of art-making that often requires plodding through hours, days, and weeks of menial rubble-and-manure-shoveling before something that may (or may not) resemble a work of art emerges. Michelangelo's sculptures of dying slaves wresting themselves free from the marble in which the artist "found" them captive continue to provide what is perhaps the archeological paradigm's most gripping image.[5] Furthermore, there can also be no archeology without display—the modern culture of museum display (if not of the museum itself) is as much "produced" by the archeologist's desire to exhibit his or her findings as it is by the artist's confused desire to communicate his or hers. After all, the logical conclusion of all excavatory activity is the encasing of History's earthen testimony within a beautiful, exquisitely lit, amply labeled glass box—an apt description, indeed, of much artistic and meta-artistic or curatorial activity of the last decade and a half.[6] Finally (and most importantly, perhaps), art and archeology also share a profound understanding—and one might say that they are on account of this almost "naturally" inclined Marxist epistemology—of the primacy of the material in all culture, the overwhelming importance of mere "matter" and "stuff" in any attempt to grasp and truly read the cluttered fabric of the world. The archaeologist's

commitment is to earth and dirt, hoping that it will one day yield the truth of historical time; the artist's commitment is to the crude facts of his or her working material (no matter how "virtual" or, indeed, "immaterial" this may be), which is equally resistant to one-dimensional signification and making-sense, equally prone to entropy—yet likewise implicated in a logic of truth-production.

In this critical Bataillean sense of a "base materialism"—a materialism from which all traces of formalist idealization have been evacuated—both art and archeology are also work—hard and dirty work, certain to remind us of our bodily involvement in the world. The archeological imaginary in art produces not so much an *optics* as it does a *haptics*—it invites us, forces us to intently scratch the surface (of the earth, of time, of the world) rather than merely marvel at it in dandified detachment. By thus intensifying our bodily bondage to a world that, like our bodies themselves, is made up first and foremost of matter, the alignment of art and archeology compensates for the one tragic flaw that clearly cripples the purported critical claims and impact of the current "historiographic turn" in art: its inability to grasp or even look at the present, much less to excavate the future.

1    Walter Benjamin, "Excavation and Memory," in *Selected Writings, Volume 2, Part 2, 1931–1934*, ed. Michael W. Jennings, Howard Eiland, and Gary Smith, trans. Rodney Livingstone et al. (Cambridge, MA: The Belknap Press of Harvard University Press, 1999), 576. Benjamin continues: "Above all, he must not be afraid to return again and again to the same matter; to scatter it as one scatters earth, to turn it over as one turns over soil. For the "matter itself" is no more than the strata which yield their long-sought secrets only to the most meticulous investigation. That is to say, they yield those images that, severed from all earlier associations, reside as treasures in the sober rooms of our later insights." In the words of Peter Osborne, "Benjamin's prose breeds commentary like vaccine in a lab," *Radical Philosophy*, no. 88 (March/April 1998), http://www.radicalphilosophy.com/default. asp?channel_id=2188&editorial_id=10292.

2    Mark Godfrey's much-discussed essay "The Artist as Historian," published in *October* 120 (Spring 2007), has become a local landmark of sorts. In it Godfrey states that "historical research and representation appear central to contemporary art. There is an increasing number of artists whose practice starts with research in archives, and others who deploy what has been termed an archival form of research" (142–143). He then goes on to focus on the work of one artist-as-historian in particular, Matthew Bucking-ham, forgoing the opportunity to offer the reader an explanation, no matter how speculative or tentative, as to *why* historical research and representation in general have become so central to contemporary art (again). Furthermore, as the work of a historian does not necessarily coincide with that of a historiographer, the job description that I would suggest is more accurate with regard to contemporary art practice: the act of "writing" (or, more broadly, "narrating") adds a key distinction here.

3    This analogy prompts the memory of a similar televisual metaphor: When asked about the socio-political import of hip-hop, Public Enemy's charismatic frontman Chuck D famously called the genre "the CNN of black America," in that it also provides its (supposedly marginalized) constituency with informal, unofficial history lessons and alternative views of mainstream "news"—or any fact of world history that may have fallen by the wayside in a process of ideological homogenization. Likewise, it has sometimes been said that many of the last decade's most important mega-exhibitions (biennials, documentas, Manifestas—*not* art fairs) at times came to resemble documentary film festivals where the likes of Discovery Channel, the History Channel, and the National Geographic Channel come to exchange their wares, making the art world look like something akin to a BBC World program of politically disenchanted aesthetes and TV-hating intellectuals.

4    The historiographic turn in "post-socialist" European art specifically is the subject, among other things, of Charity Scribner's aptly titled *Requiem for Communism*, published by MIT in 2003. An exhaustive list of practitioners from post-socialist "Eastern" Europe who self-reflexively mine this particular field would be hard to compile; however, such a list would definitely have to include the names of Chto Delat, Aneta Grzeszykowska, Marysa Lewandowska & Neil Cummings, Goshka Macuga, David Maljković, Deimantas Narkevicius, Paulina Olowska, and to a certain extent also Anri Sala and Nedko Solakov. Artists from the "West" who have consistently devoted their attention to the intricate meshwork of some of these histories include Gerard Byrne, Tacita Dean, Laura Horelli, Joachim Koester, Susanne Kriemann, Sophie Nys, Hito Steyerl, Luc Tuymans, and many more.

5    Michelangelo's statement with regard to the slave figures, that he was "liberating them from imprisonment in the marble," also recalls the famous motto that guided his near-contemporary Albrecht Dürer: "Truly art is firmly fixed in Nature. He who can extract her thence, he alone has her." We could easily replace Dürer's idealized, quasi-divine Nature in this last quote with Culture, History, or Time in order to paint a fairly accurate picture of the thinking that goes on behind (or, better still, *underneath*) much historiographic-art production today: this strand of contemporary art is as much a business of extraction as it is one of excavation.

6    A great many artists have been "mining the museum" in recent years, and their interest in museological displays and genealogical frameworks certainly belongs to the broader thrust of the historiographic turn in contemporary art: Fred Wilson coined the geological formula, Louise Lawler and Mark Dion did some exploratory groundwork (quite literally, in the latter's case), while Carol Bove, Goshka Macuga, Josephine Meckseper, Jean-Luc Moulène and Christopher Williams rank among the micro-genre's better-known contemporary practitioners. Many of the artists working in this field of a critical museology have a complicated relationship with the habitus of institutional critique, to which it is obviously indebted; they certainly "long for" the museum much more strongly and directly than the

first generation of institutional critics would ever allow themselves to. In the speleological imaginary of "mining the museum"—note the sexual undertones of this metaphor—the museum has become an object of desire as much as an object of critique, a cavity as much as an excavation site.

Marion von Osten

# Architecture Without Architects —Another Anarchist Approach

The title of this text is a hybrid of two existing titles. "Architecture Without Architects" was the name of an influential exhibition by the architect Bernard Rudofsky at the MoMA in 1964; "Housing: An Anarchist Approach" was the name of a famous book by the English architect and anarchist Colin Ward in which the author proclaims the rights and productivity of self-built housing and squatting in postwar Europe. Whereas the latter's collection of essays discussed specific cases of European and Latin American squatter movements from the 1940s to the 1970s, Rudofsky's exhibition presented photographs of local vernacular architecture from all over the world, with the claim that architects should learn from premodern architectural forms. Both of these perspectives identify a condition that emerged during decolonization, in which a massive crack appeared in the modernist movement and its vision of top-down planning. But they were also two very different interpretations of the simple fact that, throughout the ages and around the world, architecture has been produced without the intervention of planners or architects. Whereas Rudofsky's approach suggested an aesthetical and methodological shift, Colin Ward's was a political reading of spatial self-expressions that might offer new methodologies and an alternative understanding of society. In my article, after more than thirty years of debates about high modernism, I will try to bring into play a third way of thinking that attempts to connect the question of design with that of the political, from the perspective of a globalized world. These ideas have been informed by many conversations, much research, and invitations to Egypt, Morocco, and Israel. I would like to thank everyone who was involved in these discussions: Nezar AlSayyad,

Kader Attia, Tom Avermaete, Dana Diminescu,
Noam Dvir, Zvi Efrat, Sherif El-Azma, Monique
Eleb, Jesko Fezer, Tom Holert, Shahira Issa, Serhat
Karakayali, Abderrahim Kassou, Brian Kuan Wood,
Andreas Müller, Omar Nagati, Françoise Navez
Bouchanine, Horia Serhane, Katja Reichard, Peter
Spillmann, and Daniel Weiss.

### A Colonial Global Modernity

"Travelling between any two cities in
the world, passing through airports along ring
roads and into business districts or tourist
hotels, seems, at least in part, always to be a
return home. In the main this is because modern
architecture is a global phenomenon and what
contains and helps to define or frame our
experiences are usually buildings of familiar
appearance," says the English art historian Mark
Crinson in the introduction to his book *Modern
Architecture and the End of Empire*. He argues
here that this global similarity and formal analogy
concerns more than just modern architecture:
"More specifically it is modernist architecture:
that embrace of technology, that imagined
escape from history, that desire for transparency
and health, that litany of abstract forms . . ."[1]
For Crinson, this universal formal language,
with its norms and forms, has created the
global language and appearance sufficient to
suggest a common trajectory shared by global-
ized cities today.

At first glance, modernist architecture and
urban planning appear to have little in common
with New Urbanism's gated communities and
upper-class boulevards, built far away from the
"global city" center and the informal settlements
growing up on its outskirts. The differences

become even more obvious as we learn that modernist discourse on urban planning was not meant to serve only the new urban elite; on the contrary, modernist architecture and urban utopias were designed to be the ultimate urban fabric, creating and realizing entirely new societies and modern citizens. The function of modernist architecture as both symbol and organizational model for the "new modern man" in Europe and America, as well as in the colonies, must be highlighted here. Housing and urban planning projects symbolized a new society, representing a modern, industrialized way of living, working, and consuming. Moreover, urban planning as such was an invention of Euro-American modernity, having emerged towards the end of the eighteenth century, in times of aggressive colonial expansion and the advancement of a new world order. The spirit of social reform, based on new forms of industrial manufacturing and consumption, was translated into the first master plans for housing developments, and these concepts for urban planning became schema that were used strategically for very different social groups, having in common only their use as a tool for governing life and the living being. As spatial organization and urban planning served to strategically control and mobilize a population, and appropriate its territory, so did it also claim to shelter this same population.

Some years ago, researchers became aware that in the period of modernist ascendancy, and in particular during what came to be known as "high modernism," colonial territories became laboratories for European avant-garde architects and urban planners to realize many of their experiments. The discourse surrounding

colonial "new town" planning was, upon its emergence, immediately recognized internationally, documented in magazines, congresses, and exhibitions. Concepts and practices traveled not only from Europe and America to the global South, but also moved in the opposite direction. In essence, modern city planning has always been bound to colonialism and imperialism—many large-scale technical developments were even tested and realized on colonial ground. Colonial modernity not only created global political and economic structures, pressing for the adoption of the nation-state and capitalist forms of production, accompanied by oppression, exploitation, and the systematization of racial divisions; but it also produced, as Crinson remarks, the aesthetical and infrastructural basis for a globalized world, for the global modernity we live in, as the postcolonial historian Arif Dirlik has it.[2]

The travel experience in a globalized world, formed by a colonial modernity, is today additionally structured by a global elite and its flows of capital, its production sites, its aesthetics, infrastructures, and urban lifestyles. Cities are influenced by multiple, simultaneous trajectories—the new geometries of a network society, as Manuel Castells describes them—drawn by the telos of globalization.[3] "Global cities" today seem to be governed and structured more by privatized initiatives than they were in modernist and Fordist times, in which the nation state was the central actor in both Europe and America and in the colonized South. Many studies, books, and exhibitions in the last decades have focused on global flows of capital and transnational enterprise, as well as on the informal network economies and migrations that accompany them. In

these cases, the activities of non-governmental organizations and enterprises seem to be key in determining how urban landscapes are created and used in very particular ways.

Beyond the almost forgotten colonial modernity that Mark Crinson brought back into the debate on global cities, there are certainly many trajectories and actors other than new global or neocolonial powers shaping the urban fabric today. In these global cities, an increasing number of improvised practices have become key forces shaping the urban landscape by creating new possibilities and realities for making life a bit easier for the individual as well as for the community. In one example among many, one finds people improvising pathways that cut through emblems of global modernity—crisscrossing highways, districts, and gated communities, re-partitioning segregating infrastructure by asserting a new layer of functionality. The same is true for the self-builders who, for practical reasons, occupy land just beyond the walls of New Urbanism's gated communities to construct improvised huts.

The French sociologist Alain Tarrius goes a step further, arguing in his latest book *La remontée des Sud* that, contrary to the assumption that the South is structured by flows of global capital, one instead finds its local and transnational economies impacted mainly by a growing number of informal and migratory practices.[4] By taking into account the informal activities of small-scale economies and the flows of capital linked to transnational migration, Tarrius arrives at the conclusion that a comparison of the economic output of the formal and informal sectors of the North and the South does not present as stark

an asymmetry as the West has liked to imagine. Nevertheless, while perceptions have shifted, allowing us to look beyond the grand narratives of Western globalization theories, it remains important to acknowledge how North-South relationships are still hierarchically structured.

Various localities, social groups, and local actors have each perceived the aesthetic and infrastructural basis of colonial modernity in their own way; most significantly, this modernity has been appropriated and used against its aforementioned original intentions. The appropriation of colonial infrastructure's leftovers—its existing buildings, public spaces, and territories— articulate personal needs and practices that improve the circumstances of contemporary inhabitants. If one takes these various strategies into account, one finds that they, too, assume the shape of universal patterns, spanning the globe. They follow migration patterns and transnational ways of living, as improving conditions within precarious economic environments are linked to the transnational flows of money sent from relatives working and living abroad, forming global patterns that concern not only mobility, but new approaches and contributions to existing city structures as well.

As the users of the leftovers of colonial modern infrastructures and landscapes, these dwellers and self-builders appropriate existing buildings, public spaces, and territories to articulate personal needs and relieve the precariousness of their situation. If we look more closely at the junctions and coordinate systems of mobility and circulation reflected by these small-scale improvements, what we find are not established and settled societies, but dynamic

and interconnected transnational spaces created by migration. These migrations, however, gain their legitimacy more from the migrations that preceded them than from the logic of arriving at and occupying new territory. Migrants have now settled many areas beyond the spaces of urban majorities, informed and encouraged by the never-ending movements of migration itself. Yet those who move to work abroad are not the poorest people in a society, but usually come from a family background in which an investment has had to be made in a shop, a house, education, and so on. Inhabitants' everyday practices of coping with their circumstances—their means of appropriating existing environments or territories as well as the transnational reality of migratory societies—respond to existing conditions and circumstances stemming from the colonial modern past as well as the global modern present. These practices are therefore extremely contemporary, and almost anarchistic in nature.

## The Vernacular as Didactic Model
The tension between the formal and the informal city, between architecture by architects and architecture without architects, has existed since the very beginning of the modern urbanization project. Prompted by capitalist class-making and the influx of rural migration to cities, large housing programs and informal housing increasingly grew up near the city's borders—the city essentially began to build itself. The trajectories of this tension between the formal and the informal city were major attractors for the emergence of the modernist movement towards the end of the nineteenth century as well. Their studies of vernacular architecture in the Mediterranean

and its aesthetics, functions, and structures were partially synthesized into the most modern form of new industrialized building types. Though they were hybrid translations, modernist houses and settlements, with their whitewashed walls, created the idea of a pure form and a hierarchy between the modern and the premodern. By asserting a temporal rupture between the contemporary and the traditional, modernism embraced the possibilities of industrialization and standardized forms. This technocratic and formal approach experienced a deep crisis in the 1950s when the next generation took the self-built environments of hut settlements on colonial ground into account in designing processes and models for urban planning.

For a number of years, I have been interested in the deep crisis in high-modernist thinking that came about in the era of decolonization, prompting me to begin an investigation into the housing developments that were built under colonial rule, mainly in Casablanca in the 1950s on the outskirts of the European city. This article will offer some open-ended thoughts relating to my research. This paradigm shift in the postwar years marked a great paradox, as colonial modernity was, and is, an articulation of the ultimate ability to plan a society. As previously mentioned, colonial modernity also became a testing ground for new discourses around modernization and for the large housing programs that were installed throughout Europe and America and the colonies after the war to create a global consumer society. But at the same time as global decolonization was taking place, this ability to plan was placed into question by a younger generation in the West, who were interested in the everyday, the popular,

and the discovery of the ordinary celebrated by the so-called "found" aesthetics that encouraged a new relationship to the constructed environment as it is used and visually perceived by photographs and anthropological studies.[5]

As a result of this shift in perspective, there was a dispute at the ninth CIAM (Congrès International d'Architecture Moderne) meeting in Aix-en-Provence in the summer of 1953, in which a team of young architects (who later formed the group "Team 10," when they were charged with organizing the tenth congress) presented new ideas on urbanism and the function of architecture that were highly critical of the functional separation between housing, work, leisure, and transportation in urban planning. In calling for an amendment to the 1933 Athens Charter developed at the first CIAM meeting, the group wanted to call attention to the interconnectedness of housing, street, district, and city, and the meeting ended in conflicts with the congress' older generation of founding members such as Le Corbusier, Gropius, and Gideon. The context for this dispute were three visual urban studies (so-called "grids"): the "GAMMA Grid" generated by the Service de l'Urbanisme from Casablanca (which included the young George Candilis, Vladimir Bodiansky, and Shadrach Woods), a study of an Algerian shantytown in the "Mahieddine Grid" by Roland Simounet et al.; and the "Urban Re-Identification Grid" by Alison and Peter Smithson, a study of how playing children used the street in East London's working class and colonial migrant district of Bethnal Green. Two of these studies were investigations of the self-built shantytowns that grew up on the outskirts of the French colonial towns of Casablanca and Algiers.

All three studies resulted in discussions concerning how the CIAM IX meeting itself marked a worldwide shift in approaches to postwar modern building for its presentation of self-built environments as models for understanding the interrelation of the public and the private spheres in relation to a new concept called "Habitat." Discussions stemming from the studies of working class districts and shantytowns led to a generational conflict that marked the dissolution of CIAM as an international organization of the modernist movement.[6]

My interest in this crisis is twofold, and provokes many questions that are still relevant today. First off, two architects from the GAMMA group, Georges Candilis and Shadrach Woods, later leading Team 10 members, were already able to present a completely planned and realized building that they had constructed as an experimental high-rise structure for incoming Moroccan workers alongside the shantytowns in Casablanca—they had transferred their analysis of hut settlements directly onto a modernist architectural project. In the framework of Casablanca's extension plan, they built two experimental housing blocks—the Cité Verticale —that synthesized their studies of the reality of the Bidonville with the modernist approach to planning. The result was a design that integrated the Bidonvilles' everyday vernacular practices, local climatic conditions, and a modernist idea of educating people for a better future. On a formal level, the buildings can be seen as a type of local traditional building—the patio house— translated into a stacked block of apartments. And yet, the basic capacity for young architects to fully realize a whole settlement was

fundamentally bound to the circumstances of colonial occupation, and this was not questioned by the new generation. Still, the building model and shantytown study had a lasting influence on a younger generation of architects, who witnessed modernism adapting to local climatic and "cultural" conditions and deviating slightly from its universalist path.[7]

The new housing programs—of which the Cité Verticale was only one among many—were a first attempt by the French protectorate to build modern settlements for the colonized and not for the colonizers. In Morocco and Algeria, these programs were a response to the growing influx of migrants from the countryside into the colonial city after the Second World War, for whom the French protectorate built fenced settlements far from the colonial city centers. Within these, Moroccan settlers began building informal huts, which were then named after the materials used to build them, such as in the case of "Bidonville" (Tin Can City). The shantytowns that emerged from this limited access to the formal city centers became the subject of the "Service de l'Urbanisme" project implemented in the last decade of French rule in Morocco and led by Michel Ecochard, the director of Casablanca's urban planning office. The strategy of the protectorate from the late 1940s on was to build enormous numbers of housing estates in the framework of a large-scale extension plan of the city, one of the largest planning operations of the time for the new sub-proletarian workforce. The strategies of the Service de l'Urbanisme varied from the reordering of the Bidonville (*restructuration*) to temporary rehousing (*reloge-ment*) and finally to the creation of new housing

estates (*habitations à loyer modéré*) based on
the standard Ecochard grid of small, quickly
built single-floor patio houses. These low-rise
settlements were originally developed to contain
and govern the growing number of inhabitants
living in the shantytowns and working under
horrible conditions in the nearby phosphate
factories; as urban strategies they were from the
outset located in the field of tension between
the emancipatory aims of improving inhabitants'
everyday lives and the search for appropriate
governing tools that complied with these inten-
tions. In 1952, an important march organized
by the Istiqlal Party, the national liberation
movement, and other anti-colonial forces took
place in the Bidonvilles of Carrière Centrale, and
was brutally suppressed by the French rulers.
As a result, the construction of the new housing
plan took place in the midst of military actions
with tanks and heavily armed troops, arrests and
killing. Though it must have been virtually impos-
sible not to recognize the conflict, the optimistic
young French planners seemed hardly disturbed
by the conditions surrounding their work.

Moreover, many ambiguous attitudes
emerged on the part of the colonial rulers towards
the existing territory and its inhabitants. While
the Ecochard plan applied notions of "culturally
specific" dwelling, taking—in their interpreta-
tion—local practices as a point of departure in
developing a variety of dwelling typologies for
different categories of inhabitants, these catego-
ries were still confined to existing definitions of
cultural and racial difference. However, it was
only under colonial rule that they were reinforced
and converted to technologies of governance.
While the new housing complexes of Carrière

Centrale, El Hank, Sidi Othman, and others were divided both racially and religiously into developments for Muslims, Jews, and Europeans, the estates for Muslims were built farther away from the colonial European city center, on the edge of an empty intermediate zone known as the "Zone Sanitaire." This striking spatial segregation was a legacy of the colonial apartheid regime in which Moroccans were forbidden to enter the protectorate city unless they were employed as domestic servants in European households, and likewise constituted a strategic measure, facilitating military operations against possible resistance struggles.

The shared concepts and singular works of Team 10 have been widely discussed and researched by architecture historians lately, as a young generation of architects searches for an adaptable modernist language that goes beyond the recent elitism of star architecture. But many recent re-evaluations have been blind to the context and conditions to which the ideas of Team 10 were connected, mainly as studies on vernacular architecture and large-scale New Town planning in French colonies. Moreover, many authors have claimed that Team 10 architects in Morocco were the only ones to have considered the possibility of appropriating already-built structures in their plans. Looking at the floor plans, however, one merely finds the inclusion of a balcony as a patio-like space and various ways of connecting multiple apartments to a communal area, concepts still based on a European conception of a nuclear family and hardly an incorporation of the needs and ways of living of the people for whom it was built, representing a hybrid of colonial modernity and

its so-called "culturally specific" conceptions.

For European architects, the hut settlements and Bidonvilles were merely the spatial expression of a rural or culturally specific tradition of unplanned self-organization, a natural consequence of the disorganized structure of the new suburban situation that demanded their intervention and ordering principles; it was inconceivable that shantytowns might have existed only because the protectorate forbade people from participating in the colonial city itself. Moreover, the specific urban—and already modern—character of the self-built environment that was already a means of coping with modern city life (as well as colonial subordination) was not taken into consideration by Western planners, and any sympathies they might have had for the liberation movement have never been expressed in their writings. On the contrary, the architects positioned themselves as representing the needs of the local people while barring the same population from participating in their decision-making processes. For them, learning from the inhabitants was only a matter of adjusting their planning and architecture according to ethnological findings. Their concept of observing everyday dwelling related uncritically to already existing ethnological and anthropological studies and Orientalist narratives of African space, which included perspectives similar to those used to study the working class in Europe. In addition, while new concepts of postwar architectural modernism strongly related to the everyday practices of population groups that had become mobile, they were, on the other hand, used to regulate and control, employing the planning instrument of an architecture for the

"greatest number." Hence, improvised dwelling practices (which, like migration itself, are a type of survival strategy) were only transferred into new planning concepts for larger architectural and urban environments such as the satellite city Toulouse-Le Mirail, which Candilis, Josic, and Woods built after French decolonization. Planning not just one settlement, but a completely new town and its social, communication, and traffic systems, Toulouse-Le Mirail was planned to such an extreme that it was as if the experience of the anti-colonial movement had been completely forgotten. To this day, architects and architectural theorists have yet to fully question the colonial and postcolonial motives embedded within their own planning discourses. The ethnographic regime that emerged from the postwar modernists' early studies of the vernacular, the self-built, and squatter movements in the colonies was merely confirmed when the movement used an anthropological framework as a device for architectural planning. Simultaneously—and this is essential—the struggles of the anti-colonial liberation movements have been erased from that history, and as a result the postcolonial subject—as the subject of another modernity— is still in the making.

The didactic model of vernacular and self-built architecture—which remains influential even today for Rem Koolhaas and others—has to be critically examined in the context of colonial and global modernity. The "Learning from . . ." methodology needs to be contextualized against its ambiguous and asymmetrical postcolonial histories. With this and many other relevant critiques of Euro-American modernism in mind, it becomes important to acknowledge

the impossibility of projecting any new utopias
from the aesthetic regimes of planned worlds,
the universal abilities of the human subject,
or the "creativity of the poor," studied by the
modern sciences only to improve Western design
practices.

### Negotiating Modernity—
### Making the Present
When visiting the famous settlements
built by George Candilis and Shadrach Woods
in Casablanca for the first time some years ago,
I encountered the same difficulty reported by
many other visitors before me: one can hardly
find (or recognize) the buildings or the neighbor-
hoods anymore. This was partly due to the fact
that the *banlieues* still had yet to be included
on Casablanca's city map, but also because
their inhabitants had appropriated the build-
ings to such an extent that they were rendered
nearly unrecognizable. The buildings had not
been whitewashed and Corbusier–colored for
some time, repainted instead in light yellow and
bonbon-rose. The famous balconies of the Cité
Verticale—published in so many international
magazines and books—had been closed off to
create spare rooms, and on some of the flat roofs
people had improvised terraces similar to the
vision of the Unité d'habitation. On the entrance
level, new doors had been introduced, and little
front gardens with shade trees and flowers had
been planted. In one of the ground-floor apart-
ments, a carpenter built hand-made modern
kitchen furniture, while plaster ornaments for
the interiors were sold in another. I managed
to speak with many of the people living in this
exceptional building, and found that, like those

who lived in the Cité Verticale or the Sidi Othman, built by the Swiss architects Hentsch and Studer, they were well informed of the buildings' exceptional status and almost proud to live there. Likewise, they took pains to distinguish their neighborhoods from the existing Bidonvilles around them, however similar they were in scale and function. Most of the inhabitants had lived there since the buildings were erected, or were born there. Though the symbolic function of the high-rise model buildings had done its part to create the "new modern man," the inhabitants remained dependent on the income of one or two relatives working abroad in order to improve and to appropriate the buildings. Several people in the postwar-era settlements, young and old, spoke of having members of the family in Europe or the US who would return to Morocco in the summer. Some of these relatives even lived in the *banlieues* around Paris, built just a few years after the high-rise buildings in Morocco.

But the disorientation experienced by a first-time visitor to the outskirts of the town is not only due to the new additions and improvements by inhabitants to the high-rise settlements, but also—and to a greater degree—to the urban fabric surrounding these famous buildings, which remains that of the monstrous industrialized housing plan created by Michel Ecochard. The so-called "carpet settlements," the standard 1950s grid, provided the basis for what was to become the major urban fabric of today's Casablanca. From Moroccan independence up to the early 1980s, this model was continuously built up by the urban planning offices of the Kingdom. The structures of these carpet settlements were implemented in other North

African countries as well, and even in an adapted form in Israel. One can understand them as a North-African colonial base-model structure, and they ultimately provided much more viable foundations for city-building than the exceptional high-rises built in their midst. The Ecochard grid created the universal industrialized language for rapidly built workers' homes and large territorial expansions. In Morocco they were adapted by the postcolonial powers to house the new proletarian classes, which had not experienced any fundamental improvement in social status after the French protectorate left the country in 1956. Thus the trajectories of colonial modernity can still be traced in all spheres of life today.

Nevertheless, when visiting Casablanca, it is striking to find not only that the Ecochard grid played such a significant role in forming the urban fabric, but also to see how their aforementioned disciplinary and highly segregating character has almost disappeared. This shift did not emerge through any process of democratization on the part of the government, but rather through the various means of appropriation performed by the inhabitants themselves. Perhaps even more remarkable, the single-floor mass-built modernist patio houses, intended to facilitate the control of Moroccan workers, have been altered so significantly that one can no longer distinguish the original base structure. The builders simply used the French planners' original design as a base structure upon which to construct three or four floors of apartments. This is by no means an isolated example: When visiting Casablanca, one finds that nearly all of the buildings on its outskirts have been appropriated in a similar way.

When reflecting on these carpet settlements and their application as basic infrastructures, one finds that in spite of their problematic intentions, they still prove useful for people—and this could be much more extensively studied. A new approach to planning would therefore begin with a reflection upon how the existing needs of inhabitants have been expressed in the appropriation of these infrastructures, providing insight into the possibility of improving the existing world.

What one can "learn" from the actual uses of the colonial modern "heritage" concerns its manifold adaptations to circumstances after decolonization, to regulate people surely, but also as a basis for the self-expression of those that it sought to govern. Though the housing programs did take certain specific local conditions into account when they were conceived, these conditions turned out to be much more complex after decolonization than previously thought. The argument that the Team 10 buildings were the only ones to have accommodated the possibility of appropriation in their design grows weaker when one observes how a modernist city such as Casablanca has been used and changed by its citizens. The many ways of appropriating space and architecture by the people led to the assumption that both colonialism and the postcolonial government never managed to assume complete power over the population, and that the level of craftsmanship within the population remains very high. When I asked the man who guided us through Hentsch and Studer's Sidi Othman building about how public spaces, architecture, and interiors have been so thoroughly appropriated by the people, he responded that, "We are all

engineers, we are all architects. If we have a basic structure or land, we just start to build." This surely marks a relationship to one's environment that is almost forgotten in Western societies: that we are all architects.

The urban fabric of many other southern Mediterranean cities is filled with so-called "spontaneous" settlements, in addition to the hut settlements. Already in the 1950s these self-built settlements were the locus of the first encounters and negotiations with the modern city for a number of people moving to the city from rural areas. Horia Serhane, an urban theorist from Morocco, has stated that people in the hut settlements learned about building practices in the city quarter, the Medina, which was already a multiethnic town structure before the French occupied the country (It was subsequently museumized by colonists and tourists from Europe.) The concept of the Medina house is that of a growing house, a house that is built according to the needs and developments of a family or community. This strategy was then applied by newcomers to the self-built hut settlements of the Bidonvilles, and this is still the case today. Those huts not destroyed by bulldozers or owned by slumlords might—and often do—grow into brick homes over time, and into stable city neighborhoods.

If one takes a broader look at the many self-built houses south of the Mediterranean that use the almost universal standard of a concrete-steel grid of pillars, one finds large swathes of growing cities created with these elementary structures. This simple grid has become standard for the growing building practices found in hut settlements, in the Medina, as well as in the previously discussed "spontaneous" settlements.

People begin by building a first floor with this simple concrete-steel grid and leave the structure open on the roof to retain the possibility for further building—when the finances are there, the family grows, whenever it becomes possible or necessary. But this basic structure is virtually a replica of the Maison Dom-ino developed by Le Corbusier in 1914–15, which used simple reinforced concrete pillars as part of an industrialized building process influenced by the mass production of goods. Corbusier developed the Maison Dom-ino as a basic building prototype for mass-produced housing with freestanding pillars and rigid floors. As we can see, his ideas became not only a foundation for the modernist approach to architecture in general, but also for self-builders in the global South. Whether or not these are the best solutions for responding to weather and temperature remains an open question, but in terms of usable hardware, these concepts have become a form of common property, a part of the public domain.

A third way of thinking about architecture without architects might begin by reflecting on the trajectories of colonial and global modernity, and how people can make use of them today. The contact zone, which, as James Clifford showed, was affected by concepts and practices of modernity, colonialism, and migration, is reformulated and adapted by minor daily practices, small in scale but globally massive in number and impact. This shift in perspective might suggest possibilities for rethinking certain political concepts. On the one hand, the new boundaries created by global modernity and its politics of exclusion attempt to regulate mobility and circulation between the South and the North

in a way that can be compared with the restriction of access to the colonial city. Meanwhile, however, the practices of those who are dealing with these limitations by crossing and appropriating both its border regimes and its pre-fabricated urban landscapes are creating another post-national contemporary reality that assumes another logic altogether.

These are not signs of pessimism but rather of a new political demand, as well as a broader understanding of the concepts of citizenship and participation. Moreover, urban infrastructures that are built, used, squatted, and claimed by the people themselves are almost nonexistent in Western societies, which themselves claim to offer more possibilities for liberal forms of living than non-Western societies. From the point of view of these investigations into daily practices of appropriation and self-building in the South, these concepts need to be rethought as well, as the central question concerns whose freedom we are talking about, and from what perspective. In both colonial and postcolonial situations where modernity arose and transformed itself, it was usually the result of conflict-ridden and contra-dictory appropriations and reinterpretations. The tensions within the modern project still remain to be resolved, because too little attention has been given to the roles played by the decisive actors in transforming modernity. The different ways in which the various spheres of modernity—socio-economic, artistic, political, and so forth—are interrelated have been, and still are, regulated by a regime that shifts through negotiation, conflict, and struggle.

To close this article, I would like to return to my investigations of the Cité Verticale. It was

only a few weeks ago that I managed to put down my thoughts on a structure created by Candilis and Woods that partially went beyond the above-mentioned conceptions of high modernism and its crisis. This structure is actually a very abstract form that was placed outside the Cité Verticale, and it seemed to have a kind of non-utilitarian, almost contingent (non) function. As loose additions to the constructed buildings, these objects might be understood as an early experiment by young architects to create extensions from the home into public space. Their form almost reminds one of minimal sculptures, but surely they were intended to be functional objects. However, their intended use can no longer be determined. Today, gardens, new door entrances, and workshops have used these extensions as possible ground structures. The objects might therefore be the only expression one can find on the part of the architects that they accepted, on local ground, that they were no longer the masters of the plan or the authors of the needs of others—that the emerging postcolonial society they witnessed beyond their construction site would soon take over (the French departed and Morocco became independent only three years after the buildings were erected). They suggest a disclosure on the part of the modernist architects that they in fact had no idea how to react to the self-articulations of the subaltern, which previously had no voice. In this almost unnoticed projection into the public sphere, they tried to react to something useful and useless at the same time, as they had no idea where this emerging social process would eventually end. This almost deviant approach to design might have been their way out of

the dilemma of having to plan and study the colonized through presumptions and severe misreadings, out of the trap of the colonial powers' monstrous urban plans. But perhaps they still understood that the most radical form of design emerges when the people begin to represent themselves without mediators and masters. And until now, one finds no writing about these strange objects just outside the settlement. To revaluate and speculate on them became for me a point of departure, and perhaps the basis for a future shift in perspective.

1    Mark Crinson, *Modern Architecture and the End of Empire* (Aldershot, UK: Ashgate Publishing Limited, 2003), 1.

2    Arif Dirlik, *Global Modernity: Modernity in the Age of Global Capitalism* (London: Paradigm Publishers, 2006).

3    Manuel Castells, *The Rise of the Network Society* (New York: Wiley-Blackwell, 2000).

4    Alain Tarrius, *La remontée des Sud: Afghans et Marocains en Europe méridionale* (La Tour d'Aigues, France: Éditions de l'Aube, 2007).

5    See for example *As Found: The Discovery of the Ordinary*, ed. Claude Lichtenstein and Thomas Schregenberger (Baden, Switzerland: Lars Müller Publishers, 2001); Felicity Scott, *Architecture or Techno-Utopia: Politics after Modernism* (Cambridge, MA: MIT Press, 2007); and many other publications of the last ten years.

6    See Jos Bosman et al., *Team 10: 1953–1981, In Search of a Utopia of the Present* (Rotterdam: NAi Publishers, 2005); cf. http://www.team10online.org.

7    See Tom Avermaete, *Another Modern: The Post-War Architecture and Urbanism of Candilis-Josic-Woods* (Rotterdam: NAi Publishers, 2006).

Gean Moreno and Ernesto Oroza

# Learning from Little Haiti

*It is at work everywhere, functioning smoothly at times, at others in fits and starts:* an urban process in which things designed for one particular function are used for another. A standard stock of materials suddenly confronts a logic of construction that reinterprets it completely in uses and contexts that were never imagined for it. At times, this combinatorial propensity—even promiscuity—lying dormant in various artifacts and materials is fired up to such a degree that the apparent inevitability of established typologies and uses are undermined completely.

Individuals with no or limited connection to each other—in terms of the merchandise they offer, the clientele they cater to, or, in certain cases, in terms of nationality and ethnicity—perform the same gesture: every morning they drag a speaker out their front door and crank up the music. This gesture forms part of a bank of local knowledge that is itself a negotiation between imported habits (putting speakers in front of stores) and what the city allows (speakers that remain seemingly impermanent or extractable elements of the commercial structure). If a photographic map of the commercial axis of Northeast 2nd Avenue in Miami's Little Haiti neighborhood were to show all locations where speakers are placed on sidewalks in front of businesses, a number of observations could be made.

A pair of produce bins from the 99-cent store are tied together to make a protective casing for the speakers, which a shop owner drags every morning to the sidewalk in front of his business. Elsewhere, the seats of discarded chairs are collected over a couple of months and glued to a set of milk crates to produce a makeshift social space for afternoon dominoes games under a blooming Poinciana tree in a backyard. These are examples of a process that is activated so often that to continue to approach the phenomenon as a series of isolated instances—as this or that retrofitted object or clever solution—is to miss the point. What we have here is a system, even if a self-organized and

improvised one, that spontaneously reshapes urban spaces. The way that certain retrofitted and updated objects—not to speak of graphics and languages—found in immigrant and marginalized neighborhoods in cities throughout the West effectively alter urban morphologies and patterns of behavior cannot help but push us to think of them beyond individual instances. The density of examples adds up to a force of urban reconfiguration. Though these unexpected objects are usually produced by individuals responding to isolated needs one design decision at a time, it is when these endeavors are considered collectively that we start to see this collection of solutions synthesizing into a vital urban force.

The purpose of the speakers is obvious: they are there to attract the attention of passers-by. But they must achieve this aim, which is identical to that of commercial signage, in such a way as to elude both the legal constraints that demand that signage follows certain norms (such as the request for permits and the payment of fees) and the more cumbersome economic one that places signage production in the hands of a specialized group of professional sign manufacturers, who themselves have to fulfill certain legal requirements, such as having state licenses and active insurance policies, and who demand remuneration in line with the standards of their field. This doesn't mean that these businesses don't have any signage. There is a kind of homemade graphic painted directly on the exterior walls of most of these shops. But what they lack is a sign-object, a light box or neon sign. Homemade graphics cannot provide what the sign-object can: an expanded visual representation, a way to invade the surrounding public spaces. But the speaker makes up the difference by projecting the business outward. It reverses the hierarchy of the visual over the auditive, and in the process betrays a certain mistrust of the former as compared to the latter: it harks back to the vendor's cry and other vernacular processes of the marketplace that defy the line-of-sight geometries that the visual requires. As the message of a lit neon sign or a light box can be said to spread out visually, so the music pumping out of the speaker spreads out sonically—only it can turn corners, traverse walls, and climb over obstacles.

This is why a snapshot of a milk crate at the moment in its life-cycle when it transitions from one use to another—when it is stolen from the

supermarket and used as the leg of a display table for pirated DVDs—can be a better model for urban reconfiguration than a Herzog & de Meuron building caught in a sweeping shot from a helicopter or in a vertiginous 3D zoom. This snapshot neatly captures the fact that a city's morphology is as prone to alteration by small and repetitive gestures as it is by megaprojects. In time, such small gestures at the level of everyday objects can acquire a profound density in their collective effect on urban textures and grammars, and say something about the scale at which a city is to be imagined and realized.

Just as the music emanating from these speakers can be said to invade public space virtually, there is a physical invasion that accompanies it. The speakers are literally placed on public sidewalks. And with the speakers, a number of other elements are also brought out. Plants in shopping carts, sugar canes in milk crates, bouquets of brooms stuffed in trash cans, fully-dressed mannequins, exercise equipment, belt racks, chairs, clothing, flags, local newspapers, overstocked soft drinks, and all kinds of merchandise spill out beyond the shop's walls, beyond its architectural limitations. A schematic drawing of this speaker would have to include not only the actual object, but the wiring with which it connects to the city, the systems on which it is mounted for easy transportation, the systems it is inserted into for protection. It is the combination of these three elements with the object of the speaker as a particular entity that distinguishes its use and treatment in the context of this neighborhood from how it might be understood elsewhere. If it is co-extensive with the systems into which it is introduced, it is an assemblage that folds into an even larger *mise en scène* that it constitutes along with the other objects (which are themselves assemblages, composed, for example, of the sugar canes in the milk crate or the plants in the shopping cart). So mannequin, merchandise, speaker, the homemade graphics, the typical (and typically patterned) bars on the windows, as well as the darkness of the space's interiors, together form larger expressive units. Beyond simple display structures, they generate new territorial and identity markers: They are a scenery that diagrams not only the merchandise available in the store, but a certain cleverness in relation to the burdens presented by the neighborhood and the city.

As industries shift from standardization to optimization, as cities move from the physical to the virtual, traditional approaches to urban

planning have become obsolete. In essence, cities now change and grow below the threshold of visibility associated with architecture and urbanism. Information networks, Wi-Fi hotspots, fiber-optic grids, traffic fluctuation, crime rates, tax schemes, zoning regulations, ordinances and other legal constraints—all these matter as much, and often more than, the actual buildings around which they circulate. Consequently, certain designers have argued for decades that urbanism should begin at the level of the object. Already in 1988, Andrea Branzi proposed that this shift implies a new metropolitan theorem:

> This theorem recognizes that changes in the metropolis take place not only through the construction of architectural structures, road systems or urban services, but also through the renewal of the systems of objects and the individual commodities that improve and transform the cultural and technical fitness of places for habitation, creating the city of the present inside that of the past, and the city of the future inside the present one.[1]

As the non-architectural becomes a central component in the alterations that cities have undergone, entirely new cities emerge within the shells of buildings that speak to the concerns of another time.

Although the speakers are employed to call attention to the business, they must remain "unnoticed"—seen and heard, but not as permanent elements used to augment the traffic of consumers (or the profitability of the business). They are not to be understood as part of its intrinsic promotional machinery, even if this is precisely what they are. They should appear to be employed primarily for the entertainment they provide. Entertainment value and commercial value,

therefore, remain in a permanently ambiguous relationship that conspires against the rigid parameters of city inspectors—against the very inflexibility they embody. Beyond this, the speakers have to be portable in order to fend off any suspicion that they could be systems of communication anchored to the commercial spaces, a non-extractable part of the business itself. This portability is more than a physical fact; it is marked by what seem like clues of their provisional nature. In other words, the speakers aren't equipped to, in any way, survive the elements. A good downpour would ruin the fabric that they are usually wrapped in, and even the wood they are made of. This need to emanate a sense of fragility is intrinsic to the ambiguous status that the speakers need to convey. It has to seem as if that very day could be the first day, or the last day, that they will be brought out, as if the speakers are separate not only from the business itself, but from the pattern of behavior that characterizes their owners.

Whereas the global approaches of modern architecture relied on criteria extrapolated from an imaginary and ideal future, these new practices aim to start with an understanding of what exactly is needed and possible at a local level. Teleology is replaced with radical pragmatics. Analysis and sober prognosis replace sweeping emancipatory desires and pronouncements, opening up the possibility of an immanent architecture or design that arises from real contextual constraints and needs, from an understanding of the urban ecologies into which the structures or objects are introduced. It means working from a clearer understanding of form, space, and material as active entities—as themselves types of information or creative forces that interact with one another.

System is given priority over thing, "software" or program over product, framework over object. What we end up with matters, of course; but how we end up with it, a hyperawareness of the foundational processes, is perhaps more important. There is a general tendency, in certain quarters, to move away from the designing of individual artifacts—

whether these are entire neighborhoods, buildings, or chairs—to designing systems that themselves produce the artifacts, systems typically responsive in some way to the "insubstantial" flows that crisscross cities. In other words, it becomes a matter of instituting processes that generate forms.

Another thing one would grow aware of when analyzing this imaginary map is the repercussions that the accumulation of these vernacular practices has over the city, and how the force of repetition renders simple gestures disproportionately powerful. In this particular neighborhood, the recurring feature of the speaker in front of the store begins to help it forge a collective identity or local aura, providing new markers of reference. Beyond the rare single instance in which we find speakers used in this way (in an electronics shop Downtown or a hip new boutique in South Beach), here, each speaker is part of a pattern that, through its repetition, becomes the very urban fabric of the place. It's not grafted onto this fabric, as it may be in exceptional cases. Rather, here it is this fabric. Recurrence dismantles the risk of exceptionality. The string of speakers as a stand-in for a practice that is nowhere repeated in the city marks a discontinuity, but also a continuity, an internal practice of the neighborhood. It's a rupture that happens not through a single instance of interruption but through the introduction of a new logic of usage. It is expressed in a group of artifacts, in a statistically significant set of objects. Each speaker is consubstantial with the next as the weave of a pattern. Each aids in producing a homogenized urban area, but does so in a way that renders this area different from the rest of the city. Each speaker plays a double role, then: as a figure of cohesion (internal to the neighborhood) and as a figure of disalignment (in relation to the rest of the city). It contributes to the foundation of a local identity, while simultaneously readjusting the parameters of the city's markers as they are lodged in the particular objects considered native to it—opening a space of difference or variability toward which the city's characteristic forms of production can, potentially, move. The speaker, then, straddles the fence, back and forth, in the binary equation between identity and difference. Or rather: It occupies each of its sides depending on the vantage point from which it is approached.

A shift to designing systems over things hasn't thus far meant a new homogeneity for design disciplines. The systems established have been vastly different. In some cases, as in OMA's Seattle Central Library, statistical data is used to determine the organization of

a building—literally.[2] Information translates into structure; diagrams morph into blueprints. In other cases, as in the projects of François Roche, algorithms are extrapolated from biological forms in a quest for a set of active and immanent shape-making processes, and applied to building designs. As Roche explains in a 2008 interview: "In the beginning, we were thinking to integrate nature as a substance and now we integrate nature as a protocol."[3] In the parametric approaches of architects like Toyo Ito and Aranda/Lasch, rules and systems are often established and allowed to themselves generate forms. Reminiscent of the somewhat neglected practices of Concrete art, in which the mathematical rules established at the outset determine the final shape of the work, these practices exploit the capacity of computers employed in contemporary engineering to calculate virtually infinite numbers of variables, producing even more complex forms. The data bit and the algorithm provide flexible "building blocks" with which to erect structures suitable to urban environments that are now shaped as much by invisible flows as they are by their already existing physical structures.

The hypothetical image of all the speakers connected together via their audio cables and electrical cables, enlivening the neighborhood with Creole and Latin music, speaks also to the particularized use to which the city's standardized infrastructures, like its electrical system, are put when they run into the local cultures. The benefits of basic urban services as they course through the city meet diverse tastes, technical knowledge, levels of astuteness, and needs. But, above all, they meet different strategies of survival. At the precise location where the city's electrical output meets the audio system of the shop owner, we find that turbulent intersection between the actuality of the city and the flow of new information concretized. This is one of the physical locations—one of a nearly infinite number— where the givens of the place offer specific possibilities for imported knowledge and habits to be actualized. But their

actualization, the form it will take, is absolutely dependent on what the city itself offers. And what the city offers may itself, in time, change depending on the forms that the actualizations of foreign habits and knowledge take.

As a counterpoint to these applied systems, cities have their own self-organized generative systems. These are systems that emerge when new flows of energy and knowledge interact with a series of "native" constraints and pressures without extraneous guiding principles or outside agency. We find one at work in certain immigrant and marginalized neighborhoods. It can be recognized only once it has generated enough objects to populate an urban landscape densely enough to alter it. A critical threshold of accumulation renders it visible, while an inventory of artifacts saturated with ingenuity solidifies its presence. It is indistinguishable from the concrete examples that embody it and through which it is expressed. It's a system that doesn't start with a deliberately structured form, or with a population working toward an agreed-upon goal. It has no a priori guidelines or first principles. Necessity catalyzes it. Socioeconomic realities, migration patterns, imported forms of knowledge and taste, faraway geopolitical decisions and conflicts (often distant in both time and space), and other intangible factors "shape" this system and the object typologies and solutions that it generates.

If we insist on visualizing a map of recurrences in Little Haiti, it will be noticed, too, that all these speakers are protected with improvised wire casings, mounted on casters mass-produced for large trash cans, carried in shopping carts, or tied to the building structure itself with rubber bands, tapes, chains, their own power cords, and other materials. The consistent reappearance of these traits begins to produce an archetype. It is important to point out here, however, that what matters in this situation is less the speakers themselves than the logic of reapplication that is at work. The archetype is not the recurring speakers as much as the return of an object that has been appropriated to perform a function for which it wasn't originally designed.

Reapplication is the foundational process of this system. In cases other than that of the speaker, it isn't even any one single object that is used, but two or three seemingly incompatible ones that are brought together to produce a new artifact. The leg of a table is cemented to a flower pot; the brass headboard of a bed is used as a ladder, rubber flip-flops wedged beneath its "feet" to prevent sliding; standard PVC pipes are used to erect a veranda. The archetype, then, is the object that captures these energies of reapplication—its empirical examples are the hybrid artifacts that one bumps into around every corner, in backyards, in local shops. Unlike the traditional typologies of design—chair, bench, lamp, and so on—which are defined in relation to the way a set of recurring traits gather around a particular function (and the continuous challenging of these traits and their service to this function), the typology here is defined by the recurrence of a logic of reapplication, by the way it gathers a mass of energy and know-how. This logic of reapplication often produces strange alliances between objects, materials, and practices that few had previously thought to bring together. It creates the possibility of constantly generating unexpected solutions, loosens production from guarantees, shakes calcified practices and conventions so they might grow reanimated again and morph.

This system seems to begin to organize itself with the introduction of immigrant populations— as flows of energy, know-how, and values—to the generally stable context of a city, upsetting the equilibrium at certain points on the map, unsettling balances, opening up zones requiring new forms of creativity in order to make them habitable. This system acquires its shape through negotiations between the application of hetero-geneous knowledge and resistance to it. It's not simply that a new population introduces foreign modes of construction into a particular site and overtakes it. The exchange is more complex: The constraints presented by the city also play a part by responding with zoning regulations and legal ordinances, existing urban layouts and infrastructures, the behavior patterns and value systems of the local population, other information and energy flows, the standard stock of materials found in its lumberyards and home improvement stores, and the structural

proportions that this stock encourages. The city resists. It's not a completely pliable site, a featureless and passive landscape, a plane onto which forms are simply grafted. The city has its say in the exchange by inhibiting certain kinds of production and encouraging others—it always presents a series of ready constraints, and can constantly generate new ones. The system emerges from this mutual exchange, on a plane of interaction and friction between new flows and established patterns, at the turbulent intersection where a new reservoir of skills meets the entrenched "way that things are done." The system is formed by the feedback loops within these opposing forces of give and take.

Even if we can speak of a kind of freedom at ground level in which the producer can choose his/her tools, methods, and goals, there are at least two factors circumscribing this freedom. On the one hand, there is necessity. In the socioeconomic context that serves as the "natural" habitat for this system, need functions as a catalyst for production and retrofitting. It even conditions production insofar as the altering of mass-produced objects is performed as a response to immediate necessity, and not as some gratuitous figural violation. On the other hand, there is the stock of available materials and the set of established regulations that already exist in the environment that supports the system. It is in offering unexpected solutions within an already established horizon of specific materials, specific rules, and specific needs—in applying foreign knowledge and imported energy—that we find this system articulated.

This typology also emerges as a kind of social diagram: It reveals, on the one hand, the necessities that mark the

contexts from which these objects emerge. Every object is designed for a specific purpose, to respond to an immediate need. The obverse of a collection of these objects is the inventory of needs they aim to satisfy. Their logics and structures respond, almost biologically, to the conjunction of cultural exigencies and urban and socioeconomic pressures. On the other hand, they diagram the "movements" of the system's other quasi-biological drive—its parasitical logic. If this typology inexorably functions in relation to already existing materials, if it "takes off" from the stock of available materials and applies imported knowledge to it, then we can follow the path to where this stock material is found. It is obvious that the mathematics of certain objects (the four- or eight-foot modules of standard stocks of plywood, for instance) point to the fact that home improvement stores play an important role in this mode of production.

But this articulation never finds its ultimate form. Its momentary configurations are contingent on its set of constraints—any "snapshot" of it may just describe a transitory state in the life of its changing dynamics. At any moment, new ordinances can pass, new urban features appear (a freeway bisecting a neighborhood, for instance), immigrant populations age and grow increasingly inactive or they begin to fan out into other neighborhoods, second-generation immigrants assimilate local lifestyle habits, new technologies and materials enter the market and facilitate the emergence of new vernacular practices, unexpected historical shocks produce waves that end up affecting faraway places (creating new migrations, for instance).

    The relationship between flows of energy and knowledge and the actuality of the city, then, is in perpetual flux. It may strive toward a kind of balanced exchange, but new elements may emerge as a response to the interaction between the parts. And these new elements, too, are integrated into the system—they are absorbed into its internal movements. As they cause the parts to shift when they are introduced, they also force new design solutions, new concrete

practices at a quotidian level. This incorporation of new elements means that the system can change in unforeseeable ways in relation to the new stimuli it encounters. Or, conversely, it reaches a terminus of variability and mutation, and disintegrates.

A map of recurrences for each of the city's vernacular practices will reveal patterns of conduct that not only lessen the central role of more visible and guided practices, such as professional architecture and industrial design, but also challenge and feed on these more visibly urban protagonists in parasitical fashion. Once the density and impact of these vernacular practices can be gauged, the mediatic fantasies of influence that architects and designers weave might just unravel.

1   Andrea Branzi, *Learning From Milan: Design and the Second Modernity* (Cambridge, MA: MIT Press, 1988), 15.
2   See Joshua Prince-Ramus's "TEDTALK" on the collaborative innovation process behind the Seattle Central Library, http://www.rex-ny.com/approach/tedtalks-2006; the Library on the REX Web site at http://www.rex-ny.com/work/seattle-library/.
3   See Designboom, "Francois Roche—Interview with the French Architect," http://www.designboom.com/eng/interview/roche.html.

# Michael Baers
## -in-
# Rotterdam

My Darling A:

I came to Rotterdam to make this comic because I needed a change. It was my intention to recuperate, stay with my friends Rob and Nienke (remember them? They're the couple with the zine, Fucking Good Art) who are always good company; get some space to reflect. Not that I'd been in Berlin that long. I'd returned from a month in Palestine only two weeks...

previous. But since my return, I'd spent all my time editing the 85 pages worth of e-mails I'd mailed from the West Bank in time to translate them for an October deadline, only to realize, shortly after concluding the 4th draft, that the text still wasn't publishable, and maybe in fact, I had written it for a different audience and for different reasons then those intended.

"Fancy having gone so far only to find that what lies beyond the horizon is just as ordinary as here!" wrote Jean Genet. "Then the writer of memoir wants to show what no one else has ever seen in·that ordinariness. For we're conceited and like to make people think the journey we made yesterday was worth writing up today." During my two weeks in Berlin I'd come to realize the discomfiting truth of this statement.

One seldom talks about a failed text. There is something unspeakably shameful about it, the printed lines on the page standing as evidence of one's lack of intrinsic self worth. Failed texts are kind of like train wrecks—a series of mechanical failures, shortcomings in...

...judgment, and sheer bad luck culminating in disaster. This text, this particular disaster, was actually comprised of two previous ones: the Australian dancer who a week before my return to Berlin had abruptly broken off our affair, and my encounter with the occupied West Bank. My memory of each warped and melted into one another, converging in a flammable cocktail of anxiety, infuriation, and disappointment. This had not resulted, unfortunately, in an interesting text.

So, it might come as no surprise that once in Rotterdam, I felt little desire to work. After stacking the books I brought beside me on the desk, I've spent most of my time shuttling back and forth between two photographs on my computer:

... one of C taken in Berlin...

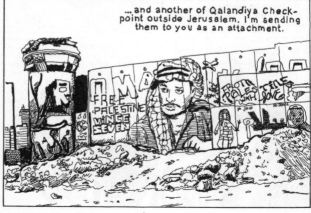

... and another of Qalandiya Checkpoint outside Jerusalem. I'm sending them to you as an attachment.

I was disgusted and disappointed with myself: disappointed by the end of the affair, disgusted by my failure with the text. I was also disappointed and disgusted by having shut myself away my first two weeks back in Berlin, insuring it would make the city feel like a stopover, somewhere I happened to be living temporarily, which in any case is true at the...

...moment. This set in motion a vicious circle, the recollection of one set of failures and disappointments calling forth the memory of more remote events in an ever-widening arc of psychic destruction. My dismal love life, my future economic prospects, career, social life, mental and physical health...each became a subject for rumination, until everything had been coated with a brown film of self-loathing. Funny how six months ago I was complaining about being exhausted; now I'm exhausted and depressed.

In his philosophy, Bergson distinguishes between perception, affection, and action as three kinds of motion. Gilles Deleuze says it is no surprise that a Bergsonian analysis of motion coincided with the inception of film, since Bergson's notion comprises cinema's central narrative mechanism:

...the hero first perceives a problem, is affected by it, and resolves to take action. "This all came to an end with the Second World War," writes Deleuze. "Suddenly people no longer really believed it was possible to react to situations... So we get Italian neorealism representing people placed in situations that cannot advance through reactions, through actions." This resembles my current situation. My deplorable state of mind results from failing to discover a concept that would deliver me out of this impasse. In any case, it's difficult at the moment to pretend all this happened to someone else.

My recent failures were, as Lacan says, appointments "to which we are always called with a real that eludes us." In the aftermath, something tells me I shouldn't try to "pick up the pieces" or "pull myself together". These metaphors are part of the problem. They keep me trying to reconstitute a lost totality rather than acknowledge that in trauma...

...*"what is assimilated is the miss itself,"* as Gene Ray phrases it. I need to reassemble the pieces, reconfigure, recombine them.

LUISTER

It comes down to learning to tolerate one's contingent, partial existence, to abide in this condition of uneasy symbiosis. Deleuze has written that we all need mediators since, "If we're not in some series, even a completely imaginary one, you're lost."

LUISTER

This is to think of oneself as a vector, intersecting with points of other vectors, passing through and continuing on. I have in my mind a diagram of this coupling of contiguity and evacuation: "In a potlatch of words and images, something like an approach."

# Biographies

## Boris Groys

(1947, East Berlin) is Professor of Aesthetics, Art History, and Media Theory at the Center for Art and Media Karlsruhe and Global Distinguished Professor at New York University. He is the author of many books, including *The Total Art of Stalinism, Ilya Kabakov: The Man Who Flew into Space from His Apartment*, and, most recently, *Art Power*.

## Hito Steyerl

is a filmmaker and writer. She teaches new media art at University of Arts Berlin and has recently participated in documenta 12, Shanghai Biennial, and Rotterdam Film Festival.

## Liam Gillick

is an artist based in London and New York. His solo exhibitions include "The Wood Way," Whitechapel Gallery, London, 2002; "A short text on the possibility of creating an economy of equivalence," Palais de Tokyo, Paris, 2005; and the retrospective project "Three Perspectives and a Short Scenario," Witte de With, Rotterdam, Kunsthalle Zürich, and MCA Chicago, 2008–2010. In 2006 he was part of the free art school project unitednationsplaza in Berlin.

Gillick has published a number of texts that function in parallel to his artwork. *Proxemics: Selected Writing, 1988–2006* (JRP|Ringier, 2007), and the monograph *Factories in the Snow*, by Lilian Haberer (JRP|Ringier, 2007), will soon be joined by an extensive retrospective publication and critical reader. He has, in addition, contributed to many art magazines and journals, including *Parkett*, *Frieze*, *Art Monthly*, *October*, and *Artforum*. Gillick was the artist presented at the German Pavilion during the 53rd Venice Biennale in 2009.

## Monika Szewczyk

is a writer and editor based in Berlin and in Rotterdam, where she is the head of publications at Witte de With, Center for Contemporary Art, and a tutor at the Piet Zwart Institute for Postgraduate Studies and Research. She also acts as contributing editor of *A Prior Magazine* in Ghent.

## Luis Camnitzer

is a Uruguayan artist who has lived in the US since 1964, and an emeritus professor of art at the State University of New York, College at Old Westbury. He was the Viewing Program Curator for The Drawing Center, New York, from 1999 to 2006. In 2007, he was the pedagogical curator for the 6th Bienal del Mercosur. He is at present the pedagogical curator for the Iberê Camargo Foundation in Porto Alegre. He is the author of *New Art of Cuba* (1994/2003) and *Conceptualism in Latin American Art: Didactics of Liberation* (2007), both from University of Texas Press.

## Sean Snyder

is an artist who lives in Kyiv and Tokyo. He is represented by Galerie Chantal Crousel, Paris; Lisson Gallery, London; and Galerie Neu, Berlin.

## Raqs Media Collective

(Monica Narula, Jeebesh Bagchi, Shuddhabrata Sengupta) has been variously described as artists, media practitioners, curators, researchers, editors, and catalysts of cultural processes. Their work, which has been exhibited widely in major international spaces and events, locates them squarely along the intersections of contemporary art, historical inquiry, philosophical speculation, research, and theory—often taking the form of installations, online and offline media objects, performances, and encounters. They live and work in Delhi, based at Sarai, Centre for the Study of Developing Societies, an initiative they co-founded in 2000. They are members of the editorial collective of the *Sarai Reader* series, and have curated "The Rest of Now" and co-curated "Scenarios" for Manifesta 7.

## Tom Holert

is an art historian and cultural critic. A former editor of *Texte zur Kunst* and co-publisher of *Spex* magazine, Holert currently lives in Berlin and teaches and conducts research in the

Institute of Art Theory and Cultural Studies at the Academy of Fine Arts Vienna. He contributes to journals and newspapers such as *Artforum*, *Texte zur Kunst*, *Camera Austria*, *Jungle World*, and *Der Standard*. Among his recent publications are a book on migration and tourism (*Fliehkraft: Gesellschaft in Bewegung—von Migranten und Touristen*, with Mark Terkessidis), a monograph on Marc Camille Chaimowicz' 1972 installation "Celebration? Realife" (2007), and a collection of chapters on visual culture and politics (*Regieren im Bildraum*, 2008).

### Irit Rogoff

is a theorist, curator, and organizer who writes at the intersections of the critical, the political, and contemporary arts practices. Rogoff is a professor at Goldsmiths College, London University, in the Department of Visual Cultures, which she founded in 2002. Her work across a series of new "think tank" PhD programs at Goldsmiths (Research Architecture, Curatorial/Knowledge) is focusing on the possibility of locating, moving, and exchanging knowledges across professional practices, self-generated forums, academic institutions, and individual enthusiasms. Her publications include *Museum Culture* (1997), *Terra Infirma - Geography's Visual Culture* (2001), *A.C.A.D.E.M.Y* (2006), *Unbounded - Limits Possibilities* (2008), and the forthcoming *Looking Away - Participating Singularities, Ontological Communities* (2009). Curatorial work includes "De-Regulation" with the work of Kutlug Ataman (2005-8), "A.C.A.D.E.M.Y." (2006), and "SUMMIT non-aligned initiatives in education culture" (2007).

### Dieter Roelstraete

is a curator at the Museum of Contemporary Art of Antwerp (MuHKA) and an editor of *Afterall*; he is also a contributing editor for *A Prior Magazine* and *FR David*, as well as a tutor at the Piet Zwart Institute in Rotterdam and the arts center De Appel in Amsterdam. He lives and works in Berlin.

### Marion von Osten

works with curatorial, artistic, and theoretical approaches that converge through the medium of exhibitions, installations, video and text productions, lecture performances, conferences, and film programs. Her main research interests concern the working conditions of cultural production in postcolonial societies, technologies of the self, and the governance of mobility. She is a founding member of Labor k3000, kpD - kleines post-fordistisches Drama, and the Center for Post-Colonial Knowledge and Culture, Berlin. She has held a professorship at the Academy of Fine Arts Vienna since 2006. From 1999 to 2006, she was a professor and researcher at the Institute for the Theory of Art and Design & Institute for Cultural and Gender Studies, HGK, Zurich. She has lectured at the Critical Studies Program, Malmö Art Academy. From 1996 to 1998, she was curator at Shedhalle, Zurich. She lives in Berlin and Vienna.

### Gean Moreno

is an artist and writer based in Miami. His work has recently been exhibited at the North Miami MoCA, Kunsthaus Palais Thurn and Taxis, Bregenz, Institute of Visual Arts, Milwaukee, Haifa Museum, Israel, Arndt & Partner, Zurich, and Invisible-Exports, New York. He has contributed texts to various magazines and catalogues. In 2008, he founded [NAME] Publications, a platform for book-based projects.

### Ernesto Oroza

lives and works in Aventura, Florida. He earned a degree at the Havana Superior Institute of Design. Oroza is author of the book *Objets réinventés : La création populaire à Cuba* (Alternative, 2002). He was visiting professor in Les Ateliers, École nationale supérieure de création industrielle (ENSCI) in Paris (1998), and professor at the Instituto Politécnico de Diseño, Havana from 1995 to 2000. His work has been exhibited in museums, galleries, and cultural spaces such as Haute Definition Gallery, Paris, The Montreal Museum of Fine Arts, The Museum of Modern Art (MoMA), New

York, and LABoral Centro de Arte y Créacion Industrial, Spain.

**Michael Baers**
is an artist based in Berlin. He has participated in exhibitions throughout North America and Europe, usually with graphical publications exhibited sculpturally. He frequently collaborates with *Fucking Good Art* and has contributed to many publications including *Chto Delat, SUM,* and *Princess Lulu.* An important correlate to his artistic practice is his work as a teacher. He has been a guest instructor in Denmark and Norway, conducting seminars that mix theory and artistic praxis. Currently he is an instructor at Det Fynske Kunstakademi in Denmark. He also occasionally writes catalogue essays, articles, and reviews.

**e-flux** journal **reader** 2009
ISBN 978-1-933128-81-8

**Publisher**
Sternberg Press

**Editors**
Julieta Aranda
Brian Kuan Wood
Anton Vidokle

**Design**
Jeff Ramsey

**Copy editing and proofreading**
Matthew Evans
Phillip Stephen Twilley

**Special thanks**
Sydney Hart, Tim Ridlen, and all the authors

For further information, contact
journal@e-flux.com
www.e-flux.com/journal

Sternberg Press
Caroline Schneider
Karl-Marx-Allee 78, D-10243 Berlin
1182 Broadway #1602, New York, NY 10001
www.sternberg-press.com